EXPOSED

EXPOSED

VOYEURISM, SURVEILLANCE AND THE CAMERA

Edited by Sandra S. Phillips

ESSAYS BY
Simon Baker
Philip Brookman
Marta Gili
Carol Squiers
Richard B. Woodward

Tate Publishing

First published in the United Kingdom 2010 by order of the Tate Trustees
by Tate Publishing, a division of Tate Enterprises Ltd,
Millbank, London SW1P 4RG
www.tate.org.uk/publishing

Published in association with the San Francisco Museum of Modern Art

EXHIBITION SCHEDULE
Tate Modern, London
28 May – 3 October 2010

San Francisco Museum of Modern Art
30 October 2010 – 17 April 2011

Walker Art Center, Minneapolis
21 May – 11 September 2011

Exposed: Voyeurism, Surveillance and the Camera is organized by the San Francisco Museum
of Modern Art and Tate Modern.

A catalogue record of this book is available from the British Library

ISBN 978 1 85437 925 2

Book design by Abbott Miller and Kristen Spilman, Pentagram

COVER
Georges Dudognon, *Greta Garbo in the Club St. Germain*, 1950s. San Francisco Museum of
Modern Art, Foto Forum purchase

Photography credits appear on page 256

Color separations by Professional Graphics Inc., Rockford, Illinois
Printed and bound in Italy by Conti Tipocolor

CONTENTS

6 Foreword
VICENTE TODOLÍ AND NEAL BENEZRA

7 Acknowledgments
SANDRA S. PHILLIPS

11 Looking Out, Looking In: Voyeurism and Its
Affinities from the Beginning of Photography
SANDRA S. PHILLIPS

Plates
ESSAYS BY SANDRA S. PHILLIPS

19 THE UNSEEN
PHOTOGRAPHER

55 VOYEURISM
AND DESIRE

89 CELEBRITY
AND THE
PUBLIC GAZE

109 WITNESSING
VIOLENCE

141 SURVEILLANCE

205 Up Periscope! Photography and the
Surreptitious Image
SIMON BAKER

213 A Window on the World: Street Photography
and the Theater of Life
PHILIP BROOKMAN

221 Original Sin: The Birth of the Paparazzo
CAROL SQUIERS

229 Dare to Be Famous: Self-Exploitation
and the Camera
RICHARD B. WOODWARD

241 From Observation to Surveillance
MARTA GILI

246 Catalogue of the Exhibition

FOREWORD

Have we become a society of voyeurs? The proliferation of camera phones, YouTube videos, and reality television would certainly suggest that this is so. At the same time, amid endless political debates about terrorism, the ubiquitous security camera has become one of the icons of our age. We watch, and we are watched.

Aided and abetted by the camera, voyeurism and surveillance provoke uneasy questions about who is looking at whom, and for what purposes of power or pleasure. Observers of the contemporary scene might be surprised to learn that no sooner had the camera been invented than enterprising photographers employed it to penetrate the secret lives of others. Surprisingly, there have been few attempts to examine the history of what we might call invasive looking, or its complex dialogue with everyday life and culture. However, artists themselves have been keen to explore its fascinations, dangers, and significance. Indeed, voyeurism and surveillance are eminently photographic ideas. They have inspired practitioners since the inception of the medium and they continue to motivate much groundbreaking contemporary photography and media work.

Published to coincide with a major exhibition organized by Tate Modern and the San Francisco Museum of Modern Art, *Exposed: Voyeurism, Surveillance and the Camera* proposes a wide-ranging exploration of photography's role in breaching the divide between public and private. By presenting both contemporary and historical work, unknown photographers and figures of international renown, all dealing with the forbidden gaze—at unsuspecting individuals, at sex, at celebrity, at pain and suffering, and finally, at all of us—*Exposed* challenges readers and viewers to think deeply about the camera's role in transforming the very act of looking.

Sandra S. Phillips, SFMOMA's senior curator of photography, approaches these themes through an astounding collection of rare early photographs, outsider and amateur photography, provocative photojournalism, and classic street photography. The fearless looking on the part of the photographers in the show brings us face to face with images that are mesmerizing, surreal, disturbing, and ultimately also pleasurable in the way that only fearless thought can be.

At Tate Modern, Sandra's collaborator is Simon Baker, curator of photography and international art, who, in addition to contributing an elegant essay to the book, has provided insightful suggestions for the inclusion of additional works. SFMOMA media curator Rudolf Frieling has selected a range of outstanding video and installation works that place contemporary media artists fully within the larger context and on the leading edge of intellectual explorations of sexuality, surveillance, and power.

The fruitful collaboration between Tate Modern and SFMOMA—two museums known for groundbreaking investigations into contemporary art and thought—ensures an international audience for the pictures and ideas that *Exposed* presents, and the dialogue it will spark. Following its presentation in London and San Francisco the exhibition will travel to the Walker Art Center in Minneapolis, where we thank director Olga Viso and chief curator Darsie Alexander and her staff for their support of the project.

An exhibition such as this depends as well on the generosity of many, many lenders, both individuals and institutions, around the world. We thank them for parting with precious objects so that all can view them, and for their dedication to the preservation of historical and contemporary photography.

VICENTE TODOLÍ
Director, Tate Modern

NEAL BENEZRA
Director, San Francisco Museum of Modern Art

ACKNOWLEDGMENTS

An exhibition of this scale and complexity can be achieved only through the generosity of many lenders willing to share their rare and historical photographs for appreciation and study. I join our colleagues at Tate Modern in extending gratitude to the following individuals and institutions:

Holly Hughes, Albright Knox Art Gallery, Buffalo, New York; Vince Aletti; Paul Amador, Amador Gallery, New York; Paule Anglim; Elisa C. Marquez, Associated Press; Piotr Setkiewicz, Auschwitz-Birkenau State Museum; Denis Beaubois; Sylvie Aubenas and Thomas Cazentre, Bibliothèque nationale de France, Paris; Black Dog Collection; Joe and Pamela Bonino; Natalie Jeremijenko and Kate Rich, Bureau of Inverse Technology; Hervé Chandès, Lucile Guyomarc'h, and Grazia Quaroni, Fondation Cartier pour l'art contemporain, Paris; Eric Franck, Martine Franck, and Aude Raimbault, Fondation Henri Cartier-Bresson; Judy Collins; Stuart Comer; Charlotte Cotton; Jordan Crandall; Thomas Demand; Michael Diemar and Laura Noble, Diemar/Noble Photography; Frédérique Dolivet; Diane Dufour; Todd Gustavson, Alison Nordström, and Wataru Okada, George Eastman House, Rochester, New York; Carla Emil and Rich Silverstein; Harun Farocki; Laura Satersmoen, the Doris and Donald Fisher Collection; Dirk Riedel, Gedenskstätte Dachau; Michael Brand, Karen Hellman, Anne Lyden, and Judith Keller, The J. Paul Getty Museum, Los Angeles; Thomas Gaehtgens and Glenn R. Phillips, Getty Research Institute, Los Angeles; Nan Goldin; Charlie Fellowes, Tim Jeffries, and David Peckman, Hamiltons Gallery, London; Cynthia Burlingham and Douglas Fogle, Hammer Contemporary Collection, Los Angeles; Mark Haworth-Booth; Edwynn Houk and Mariska Nietzman, Edwynn Houk Gallery, New York; Erin Barnett and Carol Squiers, International Center of Photography, New York; Alison Jackson; Catherine Johnson-Roehr, Kinsey Institute for Research in Sex, Gender and Reproduction at Indiana University, Bloomington; Michael Klier; David Knaus; Jenny de Roode and Maartje van den Heuvel, Leiden University Library, the Netherlands; Beverly Brannan, Library of Congress, Washington, D.C.; Chip Lord; Benjamin Lowy; Oliver Lutz; Shannon Richardson, M+B Gallery, Los Angeles; Tiggy Maconochie, Olivia Anne Rowsell, and Helena Vidalic, Maconochie Photography, London; Fiona Rogers and Sophie Wright, Magnum Photos; Joree Adilman, the Robert Mapplethorpe Foundation, Inc., New York; Jeffrey Peabody and Adrian Rosenfeld, Matthew Marks Gallery, New York; Jeff Rosenheim and Lucy von Brachel, Metropolitan Museum of Art, New York; Bruce Moore; Stéphane Bayard and Françoise Helibrun, Musée d'Orsay, Paris; Paul Schimmel and Emily Sudd, Museum of Contemporary Art, Los Angeles; Maja Finzgar and Bojana Piskur, Moderna Galerija, Museum of Modern Art, Ljubljana; Marina Chao, Peter Galassi, and Eva Respini, Department of Photography, the Museum of Modern Art, New York; Melanie Bower, Museum of the City of New York; David DeVorkin, Von Hardesty, Melissa Keiser, and Bonnie Yochelson, National Air and Space Museum, Washington, D.C.; Lucy G. Barber, Holly Reed, and James Zeender, National Archives, Washington, D.C.; Shannon Perich, National Museum of American History, Washington, D.C.; Sandy Nairne, National Portrait Gallery, London; Mary Curry, National Security Archive; Jonathan Olley; Jon Hendricks, Andrew Kachel, Karla Merrifield, Connor Monahan, and Studio One, for Yoko Ono; Alan Lloyd Paris; Martin Parr; Ami Bouhassane, Tracy Leeming, and Anthony Penrose, the Lee Miller Archives and the Penrose Collection; Andrew P. Pilara Jr., Pilara Family Foundation, San Francisco; Professor Massimo Colesanti and Silvia Fasoli, Fondazione Primoli, Rome; Jane and Larry Reed; Thomas Ruff; Dr. Friedericke Wappler, Ruhr-Universität, Bochum; Cindy Herron and Paul Sack, Sack Photographic Trust, San Francisco; Alex Sainsbury; Chara Schreyer; Andre Bernhardt and Achim Goebel, Video Art Lab, ZKM Karlsruhe, for Marie Sester; Merry Foresta, Smithsonian Photography Initiative, Washington, D.C.; David Leiber, Michael Short, Gian Enzo Sperone, and Angela Westwater, Sperone Westwater, New York; Jules Spinatsch; Andreas Gegner, Philomene Magers, and Andrew Silewicz, Sprüth Magers Gallery, London; Jerry L. Thompson and

Marcia L. Due; Cammie Toloui; Rodica Sibleyras and Madame Edmonde Treillard, representing the collection of Lucien Treillard, Paris; Martin Barnes, Sarah Gage, and Ruth Hibbard, Victoria and Albert Museum, London; Geralyn Huxley, Andy Warhol Museum, Pittsburgh, Pennsylvania; Jeffrey Bergstrom, Chrissie Iles, Barbi Spieler, and Elisabeth Sussman, Whitney Museum of American Art, New York; Polly Fleury, Hope Kingsley, and Michael Wilson, Wilson Centre for Photography, London; Stephen Wirtz Gallery, San Francisco; Robin Wright and Ian Reeves; Angela Choon, Hanna Schouwink, Silva Skenderi, and David Zwirner, David Zwirner, New York; and six private collections.

Numerous professionals in the field, including artists whom we contacted for help, provided assistance and research that helped make this show possible. We thank Athena Angelos; Amelia Antonucci, Italian Cultural Institute, San Francisco; Quentin Bajac, Centre Georges Pompidou, Paris; Erich Samuels, Bellwether Gallery; Bonni Benrubi, Bonni Benrubi Gallery, New York; Ted Bonin, Alexander and Bonin Gallery, New York; Paul Bresson, FBI; Professor Whitney Chadwick; Philip-Lorca diCorcia; Thierry Gervais, Société française de photographie; Vicky Goldberg; John Gossage; Howard Greenberg and Karen Marks, Howard Greenberg Gallery; Paul M. Hertzmann and Susan Herzig; Lisa Hudson; Peggy Le Boeuf; Theresa Luisotti, Gallery Luisotti; James Martin, Richard Avedon Foundation; Sam Mellon; Elizabeth Moy, for Susan Meiselas; Doug Munson, Chicago Albumen Works, and Linda Connor; Matthias Harder, Helmut Newton Foundation; Simon Norfolk; Irene Papanestor and Peter MacGill, Pace/MacGill Gallery, New York; Trevor Paglen; Gilles Peress; Serge Plantureux; James P. Quigel Jr., Historical Collections and Labor Archives, The Eberly Family Special Collections Library, Pennsylvania State University; Linda A. Ries, Bureau of Archives and History, Pennsylvania State Archives; Sophie Ristelhueber; Richard Ross; Stephen Shames; Michael D. Sherbon, Pennsylvania State Archives; Izabella Szarek; Kristin Ullom; and J. Kim Vandiver, Edgerton Center, MIT.

Many San Francisco Museum of Modern Art staff members assisted in organizing this exhibition and its accompanying catalogue. I would particularly like to thank Neal Benezra, director, who supported and encouraged the project from its inception. The exhibition would not have been complete without the participation of Rudolf Frieling, curator of media arts, who was an invaluable collaborator in selecting and organizing the range of media works in the exhibition. I would also like to acknowledge his team, Tanya Zimbardo, assistant curator of media arts, and Tammy Fortin, administrative assistant, for their efforts. I am especially grateful to assistant curator of photography Lisa Sutcliffe, who was invaluable in coordinating the presentation and overseeing myriad logistical complexities, as well as former assistant curators Terri Whitlock, for her dedication that set the foundation for the project, and Makeda Best and Elizabeth Gand for research and organization. Curatorial assistant Karen Rapp was a valued resource for her research skills and attention to detail. Photography Department interns Shana Lopes and Natalie Pellolio assisted with various research responsibilities.

The exhibition and its tour have been overseen by Ruth Berson, deputy director, exhibitions and collections, and Emily Lewis, exhibitions coordinator, and I extend my appreciation to them for their tireless support. For assistance and encouragement in so many ways, thanks to my colleagues in the Photography Department: Corey Keller, associate curator; Erin O'Toole, assistant curator; and Rachel Torrey and Jessica Brier, administrative assistants. Blair Winn and his staff in Development; Kent Roberts, Steven Dye, Mia Patterson, and Greg Wilson in exhibition preparation; Theresa Andrews in Conservation; Erika Abad, Olga Charyshyn, Tina Garfinkel, and Linda Leckart in Registration; Susan Backman, Anne Bast, Don Ross, and Layna White in Collections Information and Access, and Robyn Wise in Marketing and Communications all had a hand in making the exhibition a success.

I extend my gratitude to Vicente Todolí, Sheena Wagstaff, Helen Sainsbury, and Stephen Mellor at Tate Modern for their willingness to collaborate on the exhibition and the guidance they have provided in the process. At Tate Modern the exhibition is curated by Simon Baker, assisted by Ann Coxon and Katy Wan. Phil Monk, Marcia Ceppo, and Caroline McCarthy have been instrumental in overseeing the installation process and transportation of the works. Tate Modern's conservators Piers Townshend, Charity Fox, Richard Mullholland, and Alice Powell are to be thanked, as well as time-based media technicians Shuja Rahman, Hans Biorn Lian, and Tim O'Loghlin. Appreciation also goes to Tate's Press and Marketing teams, in particular Livia Ratcliffe and Duncan Holden. Justine Horseman-Sewell provided legal advice. Thanks are due to Roger Thorp and Beth Thomas from Tate Publishing.

I am indebted to SFMOMA's publications team who, under the direction of Chad Coerver, produced a handsome and intelligent book. Judy Bloch, managing editor, capably shepherded the editorial process, and Laura Heyenga, editorial associate, graciously dealt with lenders in gathering the catalogue's over two hundred illustrations. Thanks also to editorial associate Amanda Glesmann and publications intern Jennifer De La Cruz. Abbott Miller and Kristen Spilman of Pentagram made the exhibition's many parts coalesce in their imaginative design of the book, and Amanda Freymann skillfully oversaw production and printing, with expert work by Patrick Goley, Professional Graphics Inc. Fernando Feliu-Moggi provided elegant translation.

The entire Publications team joins me in extending our deepest appreciation to essayists Simon Baker, Philip Brookman, Marta Gili, Carol Squiers, and Richard B. Woodward for enriching this catalogue and broadening our understanding of a complex topic with their thoughtful contributions.

SANDRA S. PHILLIPS
Senior Curator of Photography
San Francisco Museum of Modern Art

IT IS NO COINCIDENCE that the scientific methodology of detective work, the vogue of the police or detective novel, a prevailing fear of revolutionary turmoil, and the popular use of an objective recording instrument such as the camera would all occur at roughly the same time—the late nineteenth century.[1] Nor is it merely fortuitous that early street photography, the subject of this chapter, also evolved then, for it is related to these contemporary phenomena.

Historians suggest that the increasing concern for privacy at the end of the century, provoked in large part by the invasive presence of the small camera, was a reaction to broader, rapid social changes especially in evidence in the United States. The period of the robber barons, who generated fantastic wealth from industry, also saw extreme hardship, especially for the large immigrant populations entering the country. New York City's slums were the most densely populated in the world—twice the size of the London slums that were known widely and picturesquely through Charles Dickens's novels.[2] In such crowded quarters, privacy was very relevant indeed.

Jacob August Riis was responsive to these changes. An immigrant himself, and one who had suffered depredation, he became a police reporter in New York and discovered his calling as a social reformer. Riis walked through the tough parts of lower Manhattan describing the deplorable conditions in which poor people lived. But what made his descriptive prose even more powerful were the photographs that accompanied it, made possible by the recent discovery of the magnesium flare and the flash-gun—literally a gun with magnesium and gunpowder that exploded a flash on firing.[3] Riis and some friends, mainly amateur photographers, went at night into the most destitute neighborhoods and photographed in dark alleys, small rooms, even basements, often while the subjects were asleep. The press called these photographers "the intruders," and Riis's pictures seemed especially intrusive when they were seen, greatly enlarged, in his popular lantern slide shows, his principle means of showing them to the public. Riis's first and most important book, How the Other Half Lives from 1890, included some reproductions from photographs using the then-crude halftone process; many more were reproduced as drawings by Kenyon Cox that recall illustrations to Dickens. Riis's pictures literally brought his subjects into the light so they could be seen. He wrote:

> The hall is dark and you might stumble over the children pitching pennies back there. Not that it would hurt them; kicks and cuffs are their daily diet. They have little else. Here where the hall turns and dives into utter darkness is a step. . . . You can feel your way, if you cannot see it. . . . That was a woman filling her pail by the hydrant you just bumped against. The sinks are in the hallway, that all the tenants may have access—and all be poisoned alike by their summer stenches. Hear the pump squeak! It is the lullaby of tenement-house babes. . . . But the saloon, whose open door you just passed in the hall, is always there.[4]

Although his intent was to promote an improved standard of living for the poor, protect society from endangerment, and preserve humane intimacy, many of Riis's photographs are almost shockingly invasive, a sense reinforced by the brutal, assaultive flash, especially potent in photographs made indoors of the sleeping poor. Even when awake, these people

were sometimes so dead tired, inebriated, or desperate they seemed not to care, or even to be aware of the man in front of them, focusing his camera and igniting the flare [pls. 7, 10].

Lewis Hine, as gentle as he was, made many of his photographs surreptitiously or slyly in order to elucidate the tragedy (and bad economics) of child labor. Hine was hired by the National Child Labor Committee to document children who worked in mines and factories—not a subject the industrialist owners were eager to have him record. In the mines he used a flash, as Riis had, to expose what was normally unseen [pl. 8]. He made photographs discreetly outside the factories and more evasively inside, using a ruse to enter and witness young people working the dangerous textile looms [pl. 6]. To gauge the height of these children for the accompanying evidentiary descriptions he used a buttonhole on his coat as an approximate measure.

Other turn-of-the-century photographers looked invasively at people of other cultures for sensationalist reasons or to emphasize difference. Arnold Genthe, a well-educated, Prussian-born amateur (at least in the beginning), photographed the Chinese inhabitants of San Francisco unobtrusively, with a small camera, looking at them as objects of wonder [pl. 13].[5] In the immediate aftermath of the great earthquake of 1906, Genthe photographed an area with African American residents who seemed not overly welcoming to this intruder with a camera. Other photographers smuggled their cameras into privileged spaces. One "Kodaker" photographed a Hopi religious ceremony, normally forbidden [pl. 12].[6]

When Riis made pictures of the New York slums, the friends who accompanied him on those first trips were interested less in reform than in photography itself. A notice about Riis and his early companions in the New York Times of January 14, 1890, makes this clear: "Tours through different parts of the city are now being made by members of the Society of Amateur Photographers, in order to secure some fresh negatives of picturesque localities, to be shown at the lantern-slide exhibition at Chickering Hall on Feb. 5. There is a little rivalry among the young knights of the camera to gain fine specimens."[7]

Alfred Stieglitz was one of the leaders of the "young knights of the camera," and a dedicated craftsman who was the medium's most significant and adventurous figure in the United States. The invention of the snapshot camera was an ambiguous provocation for him. In 1897 he wrote, a little too hopefully, "Photography as a fad is well-nigh on its last legs, thanks principally to the bicycle craze."[8] However, he was not blind to the potential of the hand camera. As the first to exhibit modern painting and sculpture in New York in his Little Galleries of the Photo-Secession, Stieglitz understood the sea change toward an art of formal concerns and perceived that the snapshot could represent an essence of his chosen medium. His own snapshot-inspired city views were often made near the same areas of lower Manhattan that Riis photographed, and at roughly the same time. A number were gathered into a portfolio he called Picturesque Bits of New York and Other Studies, from 1897. No crusader for social justice he, yet Stieglitz somehow identified with the poor people in his pictures—he abhorred the crass, materialistic culture of America and positioned himself as an outsider. Idealization of the outcast or poor was a component of European painting with which he was familiar.[9] His aesthetic stance, that of a privileged observer who sees the world through his own sensibilities, was challenged by two younger photographers, Walker Evans and Paul Strand, who nevertheless pursued Stieglitz's interest in the snapshot as a pure form of photography. They inherited his ambition to make photographs from real incidents encountered on the street, but photographed ordinary and even poor people without his aloof distance.

Strand first visited Stieglitz's gallery when his teacher at the Ethical Culture School, Lewis Hine, took his class there in 1907. At that time, Hine was photographing the immigrants entering Ellis Island; it was also the year Stieglitz made The Steerage [fig. 4, page 206]. Both Hine's social looking and Stieglitz's symbolic identification with the humble man of the streets would inflect Strand's own engagement with voyeuristic looking.[10]

In 1916 Strand rented a summer place outside New York City in order to think through the formal innovation of Cubism and how it might open up photography to a modern practice. He returned to the city with a new interest in portraits, of plain, poor people seen up close. That fall, Strand fitted his camera with a false lens (the real one was pointed to the side; later he would use a prism) and walked around the Bowery, looking into the faces of poor immigrants, closely enough to see them without affect or mask [pl. 2]. As

Van Wyck Brooks said in 1915 of the recent immigrant populations on the Lower East Side, they came from a "more vivid, instinctive and vital civilization."[11] These are some of Strand's most affecting and disturbing pictures: inquiring, personal, perhaps even identifying with the unmannered vitality, crudeness (he photographed a woman in the middle of a yawn), and open vulnerability of his subjects. Why did he feel compelled to make them? Perhaps as an antidote to the summer's careful, aestheticized abstractions, perhaps in an effort to retain contact with real people, people that Stieglitz also had seen at Five Points Square in New York.

Walker Evans was working as a page in the New York Public Library around 1926 when he came upon Strand's *Blind Woman, New York, 1916* [pl. 16]. Seeing it awakened "a left-handed hobby of mine," photography.[12] "It excited me very much. I said, that's the thing to do. . . . It was strong and real . . . a little bit shocking, brutal."[13] Around 1929, back from a year in Paris, Evans visited the old and ill Stieglitz at his gallery. The encounter was not a success. He later said of Stieglitz, "He was artistic and romantic. It gave me an aesthetic to sharpen my own against—a counteraesthetic."[14]

While it is true that most of Evans's pictures could not be called voyeuristic— they are formal pictures of buildings and interiors, or meditative pictures of people looking directly at the photographer, consenting to a picture—there is an apparent interest in photographing what is not meant to be seen, a kind of invasiveness, however dignified. In addition to the view camera, an instrument not easily used for unpremeditated spying, Evans used the more discreet small cameras.[15] Like many others, he included a Vest Pocket Kodak in his luggage when he went to Paris, and after his return he walked the New York streets with a series of handheld cameras, photographing workers sitting on the sidewalk eating their lunch, or peering down at pedestrians from above [pl. 19]. These pictures, though made of public circumstances, bear the hallmarks of a private view, and reflect the abstraction of such a view that interested European modernists.[16] In 1933, Ben Shahn loaned Evans his right-angle viewfinder, which permitted the photographer to point the camera in one direction but photograph in another. Evans would employ such a camera on a trip to New Orleans, where he was characteristically drawn to the more modest parts of the city,

and while on assignment for the Resettlement Administration in Vicksburg, Mississippi. There he photographed in the poor African American part of town, leaving his large camera sitting in the open, making pictures as his subjects forgot about him. He had not forgotten about them.

During the summer of 1936, Evans worked with the writer James Agee on a project for *Fortune* magazine that eventually became the book *Let Us Now Praise Famous Men*, published in 1941. This extended meditation on three impoverished tenant farmer families whom they befriended and lived with for a few weeks in Hale County, Alabama, reveals both Evans and Agee to be fully aware of their conflicted roles as both compassionate and sly intruders. Agee calls them "spies." Making something he calls "art" out of the encounter was a constant anxiety.[17] In one passage, after the Gudger family have left their house to work in the fields, Agee writes:

> They are gone.
> No one is at home, in all this house, in all this land. It is a long while before their return. I shall move as they would trust me not to, and as I could not, were they here. I shall touch nothing but as I would touch the most delicate wounds, the most dedicated objects.[18]

Evans and Agee were respectful—one might even say awestruck—when they entered these families' bedrooms, the most private areas of their painfully humble dwellings. The pictures reveal a sense of the sacramental, of the purity of the modesty of these people's intimate lives, but their makers were very conscious of invading private territory. When Evans photographed Mississippi flood victims the following year, he made a series of pictures of a young black woman sleeping in her bed that rank among the most explicitly and aggressively invasive photographs he ever took [pl. 9]. This tension would become an issue not only for Agee and Evans but for the construct of documentary photography in general.

Ben Shahn learned the principles of making photographs from Evans around 1934, and used a Leica, often outfitted with a viewer. Both Shahn and Evans wanted the naturalism that such spying afforded, assuming, as Evans wrote, that they "were working in the great tradition of Daumier and *The Third Class Carriage*."[19] Pictures Shahn made of crowds, of people watching him in the street (all believing

he was photographing something else), show the kind of reality you can see when you walk around without a camera [pls. 15, 25]. Shahn looked at subjects that also would interest Evans, such as people sleeping in the street [pl. 22], certainly an invasion of a private space.

Helen Levitt, another friend of Evans's, put a right-angle viewfinder on her Leica and photographed people in the streets of Yorkville and Harlem with a naturalness bestowed by their being unguarded [pls. 26–27]. After the Mississippi flood pictures, Evans asked Levitt to accompany him into the subway, where he outfitted himself with a camera hidden under an overcoat, a cable release running from the camera on his chest down his sleeve to his hand. Evans wanted to photograph people without self-conscious projection, in private interior moments while in public transport. The pictures seem artless and even brutal [pls. 17–18]. When, years later, they were published in *Harper's Bazaar*, he said, "The portraits on these pages were caught by a hidden camera, in the hands of a penitent spy and an apologetic voyeur. But the rude and impudent invasion involved has been carefully softened and partially mitigated by a planned passage of time."[20] Looking intrusively seems to have been Evans's great pleasure, and one of his most consistent interests. As he wrote to a friend: "Stare. It is the way to educate your eye, and more. Stare, pry, listen, eavesdrop. Die knowing something. You are not here long."[21]

The circle of Evans and Levitt briefly coincided with that of Henri Cartier-Bresson when the latter spent several months in New York in 1935. Before entering the more public field of photojournalism, Cartier-Bresson was engaged, like Evans, in making personal photographs and living a precarious bohemian existence. Friendly with the Surrealists, he was "marked," as he later confided, by "the role of spontaneous expression and of intuition and, above all, the attitude of revolt."[22] Cartier-Bresson was intrigued by the potential of the small Leica camera before he arrived in America. He made magical pictures of people living in or from the street in Europe, people on the margins. These early pictures lack distance and mediation, and tend to be more impulsive, certainly less discreet, than the more classical work he began to make when he returned to France in 1935 and formulated elegant reportage. (Nevertheless it was in Paris that he caught his friend, the American poet Charles Henri Ford, buttoning his pants as he exited a pissoir [pl. 23]). When Cartier-Bresson spent the better part of a year in Mexico in 1934, some of his most intense pictures captured the exotic-looking prostitutes in the working-class district where he lived [pl. 46]. Even his glance downward to observe a young woman sleeping in the street, protected by her mother and sheltered by her father's umbrella, reveals a prying curiosity about the exotic and erotic [pl. 21].

In Europe in the 1920s, the excesses of World War I over, the first popular pictorial magazines evolved, and with them the first professional photojournalists. This occurred first in Germany, but when German politics became destabilized, many of those journalists migrated to other parts of Europe and then to England and the United States. Brassaï (Gyula Halász), a Transylvanian, arrived in Paris and earned a precarious existence as an artist and writer in *vu* magazine [pl. 20] and other, decidedly racier publications. The more surreptitious work portraying the nighttime life of Paris—which he regarded as a distinctive subculture—was published in 1933 as *Paris de nuit* [pl. 47]. Brassaï's adherence to this underworld of a purer and rawer character allied him to the Surrealists.

Polish émigré Arthur H. Fellig, known as Weegee, published his best and most memorable book, *Naked City*, in 1945. Weegee was a tabloid photographer, a master at recording violent death and the hardships of the very poor in New York City. These pictures have none of the mystery of Brassaï's: Weegee's world is tougher, more daringly graphic, and more explicitly voyeuristic. It is almost as though the flashbulb had been invented just for him, to reveal the gore, the crumpled bodies on the pavement, the look on the face of a person who had just killed somebody, or who had seen someone die [pl. 97]. Some of his kindest photographs show New Yorkers escaping the stultifying summer heat by sleeping outside on their fire escapes, or entwined lovers on the nighttime beach at Coney Island, pictures both gentle and intrusive [pl. 49].

Street photography developed into a major and eloquent form of expression in the United States, partly because it was supported by John Szarkowski at the Museum of Modern Art, New York. Szarkowski saw Walker Evans as a great forebear of the photographers he first showed in 1967, in an exhibition he tellingly called *New Documents: Diane Arbus, Lee Friedlander and Garry Winogrand*.

He distinguished their work, and Evans's by implication, by claiming no hortatory element in their pictures, no exhortations of sympathy. Winogrand's pictures show an undisguised curiosity about the enormity of what could be seen around him; he was fascinated by the photograph's capacity to form a picture from overwhelmingly chaotic, unexpected facts. He looked over the cliff near the beach in Santa Monica to watch an old man climb the long stair under the freeway, painfully alone beside a young couple in that no-man's-land of weeds and concrete [pl. 31]. A photograph he took of a plump girl on a New York sidewalk also slyly included a couple kissing, the woman looking at the photographer making his picture of the girl in front of him: a picture of voyeuristic complicity after the fact? [pl. 24] Other photographers of the 1970s, such as Bill Dane [pl. 30] and Anthony Hernandez [pl. 34] (both working on the West Coast), have contributed to the art of watching, of peering, often with an accepting distance or engaged humor, at what happens right in front of us.

Perhaps more than any other photographer of recent history, Diane Arbus took on the notoriety of voyeurism and, with characteristic courage, transformed it. Her work engages the voyeuristic impulse to give notice to people otherwise overlooked or avoided, and sees them for their brave difference. In 1978 Szarkowski traced Winogrand's lineage from Evans through to Robert Frank, photographers who, like Arbus, were more interested in knowing the world than understanding themselves, or who by knowing the world could understand who they were in it. The remarkable openness of this work, together with a questioning of authority that began in the 1960s and continues today, has eroded the notion of documentary photography as an authoritative view. Today, looking at subjects voyeuristically in public places is subsumed into an engagement with issues of surveillance and a questioning of our relationship to intimate acts and scenes of violence.

1 See Carlo Ginzburg, "Morelli, Freud and Sherlock Holmes: Clues and Scientific Method," in *History Workshop Journal* 9, no. 1 (Spring 1980): 5–36, reprinted in his book *Myths, Emblems, Clues*, trans. John and Anne C. Tedeschi (London: Hutchinson Radius, 1990).

2 See Tom Buk-Swienty, *The Other Half: The Life of Jacob Riis and the World of Immigrant America*, trans. Annette Buk-Swienty (New York: W. W. Norton and Co., 2008), 164.

3 "Gunning for Pictures, Photographs Taken by a Pistol Flash," *The New York Times*, October 12, 1887, 2.

4 Jacob A. Riis, *How the Other Half Lives: Studies Among the Tenements of New York* (New York: Charles Scribner's Sons, 1890), 43.

5 Genthe's attitude seems ambiguous, both from his writing and the observations of others. See the foreword to Arnold Genthe, *Pictures of Old Chinatown* (New York: Moffat, Yard and Co., 1908), 3.

6 The SFMOMA collection contains two photographs of this ceremony taken by H. R. Voth with a Kodak camera.

7 "Caught with the Camera; Amateurs on the Hunt for Picturesque Views," *The New York Times*, January 14, 1890, 9.

8 Alfred Stieglitz, "The Hand Camera—Its Present Importance," from *The American Annual of Photography* (1897), reproduced in Nathan Lyons, ed., *Photographers on Photography: A Critical Anthology* (Englewood Cliffs, NJ: Prentice-Hall, 1966), 108.

9 This is evidenced by numerous examples of his photographs, including *A Venetian Gamin*, no. 167, and *A Gutach Peasant Girl*, no. 188, in Sarah Greenough, *Alfred Stieglitz: The Key Set: The Alfred Stieglitz Collection of Photographs*, vol. 1 (Washington, D.C.: National Gallery of Art and Harry N. Abrams, 2002).

10 See Maria Morris Hambourg, *Paul Strand, Circa 1916* (New York: Metropolitan Museum of Art, 1998), 35–39, for a provocative discussion of Strand during these years. See also Sarah Greenough, *Paul Strand: An American Vision* (Washington, D.C.: National Gallery of Art in association with Aperture Foundation, 1990), 37.

11 Van Wyck Brooks, *America's Coming-of-Age* (New York: Huebsch, 1915), 162.

12 Leslie Katz, "Interview with Walker Evans," in *The Camera Viewed: Writings on Twentieth-Century Photography*, vol. 1, ed. Peninah R. Petruck (New York: E. P. Dutton, 1979), 121.

13 Evans quoted in Maria Morris Hambourg, "A Portrait of the Artist," in *Walker Evans* (New York: Metropolitan Museum of Art, 2000), 17.

14 Katz, "Interview with Walker Evans," 124.

15 John Szarkowski mentions Evans's interest in "secrets" several times in his introduction to *Walker Evans* (New York: Museum of Modern Art, 1971), 18, 19.

16 See Douglas Eklund, "Exile's Return: The Early Work, 1928–34," in *Walker Evans* (2000), figs. 26, 29, 30.

17 James Agee and Walker Evans, *Let Us Now Praise Famous Men: Three Tenant Families* (Boston: Houghton Mifflin Company, 1941, 1969). Agee refers to "spies, moving delicately among the enemy," 5; "spies, guardians, and cheats," 7–8.

18 Ibid., 135–36. When meeting the first of their subjects, Agee writes, Evans "under the smoke screen of our talking made a dozen pictures of you using the angle finder," 362.

19 The painting was at the Metropolitan Museum of Art. See the discussion in Deborah Martin Kao, "Ben Shahn and the Public Use of Art," in her *Ben Shahn's New York: The Photography of Modern Times* (New Haven, CT: Yale University Press, 2000), 57–59.

20 Walker Evans, "The Unposed Portrait," *Harper's Bazaar*, March 1962, 120. Sarah Greenough also mentions the moral issue, and notes that photography in the subway was forbidden in Evans's time (it still is), in *Walker Evans: Subways and Streets* (Washington, D.C.: National Gallery of Art, 1991), 25.

21 Walker Evans, *Walker Evans at Work* (New York: Harper and Row, 1982), 161.

22 Conversation with Gilles Mora, in a special issue of *Les Cahiers de la photographie*, 1986, quoted by Peter Galassi, *Henri Cartier-Bresson: The Early Work* (New York: Museum of Modern Art, 1987), 12.

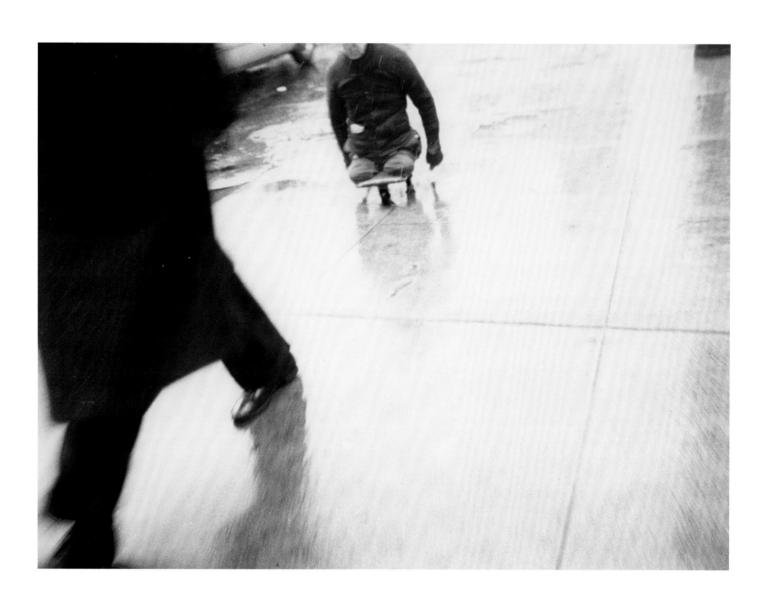

1 Robert Frank, *New York City*, 1954

2 Paul Strand, *Man, Five Points Square, New York, 1916*, 1916

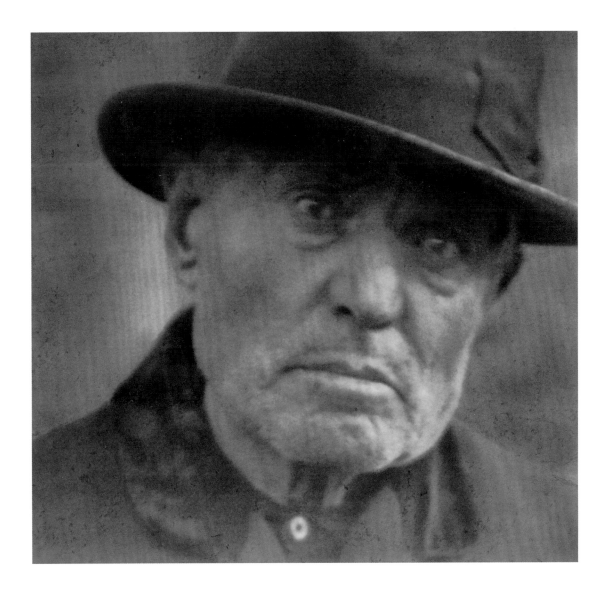

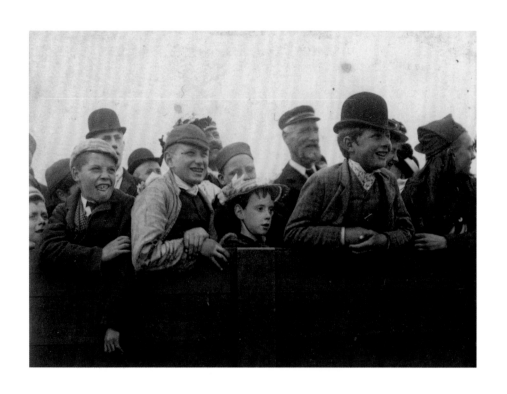

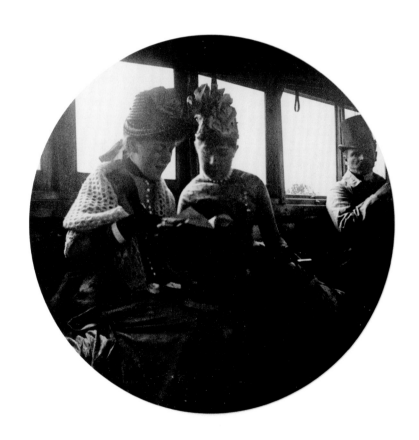

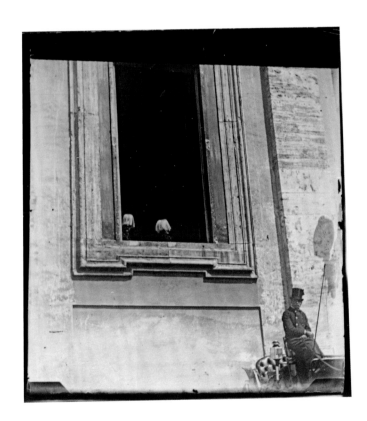

3 Paul Martin, *Listening to the Concert Party in Yarmouth Sands*, 1892

4 Horace Engle, *Untitled (Interior of a Streetcar)*, 1888

5 Giuseppe Primoli, *[Swiss Guards at the Vatican Palace]*, ca. 1889

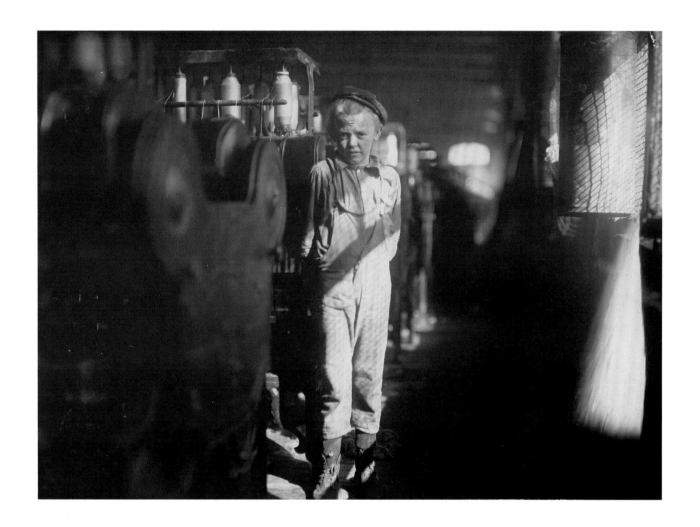

6 Lewis Wickes Hine, *"Our Baby Doffer" they called him. This is one of the machines he has been working at for some months at the Avondale Mills. Said, after hesitation, "I'm 12," and another small boy added, "He can't work unless he's 12." Child labor regulations conspicuously posted in the mill.* Location: Birmingham, Alabama, 1910

7 Jacob August Riis, *A "Scrub" and Her Bed—The Plank*, 1892

8 Lewis Wickes Hine, *Noon hour in the Ewen Breaker, Pennsylvania Coal Co.* Location: South Pittston, Pennsylvania, 1911

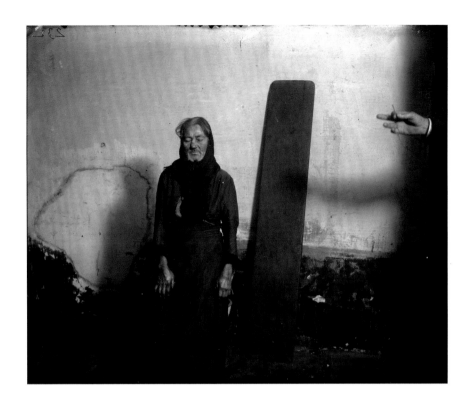

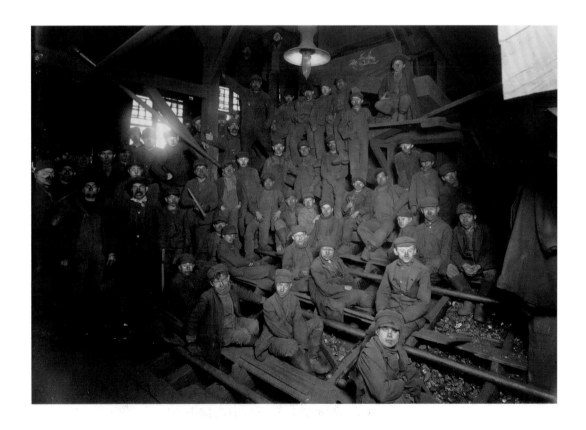

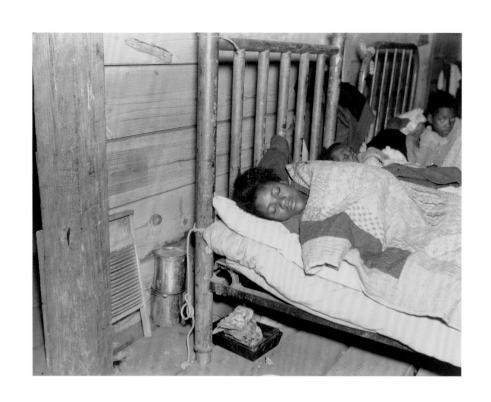

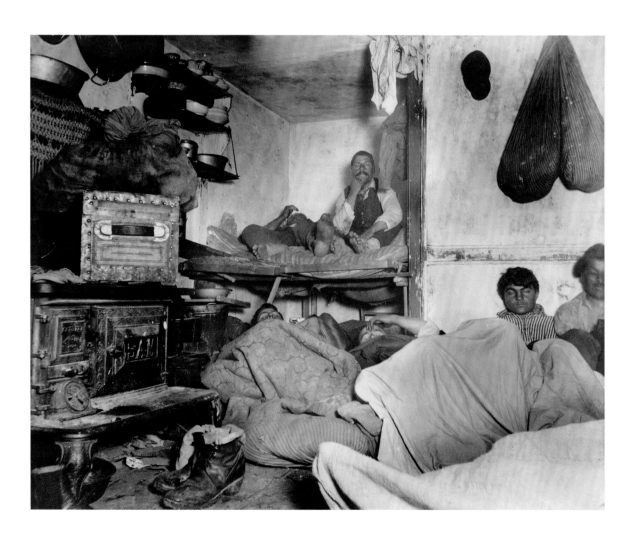

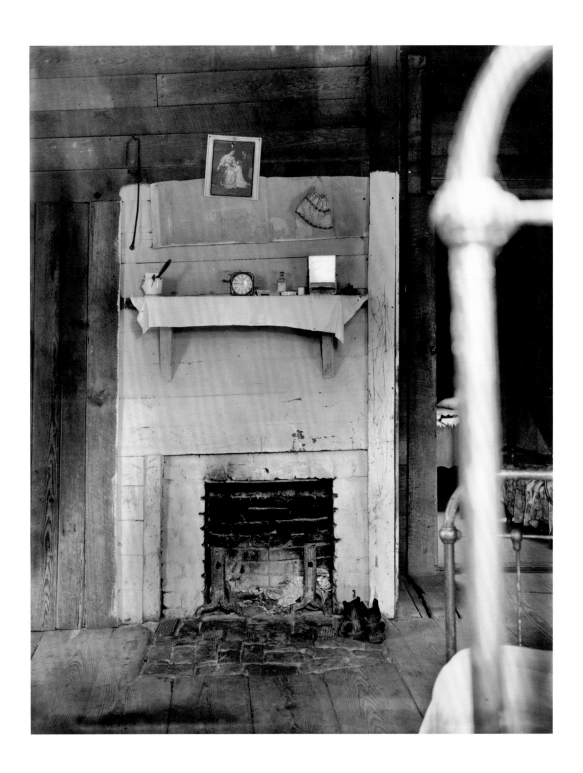

9 Walker Evans, *[Sick Flood Refugee in the Red Cross Temporary Infirmary, Forrest City, Arkansas]*, 1937

10 Jacob August Riis, *Lodgers in a Crowded Bayard Street Tenement—"Five Cents a Spot,"* 1889

11 Walker Evans, *[Fireplace in Bedroom, Burroughs Family Cabin, Hale County, Alabama]*, 1936

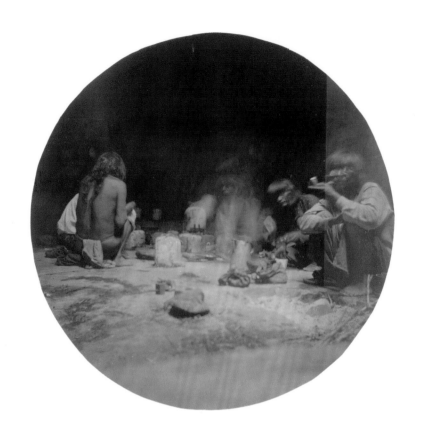

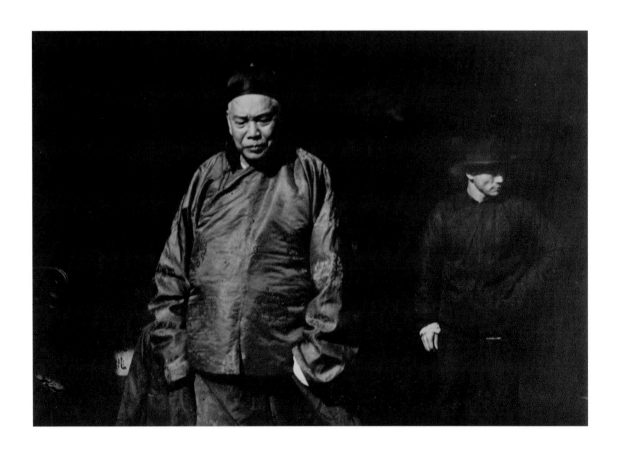

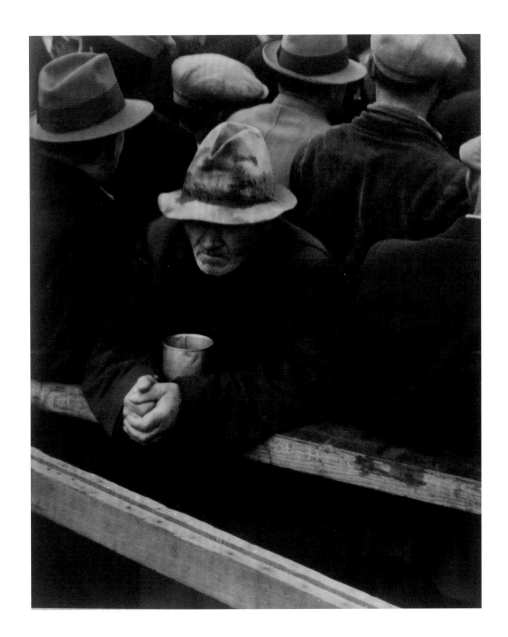

12 H. R. Voth, *Smoke Ceremony in Kiva*, 1897

13 Arnold Genthe, *Merchant and Body Guard, Old Chinatown, San Francisco*, ca. 1896–1906

14 Dorothea Lange, *White Angel Breadline, San Francisco*, 1933

15 Ben Shahn, *Post Office, Crossville, Tennessee*, 1937

16 Paul Strand, *Blind Woman, New York, 1916*, 1916

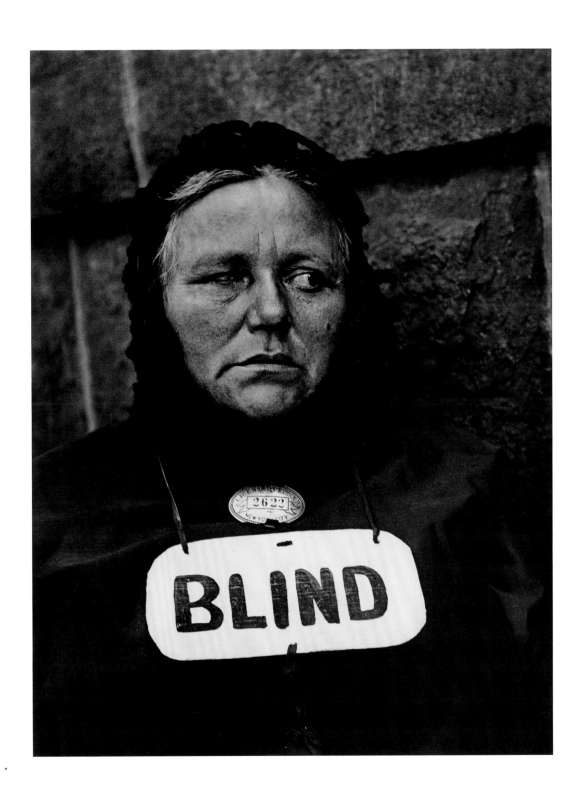

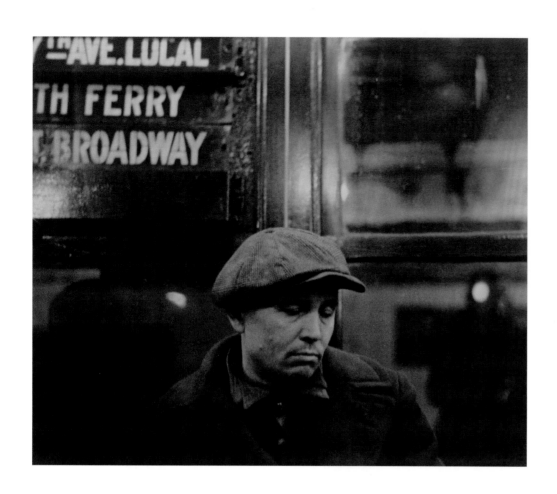

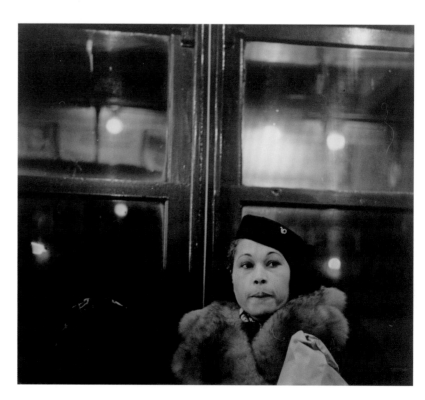

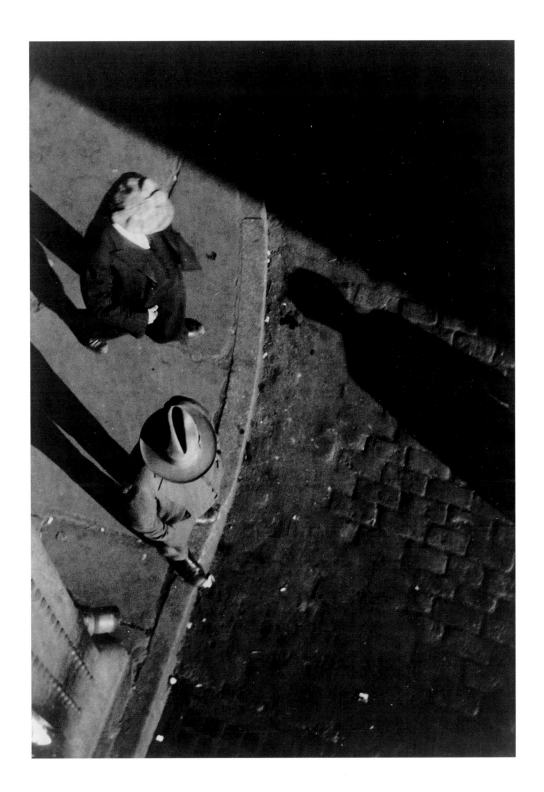

17 Walker Evans, *[Subway Passenger, New York]*, 1938

18 Walker Evans, *[Subway Passenger, New York]*, 1941

19 Walker Evans, *[Street Scene, New York]*, 1928

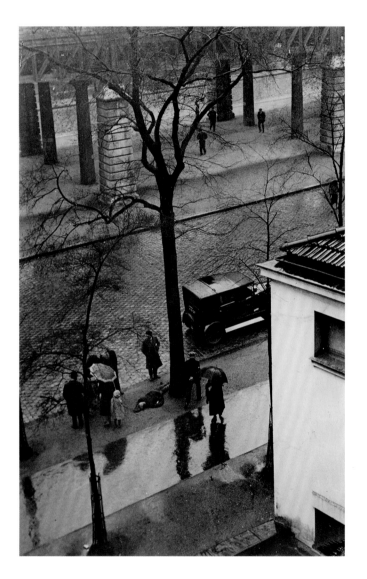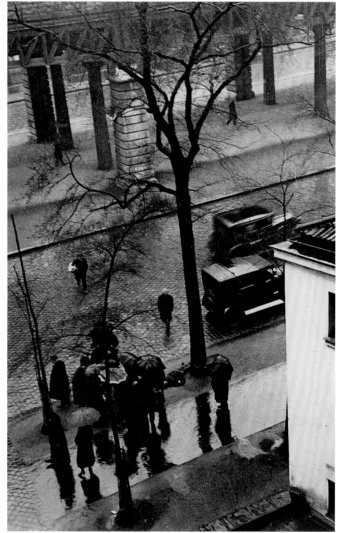

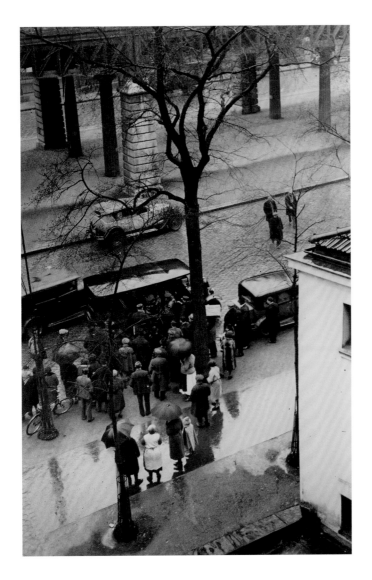
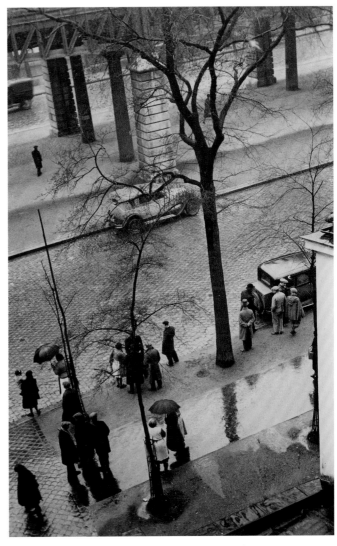

Brassaï (Gyula Halász), *A Man Dies in the Street* (detail), 1932

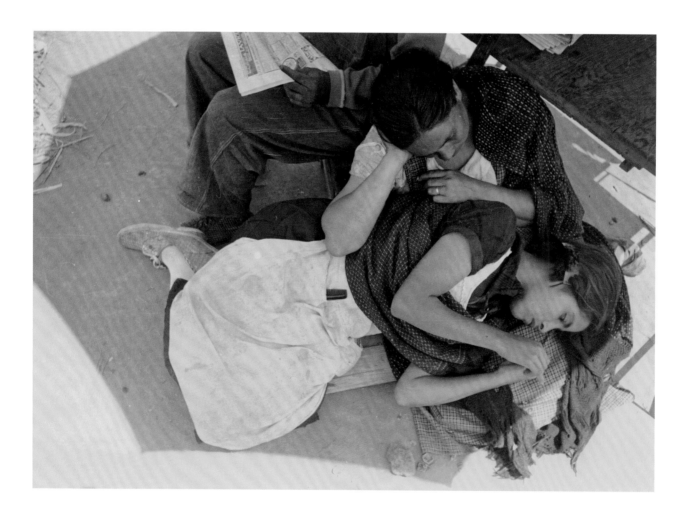

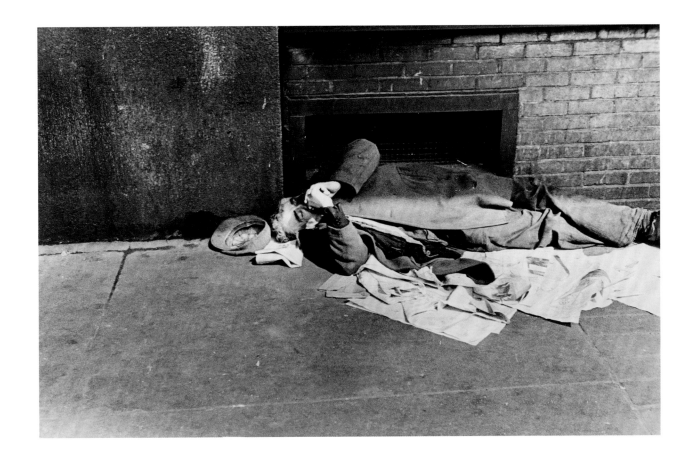

21 Henri Cartier-Bresson, *Calle Cuauhtemoctzin, Mexico City*, 1934

22 Ben Shahn, *Asleep on Sidewalk, Bowery, New York City*, 1933

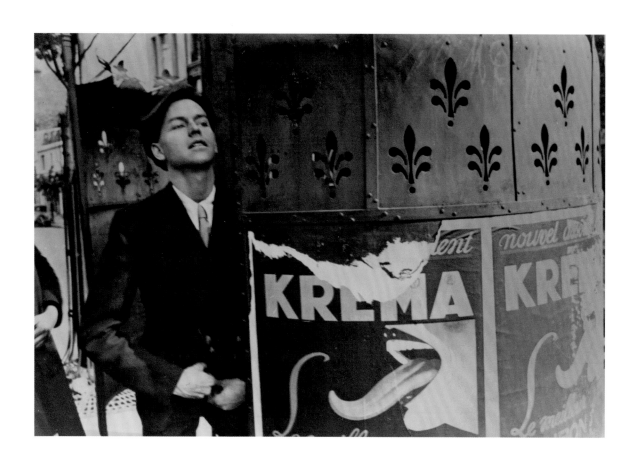

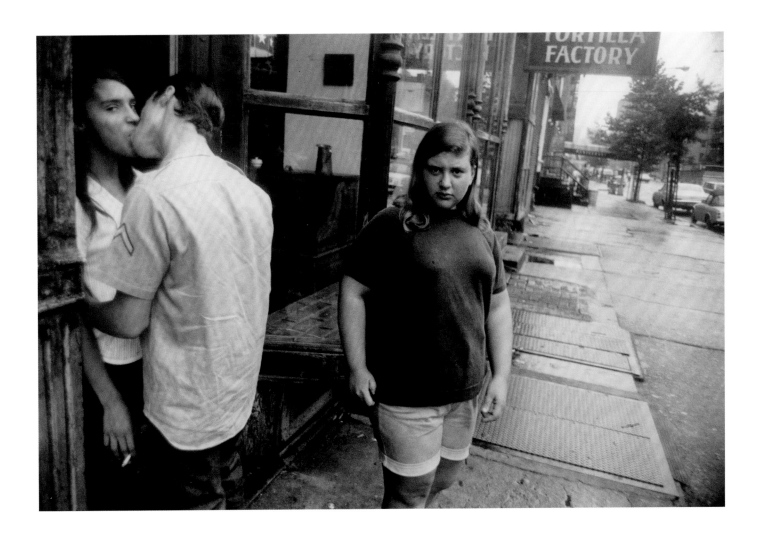

23 Henri Cartier-Bresson, *Charles Henri Ford, Paris*, 1935
24 Garry Winogrand, *New York*, 1969

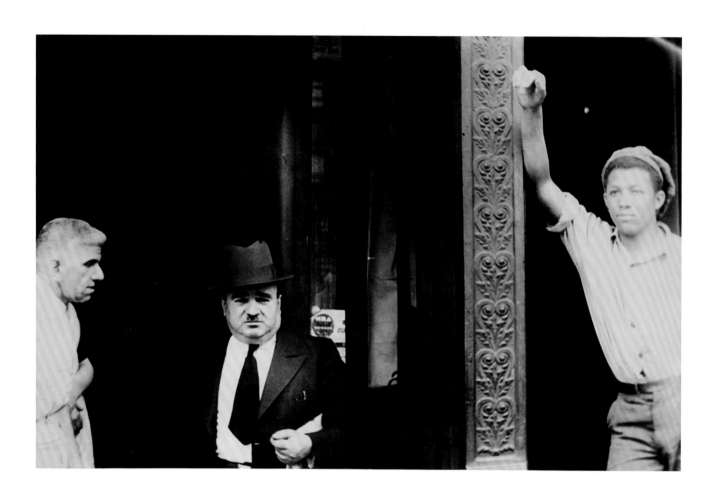

25 Ben Shahn, *Three Men With Iron Pilaster, New York*, 1934
26 Helen Levitt, *New York*, 1939

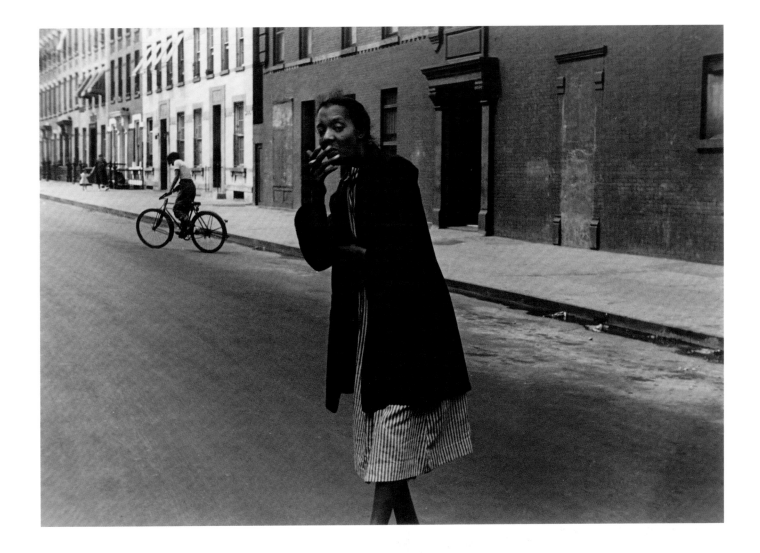

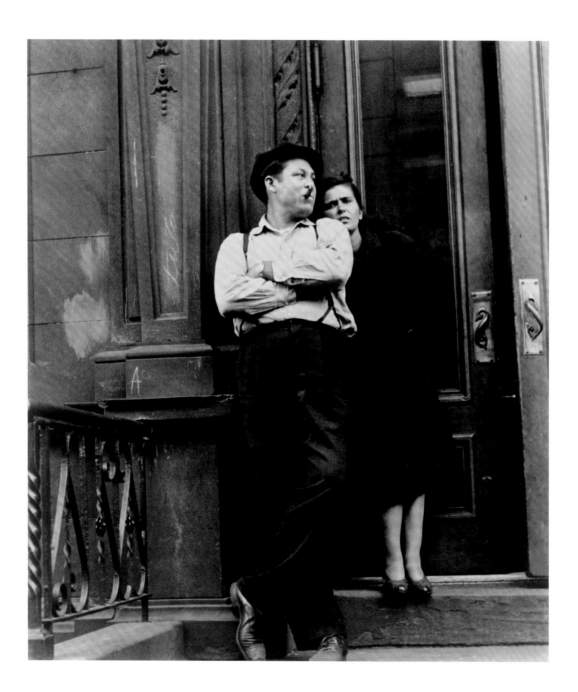

27 Helen Levitt, *New York*, 1942

28 Harry Callahan, *Chicago*, from the series *Women Lost in Thought*, 1950

29 Harry Callahan, *Chicago*, from the series *Women Lost in Thought*, 1950

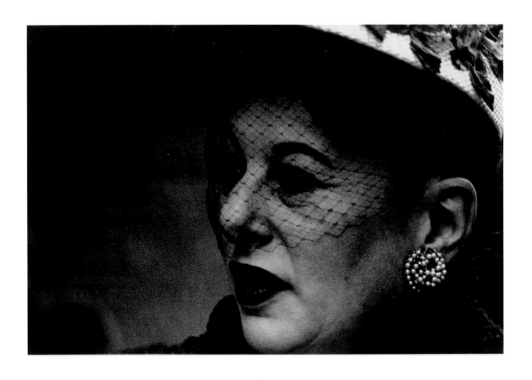

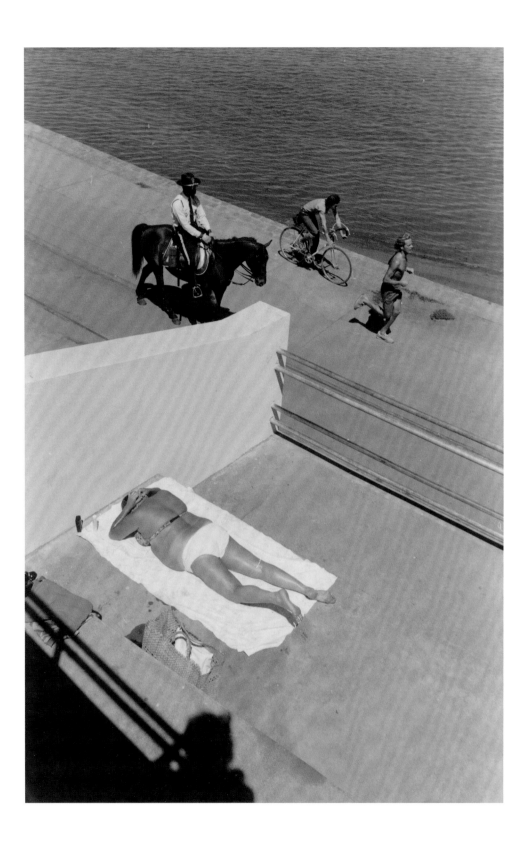

30 Bill Dane, *San Francisco*, 1973

31 Garry Winogrand, *Santa Monica*, 1982–83

32 Philip-Lorca diCorcia, *Head* #10, from the series *Heads,* 2001

33 Harry Callahan, *Atlanta,* 1984

34 Anthony Hernandez, *Landscapes for the Homeless #24*, 1989

35 Mitch Epstein, *Untitled, New York #1, 1998*, from the series *The City*, 1998

VOYEURISM
AND DESIRE

PHOTOGRAPHY HAS BEEN the voyeur's stand-in from the beginning of the medium, a way to make permanent an intrusive, and sometimes forbidden, view of sex, either for private delectation or to share and perhaps profit from it. Most of the early pictures that embodied sexual looking were of people who consented to be photographed; many were paid for their services, and often the models were prostitutes. In some of these pictures the model's features are obscured, rendering her (usually her, but not always) a kind of object, an abstraction of sex, but also protecting her from prosecution [pl. 43].[1] In the nineteenth century, pictures of nudity were often designated *académies*, models for artists' use, as a cover for soft pornography and a way to elude censorship. These pictures appropriate the iconography of the nude in painting, from Titian and Velázquez to Ingres and Delacroix. In many, a mirror is included (as, for instance, in Velázquez), and in some cases it reflects the observer-photographer [pl. 36]. Such artistic quotations reduced the risk of police interference, but often did not eliminate harassment. And just as often the photographers or the individuals who offered the pictures for sale had more hard-core pictures available.

Pornography is not necessarily invasive. Legally, privacy has been defined by what it protects or provides, namely dignity, personhood, individuality, autonomy, "a feeling that there is an area of an individual's life that is totally under his or her control, an area that is free from outside intrusion."[2] The "tort of intrusion" protects a person's privacy against one who would disturb it: "One who intentionally intrudes, physically or otherwise, upon the solitude or seclusion of another or his private affairs or concerns, is subject to liability to the other for invasion of his privacy, if the intrusion would be highly offensive to a reasonable person."[3] Pornography is usually staged for public consumption and with the consent of the models. While pornography can be voyeuristic, it tends to be more mechanistic, even clinical; it lacks the sense that we are invading a person's privacy, even though, in some cases, there are the trappings of the personal. Where the subject is a member of a group considered more vulnerable, the territory was and is more legally, emotionally, and morally entangled. Laws have been written to protect children from pictures of obscene acts that adults, usually on the internet, have attempted to sell or disseminate, or used to seduce other children. Photographs of sex can still be considered dangerous.

As soon as there were photographs there were pornographic photographs. Research on nineteenth-century pornographic photography discusses the earliest pictures made in France, already produced for international sale.[4] Sexual pictures made in the stereoscopic format exist in daguerreotypes and in the later versions of stereo cards, and were also common in various shades of "naughtiness" as postcards (which, because they were sent through the mail, could not be so obviously indecent).[5] The imagery ranges from the exotic odalisque, decorously draped (or not), to pictures where there is not the insinuation of sex but its bald presentation. There are those in which the woman is fully dressed but opens her clothing to reveal her sex bluntly and definitively, sometimes hiding her face; the clothing might be beautifully arranged and artfully hand-tinted [pl. 39]. And there exist some astonishingly direct daguerreotypes of women completely nude, opening their legs with a frankness that seems contemporary [pl. 40].[6] The stereo reinforced the sense of

viewing the subject, especially a sexual one, as a private act, making the viewer seem like a peeping Tom.

Perhaps it is not surprising that there are two early photographs of nude women in private spaces that are associated with Edgar Degas [see pl. 37]. Among the Impressionists, he was the most interested in the figure and in representing society. Working women—seamstresses, laundresses, milliners, ballet dancers, as well as prostitutes—were frequently his subjects. (All were considered available as sexual partners to men of Degas's class in nineteenth-century France.) The photographs are closely related to pastel paintings the artist was making at this time, pictures of women seen as from behind a curtain, or through a keyhole—women bathing, drying off. Degas said he wanted to show them like animals, cleaning themselves.[7] Certainly, the vantage points from which these pictures are made, their sense of invasion, give them expressive power.[8]

Degas's spirit of investigation, the objectivity he shared with his impressionist cohort when observing the effects of light and examining subjects that interested him, differed in spirit from the Romantic poets and artists who preceded him, as well as the Surrealists who came later. Both saw the artist as a kind of outsider, sometimes with dark impulses. Man Ray, the American surrealist inventor, made his most adventurous work in Paris in the 1920s and 1930s. He admired the Marquis de Sade, whose amoral world view was one the Surrealists shared. It was Sade who said, "I tell you nature lives and breathes by [crime]; hungers at all her pores for bloodshed, aches in all her nerves for the help of sin, yearns with all her heart for the furtherance of cruelty."[9] And it was Man Ray who photographed his own body with the head of the Minotaur beast, and whose protégé Jacques-André Boiffard made quite explicitly sadistic photographs—women's faces enclosed in dark, suffocating leather masks—for the adventurer William Seabrook [pl. 42].[10]

In the 1920s Man Ray made a series of pictures around the then-renowned acrobatic performer Barbette—another American artist in Paris. Barbette had a high-wire act that was highly regarded. Jean Cocteau wrote effusively about it and commissioned the Man Ray photographs. The show began as Barbette descended a stairway, elegantly attired in lavish costume with feather headdress and other accoutrements of high fashion. After removing her skirt and exchanging her high-heeled shoes for ballet slippers, she ascended the wire and performed. At the end Barbette removed her wig and revealed that she was a man. Cocteau was taken with Barbette not only because of the masterful *travestie* she (he) enacted, but because the act was a metaphor for art itself. Man Ray's pictures of Barbette, indeed, focus on the act, or art, of deception—he closely observes the performer girdling his genitals or applying makeup. They show how the secret is constructed [pl. 44].

A later and more private artist, who lived in the French provinces though he was allied to the Surrealists in Paris, is Pierre Molinier, who in the early 1950s began staging pictures of himself as a kind of ecstatic, even primal, unisexual being. Mostly he presented himself dressed in black stockings and heels and a constraining corset exposing his sex. In some pictures he is odalisque and seducer, a sophisticated, strange, sometimes menacing twentieth-century androgene [pl. 41]. Both Man Ray and Molinier employed conventions used in pornography to create private fantasies (Cocteau published the Barbette series later, in a limited edition). In the United States in the 1930s, meanwhile, Alfred Kinsey began a systematic research project on human sexuality, which included gathering a major collection of photographs of sexual subject matter. Some of the most voyeuristic and convincing tend to be those made by amateurs, of couples photographed without their awareness.

The political upheavals of the Vietnam War and student uprisings in the late 1960s and early 1970s inspired a general cultural eruption in Europe, Japan, and the United States, forcing a reevaluation of attitudes toward race, class, and gender that was both exciting and frightening. John Goodman, an American living in Boston who was a student of Minor White, took some especially direct pictures of a woman of the streets displaying herself—an abruptly different approach from the more self-engaged work of his mentor. Goodman in the seventies is the opposite of Harry Callahan, a painfully shy man who in 1950 made photographs of women in the street from a great distance and enlarged them. These have a sense of intimacy and even sexuality he found difficult to confront in closer contact [pls. 28–29, 33].

In Czechoslovakia, then a satellite state of the Soviet Union, the artist Miroslav Tichý reacted to the political realities by becoming an outcast and outsider artist.[11] Trained as a painter at the Academy of Fine Arts in Prague, where the spirit of a still lively modernism prevailed until the Russian state assumed power, he rebelled against the imposed socialist realism in painting. Tichý was imprisoned, and also put in psychiatric care. During the 1960s, in the name of free expression, he honed a position, part conscious and part delusional, as a self-styled derelict. When his studio was taken from him in 1972 he fashioned a camera out of discarded plastic disks he sanded with toothpaste and assembled with paper tubes and assorted pieces of junk. With this he followed women in the streets, in the parks, and at the local swimming pool (he peeked through the openings in the metal fence); these pictures offered him an assertion of privacy in sexual looking even as he invaded others' privacy [pl. 48]. They were expressions of a determined antisocial ideal, and they ceased entirely when the Communist regime fell. A younger contemporary, the Croatian artist Sanja Iveković, created a performance (of which there remain only four photographs) called *Triangle 2000+* in 1979 [pl. 134]. Iveković seated herself on her balcony, behind a protective wall that made it impossible for her to be seen from the street, as a parade celebrating Marshal Tito was passing. Sipping whiskey and reading, she raised her skirt with her hand, seeming to masturbate, when she was called to her door by the loud knocking of a policeman who had been observing her—she had been under surveillance. Other outsider artists in Europe at the time included Gerard Fieret in Holland, an anti-bourgeois hippie and rather mad artist whose photographs of women in frank sexual poses have his signature stamp printed all over the surface, often on the exposed skin of his subjects, a public-private gesture like the activity of voyeurism itself.

Surely the most important artist to explore voyeuristic looking at sex, celebrity, violence, and surveillance is Andy Warhol. He was the first to examine how the invasive "camera view" has become part of our culture—to assert that the way our culture knows itself is through mediation. In his transgressive film *Blow Job*, the subject, we presume a hustler, is filmed as (again, we presume) he is being sexually gratified [pl. 56]. But we see only his face, and so we see nothing except Warhol asserting the film's filmness, that it is a construction made for the viewer.[12] The young man is very sensuous, and because we cannot see what is happening the portrait is profoundly equivocal—is he suffering, is he ecstatic?[13]

In the 1960s and 1970s, as photography was evolving from a trade into a profession and was increasingly recognized as an art form, fashion photography was becoming a cultural phenomenon.[14] Irving Penn and Richard Avedon had shows at the Museum of Modern Art, New York, and had their work shown and sold in art galleries. Guy Bourdin, a French fashion photographer of uncommon sophistication and invention, created masterfully orchestrated fantasies to sell lingerie and Charles Jourdan shoes. His pictures resonate with the fetishistic and forbidden, with strange, staged interiors and Hans Bellmer–inspired, doll-like models. A former assistant to Man Ray, Bourdin had a taste for the voyeuristic that was informed by Surrealism and built upon a European-inflected formalism. His staged events refer to fantasies of bondage, sexual deviance, even murder (one shows a castoff Jourdan shoe next to an accident site on the street—a nod to the beauty of Weegee's photographs of corpses). One of his most suggestive pictures shows the partly hidden figure of a woman, semi-nude, reclining in a darkened space next to a television with an ambiguous film playing, observed by a little boy [pl. 60]. While his colleagues were challenging the established hierarchies by showing their work in art galleries and museums, Bourdin preferred to work solely within the venues of fashion. His only publications were the magazines themselves, and his only book the famous and beautiful *Cries and Whispers*, an insert for Bloomingdale's in the Sunday *New York Times* in 1976.[15]

There were other photographers who made illicit sexuality and violence a constant feature of their fashion work, most notably Chris von Wangenheim and Helmut Newton. Newton more frequently and explicitly examined voyeurism—in one picture we see him reflected in a mirror, his trench coat pulled up around him, photographing a nude, while to the side in the shadows his wife, June, sits in a director's chair, watching. This was a fairly common motif in his work, used to sell lingerie and shoes as well as lifestyle.[16] One provocative and thoughtful picture shows a stylishly dressed

woman, her legs parted, conspicuously ogling a man [pl. 55]. More recently, Mario Testino's suggestively violent ads for Gucci in *L'Uomo Vogue* represent not so much a product one can buy as the attractiveness of a kind of dangerous sexuality.

Robert Mapplethorpe's star rose from the 1970s until his death from AIDS in 1989. He became an insistently provocative, challenging figure. Mapplethorpe seemed to epitomize aspects of the culture of that period: its transgressiveness and self-engagement. While his work is not really voyeuristic (as he himself correctly observed) because it is highly formal and seeks to redefine beauty by including pornography, there are pictures that show him to be an engaged viewer.[17] One of his best, *Man in Polyester Suit*, conveys both wonder and dismay—at the impressive size and beauty of the penis, and at the lower-class quality of the man's clothing [pl. 57]. Some of his earlier pictures of leather- and rubber-encased sexual beings, while almost nightmarish, have a kind of allure, a wonder that overrides his deliberate and removed formalism. With the active assistance of his protector and patron Sam Wagstaff, Mapplethorpe established himself as a successful artist-photographer whose notorious subjects, social skills, and talent ensured him a place in the elite art circles of the time. When he died, the Whitney Museum of American Art had just closed a retrospective of his work.

Women were also challenged to re-evaluate their roles after the eruptive 1960s. Sexual looking was theorized by such intellectuals as Laura Mulvey, who examined the male gaze in film.[18] At the same time Susan Meiselas traveled to small country fairs in the northeastern United States, looking at the ways young women showed their bodies to men at these carnivals, taking active possession of their sexual exploitation. Though sexual, these are imperfect, human bodies, reflecting the complexity of the women and their stories, which Meiselas tells with sympathy and without sentiment [pl. 63]. Later she cast her analytic eye on the sadomasochistic practices in a downtown Manhattan club, where the surveillance cameras served not only to record but to protect the women inside [pl. 61].

One of the most lyrical extended documents of outsider culture made by an insider is *The Ballad of Sexual Dependency* by Nan Goldin [pl. 64]. Over a period of nearly twenty years Goldin transformed the modest home slide show, accompanied by music, into an elegiac

form. The pictures, made mainly in Boston and New York, were of her friends and lovers—artists, female impersonators, musicians, addicts, habitués of the bar scene. She photographed them in public places and in their bedrooms, people often of great physical beauty, yet vulnerable as we all are, enduring violence and death as well as friendship and joy. While the pictures owe some allegiance to Larry Clark's work (which is discussed later) and could not have been done without the great precedent of Diane Arbus, there is an openness and fleeting, lustrous beauty in Goldin's work that is rightfully and uniquely her own. *Ballad* is convincing because she is so modest, honoring her tribe. As she said, "There is a popular notion that the photographer is by nature a voyeur, the last one invited to the party. But I'm not crashing, this is my party. This is my family, my history."[19]

A fascinating subset of voyeuristic photography comes from Japan and is related to that country's tradition of erotic printmaking. Nobuyoshi Araki has made photographs of sex his special concern, and his appreciation of the fragile and transient beauty of young women, compared to flowers that also quickly fade, is a firmly established Japanese conceit—as is his delectation of women tied up in ropes or dangling helplessly in the air [pl. 58]. Other contemporaries photographed the outsider culture of gangs or habitués of nightclubs and bars, but one, Kohei Yoshiyuki, made pictures that reflect the power of sexuality seen in public, albeit furtively. He photographed with the newly available infrared-sensitive film and filtered flashbulbs in Tokyo parks where heterosexual couples would come to have sex and gay men would cruise for partners. The coupling couples seem to have inspired a kind of Bacchic fever in others who would come to watch them in the dark [pl. 50]. Yoshiyuki took even more mysterious pictures of the automatic videos in love hotels, which show blurry ghosts in sexual contact.

The sexual revolution, and the permission it has given to take the subject of sex as a serious one, has made voyeuristic looking something of a subset in contemporary art photography. Merry Alpern's pictures of a Wall Street brothel from the 1990s are now widely acknowledged [pls. 53–54]. Stephen Barker made murky, dreamlike pictures of sex in gay bars [pl. 52], and Cammie Toloui worked as a stripper and photographed the people who watched her, such as the couple in *Milk Squirt* [pl. 51]. Chris Verene has photographed

amateur photographers photographing hired models, allowing them to be voyeurs without guilt [pl. 66], while Elena Dorfman has studied the ways people use and live with life-size rubber dolls as stand-ins for humans [pl. 59]. Artists have been prescient about the connections between desire and photography in contemporary society. As the industry for pornographic photographs and film has transferred to the web, invasive looking can be done by anyone, and amateurs have become active producers. We can now see anything, virtually, if we take the time to find it.

1 David Ogawa discusses the punishments imposed upon women in "Arresting Nudes in Second Empire Paris," *History of Photography* 31, no. 4 (Winter 2007): 330–47.

2 Quoted in T. Allen, et al., "Privacy, Photography and the Press," *Harvard Law Review* 111, no. 4 (February 1998): 1087.

3 Ibid., 1088.

4 See Anne McCauley, *Industrial Madness: Commercial Photography in Paris, 1848–1871* (New Haven, CT: Yale University Press, 1994). The Kinsey Institute for Sex Research at Indiana University in Bloomington has a large collection of French pornographic photography, certainly the result of its wide availability. Jennifer Pearson Yamashiro, "Collecting Sex," in *Peek: Photographs from the Kinsey Institute* (Santa Fe, NM: Arena Editions, 2000), 175.

5 The French government wrote a law prohibiting the sale of pornographic daguerreotypes ten years after Daguerre's process was made public. Walter Kendrick, *The Secret Museum: Pornography in Modern Culture* (New York: Viking, 1987), 246.

6 Gustave Courbet was said to have been influenced by erotic stereoscopic views in the making of his painting *L'Origine du monde* (The Origin of the World), 1866, a study of a woman's genitalia. See Dominique de Font-Réaulx, "Auguste Belloc," in Bertrand Tillier, et al., *Gustave Courbet* (New York: Metropolitan Museum of Art, 2008), 383–84, where the author also discusses stereos by Auguste Belloc including the one reproduced here (pl. 39).

7 See John Elderfield, *European Master Paintings from Swiss Collections: Post-Impressionism to World War II* (New York: Museum of Modern Art, 1976), 24; and Wendy Lesser, *His Other Half: Men Looking at Women Through Art* (Cambridge, MA: Harvard University Press, 1991), 56, 78.

8 Richard Kendall, *Degas: Beyond Impressionism* (London: National Gallery Publications, 1996), 141–57.

9 Quoted in Kenneth Clark, *The Romantic Rebellion: Romantic versus Classic Art* (New York: Harper and Row, 1973), 196.

10 These pictures may have been made by Man Ray for Seabrook. Man Ray, *Self Portrait* (Boston: Little, Brown and Company, 1988), 154–56.

11 Tichý's friend the psychiatrist Roman Buxbaum writes: "In the course of twenty years, paralyzing despair gripped most of society [in Soviet Czechoslovakia]. Tichý did not let himself be normalized." Roman Buxbaum, *Miroslav Tichý* (Zurich, Prague: Foundation Tichy Ocean, 2005), 11.

12 See Peter Gidal, *Andy Warhol: Blow Job* (London: Afterall Books, 2008), 76–78.

13 Douglas Crimp has commented that we cannot see into the man's eyes, thus we cannot really know him, possess him. See Nicholas de Villiers, "How Much Does It Cost for Cinema to Tell the Truth of Sex? Cinema Verite and Sexography," *Sexualities* 10, no. 3 (2007): 356.

14 "One of the most significant changes in fashion photography . . . has been that its subject—*clothing*—has become subordinate to the photographic description of *lifestyle* and has thus been transformed from a frozen object of beauty in a tableau to a tantalizing aspect of a narrative that is primarily about life as we live it." Susan Kismaric and Eva Respini, *Fashioning Fiction in Photography since 1990* (New York: Museum of Modern Art, 2004), 12.

15 See Alison M. Gingeras, *Guy Bourdin* (London: Phaidon Press, 2006).

16 See Urs Stahel, "Participating without Consequences: Rules and Patterns of Newton's Voyeurism," in *The Best of Helmut Newton: Selections from His Photographic Work*, ed. Zdenek Felix, trans. Paul Kremmel (Munich: Schirmer Art Books, 1993), 19–30.

17 "Too many photographers use the camera to avoid participating in things. They become professional observers, which is something I never wanted to be." Robert Mapplethorpe, quoted in Patricia Morrisroe, *Mapplethorpe: A Biography* (New York: Random House, 1995), 163. The Mapplethorpe exhibition *The Perfect Moment*, organized by Janet Kardon for the Institute of Contemporary Art in Philadelphia, when shown in Cincinnati in 1990 initiated a trial for obscenity. The pictures were discussed essentially on their formal merits alone, their content avoided; the defendants successfully proved that, though obscene, they were also art.

18 Laura Mulvey, "Visual Pleasure and Narrative Cinema," *Screen* 16, no. 3 (Autumn 1975): 6–18.

19 Nan Goldin, *The Ballad of Sexual Dependency* (New York: Aperture Foundation, 1986), 6.

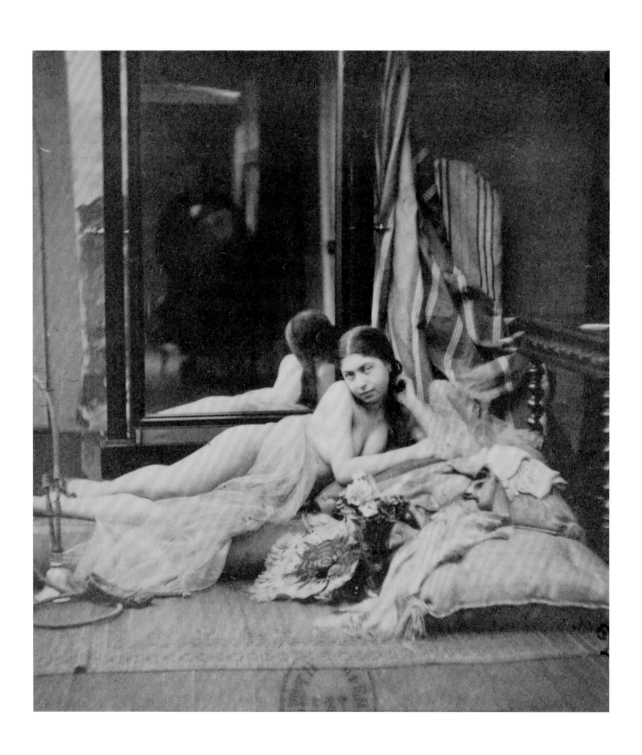

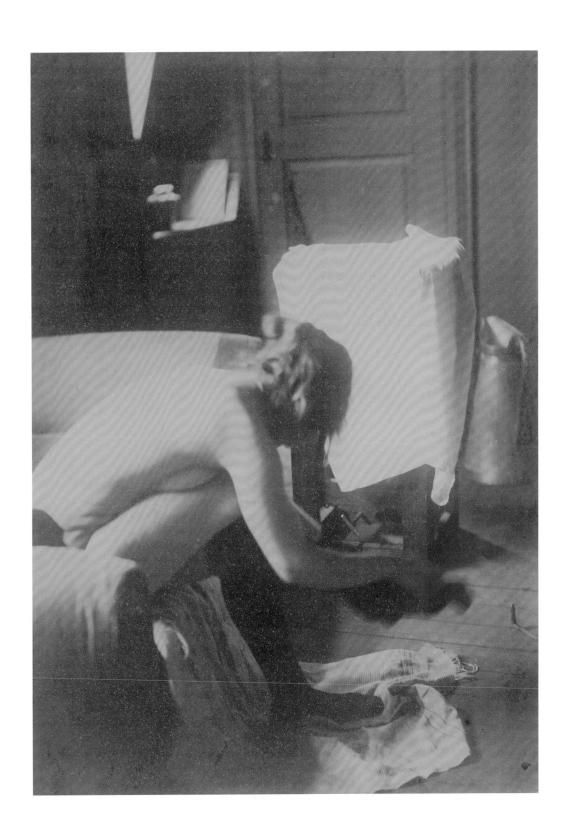

36 Louis-Camille d'Olivier, *Composition avec nu* (Reclining Nude), 1853–56

37 Edgar Degas, *Nu féminin mettant ses bas* (Seated Nude), 1895

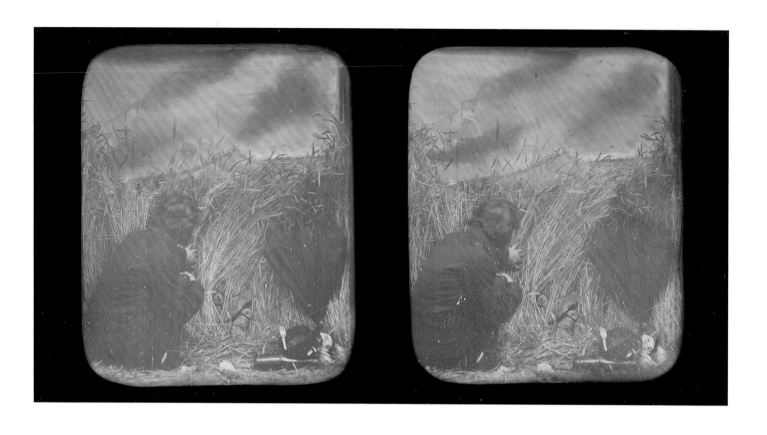

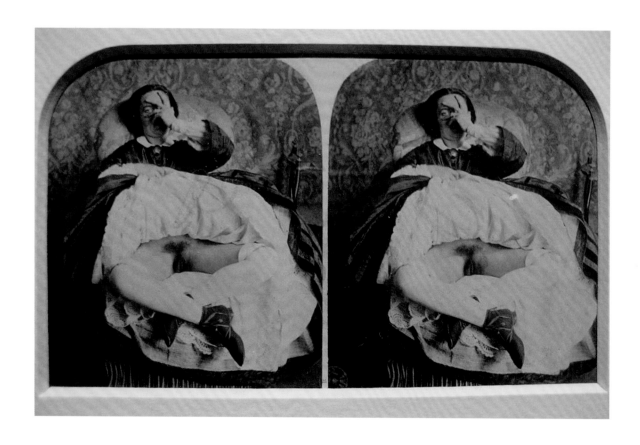

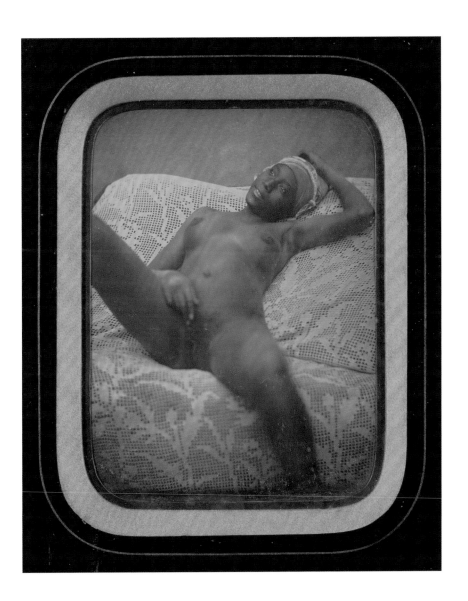

38 Felix Jacques Moulin, *The Voyeur*, ca. 1854

39 Auguste Belloc, *Untitled*, ca. 1860

40 Unknown, *Nude study of a black female*, ca. 1855

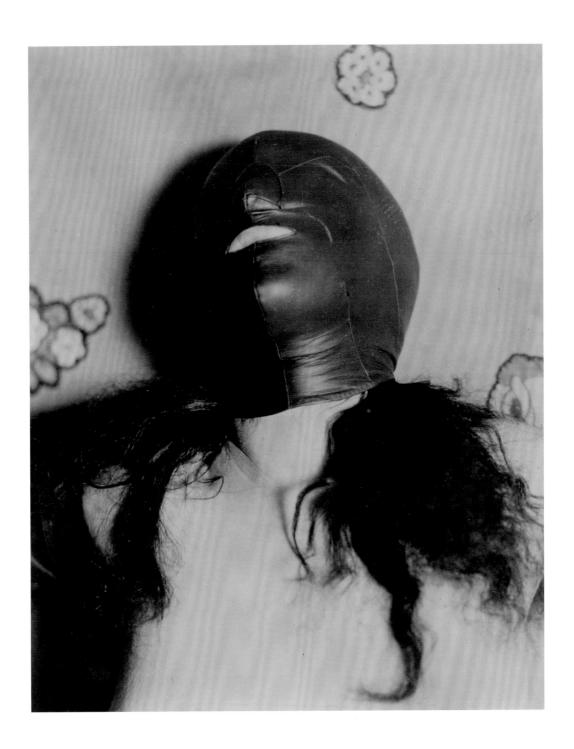

41 Pierre Molinier, *Self-Portrait*, ca. 1966

42 Attributed to Jacques-André Boiffard and Man Ray, *Seabrook, Justine in Mask*, 1930

43 E. J. Bellocq, *Storyville Portrait*, ca. 1912

44 Man Ray, *The Transvestite Barbette, Paris*, 1926

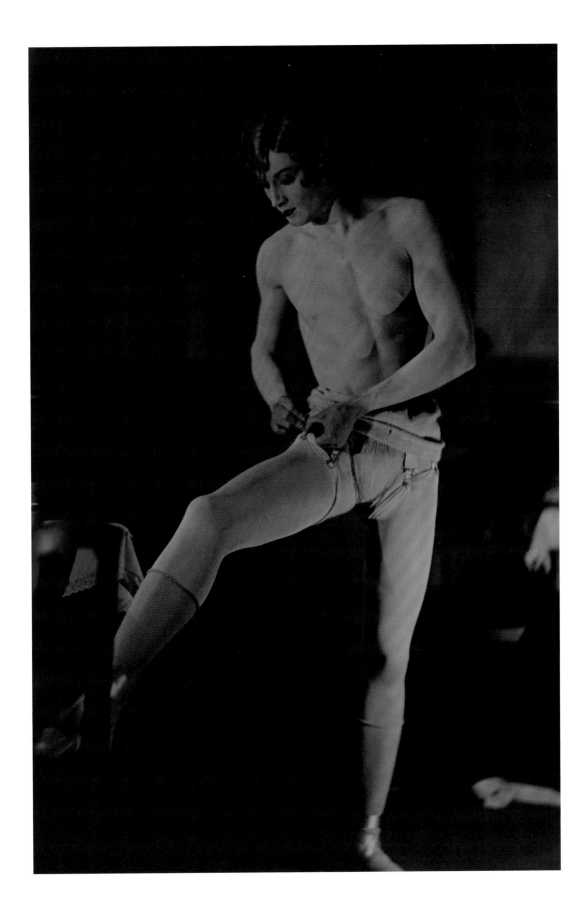

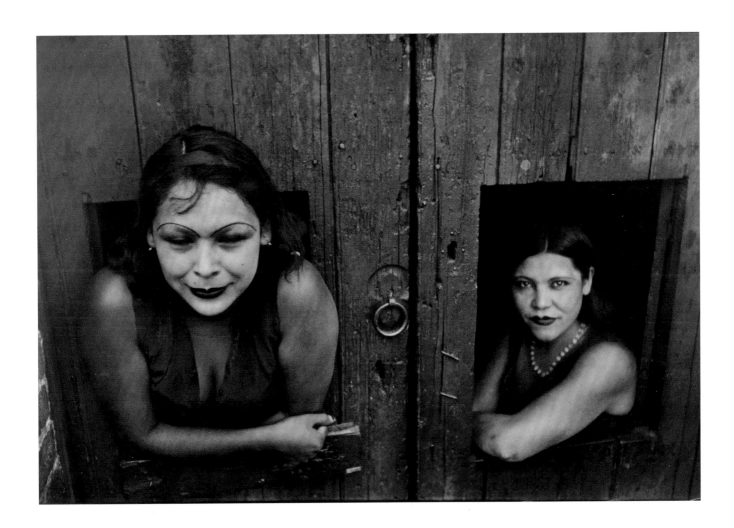

45 Robert Frank, *New York City*, from *The Americans*, 1955

46 Henri Cartier-Bresson, *Prostitutes, Calle Cuauhtemoctzin, Mexico City*, 1934

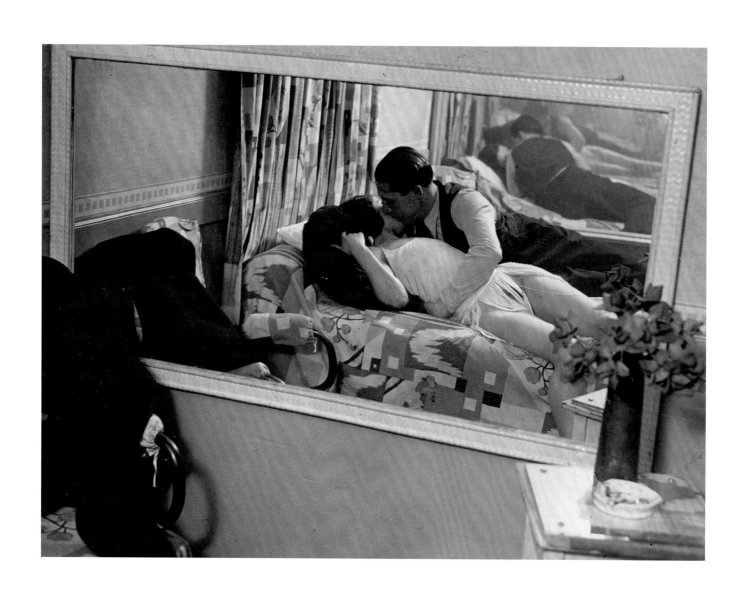

47 Brassaï (Gyula Halász), *At Suzy's*, ca. 1932

48 Miroslav Tichý, *Untitled*, 1950s–80s

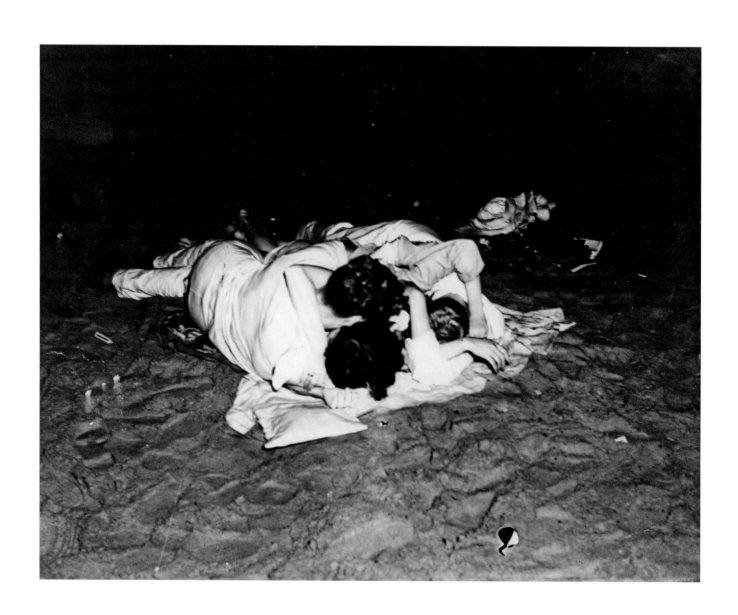

49 Weegee (Arthur H. Fellig), *Lovers on the Beach, Coney Island*, 1940

50 Kohei Yoshiyuki, *Untitled*, from the series *The Park*, 1971

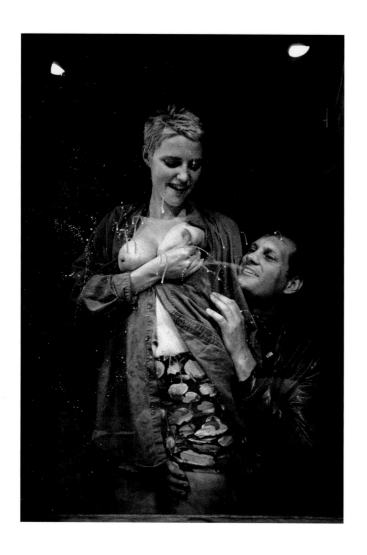

51 Cammie Toloui, *Milk Squirt*, from the series *Lusty Lady*, 1992

52 Stephen Barker, *Untitled*, from the series *Nightswimming*, N.Y.C., 1993–94

53 Merry Alpern, *Dirty Windows #14*, 1994

54 Merry Alpern, *Dirty Windows #16*, 1994

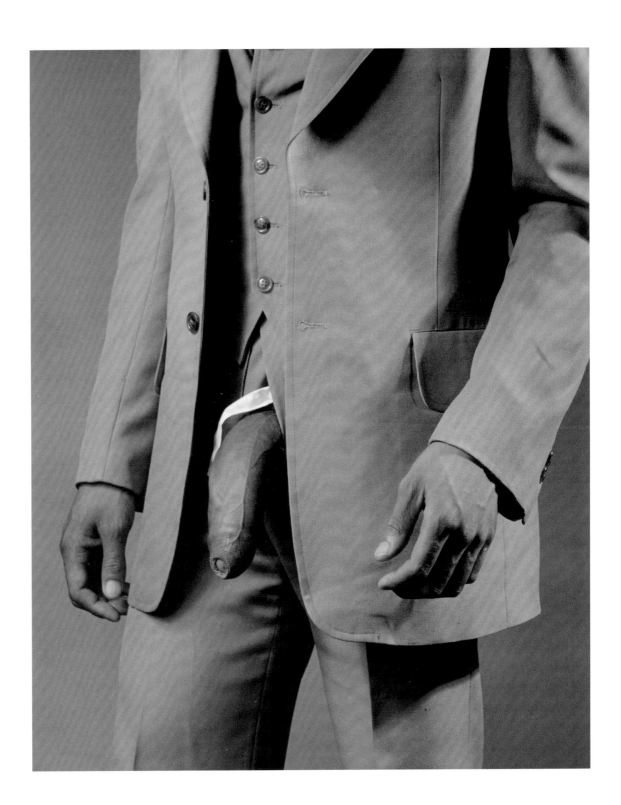

55 Helmut Newton, *Woman Examining Man, Saint-Tropez*, 1975

56 Andy Warhol, *Blow Job* (film still), 1964

57 Robert Mapplethorpe, *Man in Polyester Suit*, 1980

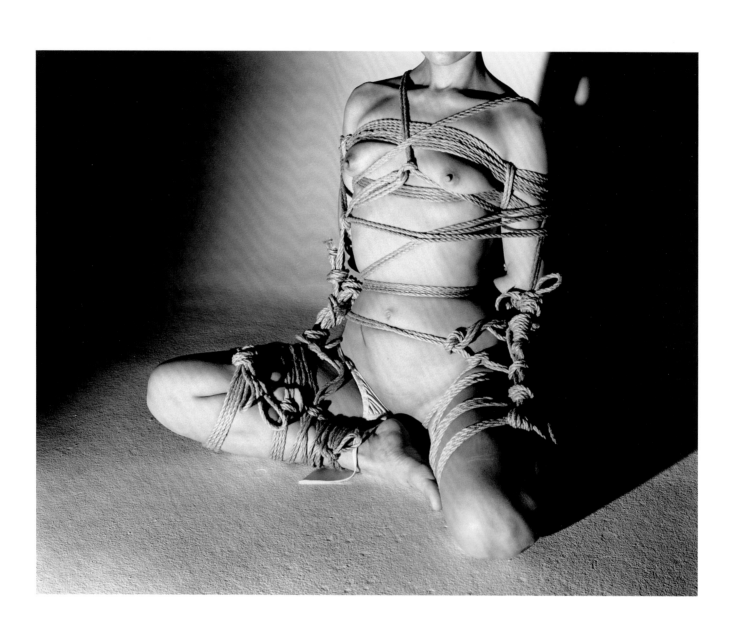

58 Nobuyoshi Araki, *Kinbaku (Bondage)*, from the series *Love in Winter*, 1979

59 Elena Dorfman, *Rebecca 2*, from the series *Still Lovers*, 2001

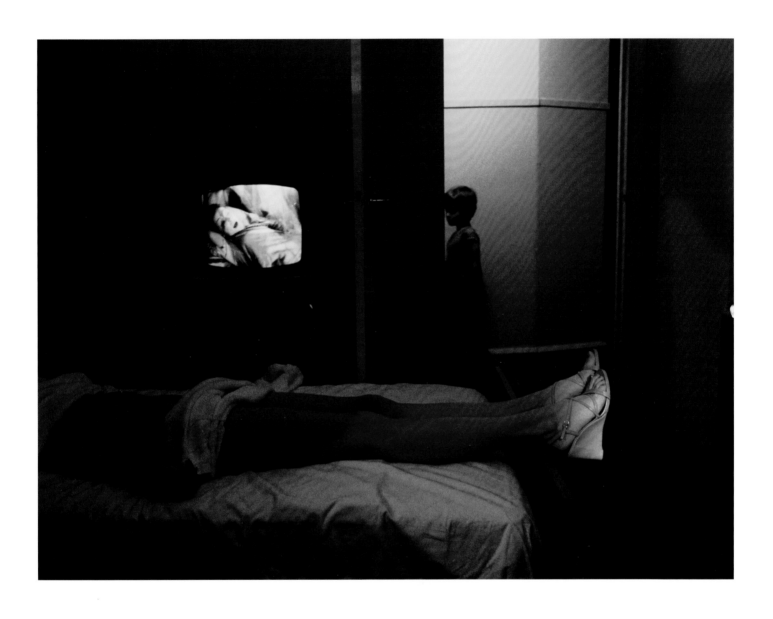

60 Guy Bourdin, *Charles Jourdan Advertisement, Spring 1975,* 1975

61 Susan Meiselas, *Security TV IV, New York,* from the series *Pandora's Box,* 1995

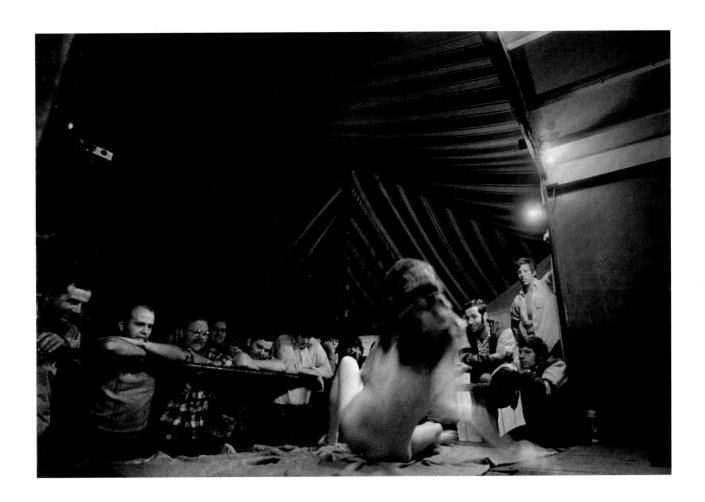

62 Wolfgang Stoerchle, *Untitled Videos Works* (video stills), 1970–72

63 Susan Meiselas, *Keeping the Crowd, Presque Isle, Maine,* from the series *Carnival Strippers,* 1974

Nan Goldin, *The Ballad of Sexual Dependency* (detail), 1979–96

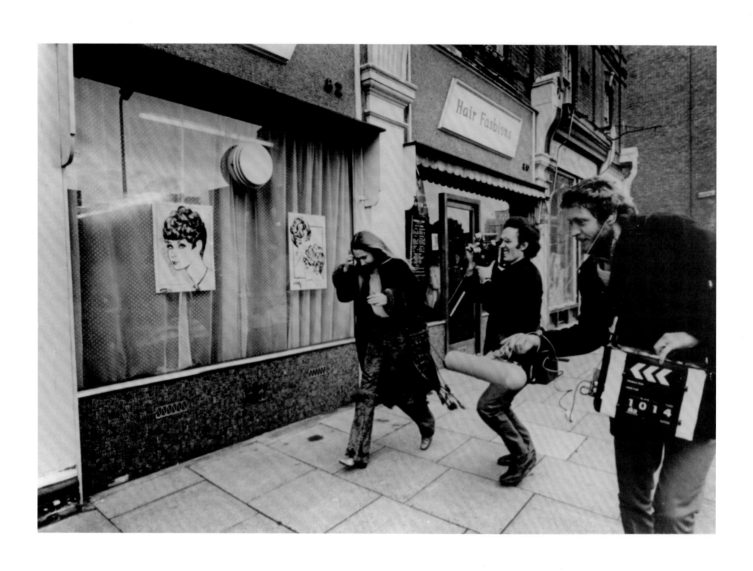

65 Yoko Ono, *Rape* (production still), 1968–69

66 Chris Verene, *Untitled*, from the series *Camera Club*, ca. 1996

CELEBRITY
AND THE
PUBLIC GAZE

PHOTOGRAPHY INVENTED MODERN celebrity culture. Before it, there were portraits of famous people such as kings, artists, and inventors, but these pictures did not possess the intimacy and immediacy the new medium bestowed. By the 1860s—with the advent of the *carte de visite*, a photograph the size of a visiting card that was manufactured in large quantities, and its 1870s iteration, the cabinet card—photographs of famous people were made inexpensive enough that virtually anyone could buy one. The bourgeoisie could have pictures for that new phenomenon, the family album, and also buy pictures of royalty and other celebrities, ironically making the cabinet card the first truly populist image format. The form was made famous by André-Adolphe-Eugène Disdéri, who used a single plate with many lenses (usually six) to make production both quicker and cheaper; his product became instantly famous when—legend has it—Emperor Napoléon III paid his studio a visit on the way to war.

The celebrated beauty the Countess of Castiglione can be credited with constructing a celebrity persona through photography. A socially ambitious Italian aristocrat and a consummate narcissist, she exploited her high birth, rapturous beauty, and succulent sexuality (her arms were compared to a perfect, ripe peach). She was a friend (also a mistress) of Vittorio Emanuele II, King of Piedmont, Savoy, and Sardinia, and was assigned the role of special agent to try to win over Napoléon III to the side of a united Italy (she was also briefly Napoléon's mistress). Later, settling in France, now without a real role in the world, she began her self-invention in photography: in a society where an independent woman was suspect, she created a fantasy role for herself.

Castiglione's pictures (there were some four hundred), made with the fashionable professional photographer Pierre-Louis Pierson, seemingly were her principal creation, her essential self. With Pierson acting as her sympathetic enabler, in the privacy of his studio this beautiful aristocrat could play the part of seductress, actress, and even demimondaine [pls. 68–70]. In front of the camera she frames the male gaze, arranges herself, poses before mirrors. The true actresses and courtesans of the period (such as Sarah Bernhardt, most preeminently) lacked her imaginative skill in self-theater, or were unable or unwilling to represent themselves in such a way publicly.[1] Like Marilyn Monroe, Castligione appreciated the fullness of her sexual attraction and lamented its passage (unlike Monroe, she lived long, and was mad at the end). But who was the intended audience—was it only herself? Was it the emperor, who had to flee France after the disaster of the Franco-Prussian War? Were these pictures made for us? They would seem to be the project of a self-conscious, media-aware contemporary performance artist, were they not also so private.

Modern celebrity pictures, though made for public consumption, participate in the same ambiguity as those of the Countess of Castiglione: they are private pictures made public. This is why they exist in a kind of moral netherworld. The principal format for early pictures of celebrities, the cabinet card, constituted a controlled rather than a spontaneous image, unlike most celebrity pictures today. The great change came at the end of the century, when the halftone process was perfected and

it was possible to reproduce photographs in newspapers. A truly public celebrity culture was born, one that has only become more blatant and invasive with time.

We tend to think that our interest in looking at famous people in private moments, depriving them of their personal life for our benefit, is a contemporary phenomenon. In fact, it was a pronounced feature of late-Victorian and Edwardian England and practiced in the United States during the McKinley and Roosevelt administrations. Average people, as well as those who should have known better, could be fooled by a camera in a man's hat with a hole cut in it. And when society perpetuated a division between normal people and the elites there was much interest in crossing the boundary. Thus, in 1909, a detective camera focused on the veiled figure of Mrs. William Thaw, wife of the railroad magnate and robber baron, whose eccentric and often abusive son, Harry, had shot and killed the dashing architect Stanford White over his attentions to Harry's wife, the pretty young actress Evelyn Nesbit. (The trial was the most sensational of the period—he got off free.) There is also an impromptu picture made of the anarchist Emma Goldman, who was surprised while riding a streetcar.[2] In England, the celebration of Queen Victoria's Diamond Jubilee provided an incentive for photographers to capture her unawares, and in 1899 the British *Penny Pictorial* magazine had a page called "Taken Unawares: Snap Shots of Celebrated People."[3] The trickery these photographers employed to get their pictures was usually more ambitious and creative than the results. In fact, the term *snapshot* was often used with reference to pictures made of celebrities: photographers are described at public events as "raising their cameras quickly, sighting the object or persons and making the exposure with almost the celerity of a sportsman raising his gun."[4] No wonder that King Edward VIII of Britain or Germany's Kaiser Wilhelm II were offended by unposed pictures, often surreptitiously obtained, and took strict measures to curtail them. Then as now, many of those published seemed designed to prove that the royals were just like everyone else.

A generation after the Edwardian pictures, the celebrity photograph made as an act of surveillance—revealing some shortcoming or injustice—reached an apotheosis in the work of Erich Salomon, the photographer most recognized for invading the private spaces of the elite [pls. 123–24]. The man who invented the so-called candid camera, Salomon was one of the first to take pictures secretly in courtrooms, in concert halls, and in the private conference rooms of public officials. His photographs were less raw than their predecessors, and their maker a discreet insider. He was often dressed in a top hat (where the camera was sometimes hidden) and tails like the diplomats themselves, and was educated, like many of them, to be a lawyer. Salomon understood the value as well as the allure of an egalitarian message in the Weimar Republic of Germany after the First World War. (During the Second, he was captured by the Nazis, and died in Auschwitz.)

Salomon's heyday coincided with the evolution of several technologies that made modern illustrated journalism practical and compelling, first in Europe and later in the United States: paper was made more cheaply, the high-speed printing press could achieve quality photographic reproduction, and the Ermanox and Leica cameras were invented, the latter using the speedy and efficient 35mm roll film.[5] The new illustrated magazines covered a wide range of subjects, from travel to all parts of the world, to movie stars, to the events of everyday life—German readers were interested in everything. By the mid-twenties almost every major metropolitan newspaper produced a weekend supplement in the form of an illustrated magazine. This was *Life* before the fact, with more spontaneity (and fewer pictures).

Readers were fascinated to see what famous people looked like doing ordinary things—things that everyone wanted to do, such as going to the beach or skiing—or getting entangled in compromising situations. In Weimar Germany, the celebrity became almost indistinguishable from most other people except when deliberately pointed out. For instance, the *Berliner Illustrirte Zeitung*, the magazine with the widest circulation, published a picture of Greta Garbo at the shore—a wonderfully evocative, dynamic photograph showing the actress's legs under a beach umbrella. But *was* it Garbo? We don't really know since her head is obscured. Even Salomon's pictures, made either secretly or at least with great discretion, demonstrate the humanness of people in the affairs of state. One of his most famous photographs shows exhausted diplomats falling asleep as they try to craft effective responses to the difficult economic and political situation in Europe that would soon lead to the next war [pl. 123].

Pictures of celebrities were a subject of intense interest after World War II. In the 1950s Rome was an active city, in the midst of a lively and international cultural rebirth. Artists, designers, and especially filmmakers were invigorated, and the state-funded Cinecittà, the "film city" in southern Rome, ensured a steady stream of wealthy, beautiful visitors who enjoyed nightlife after hours. As Carol Squiers recounts in her essay in this catalogue, the paparazzi were at first poor kids who made a precarious living through their invented trade. Certainly the most prominent were Tazio Secchiaroli and Marcello Geppetti, who often pursued their quarry on the new, fast *motorino*, most notably the Vespa, or "wasp," that darted in and out of regular traffic. Their pictures are especially memorable in film-like sequences, which usually show the subject caught like an animal, awkward or indecorous, or perhaps revealing ambition and narcissism, and fighting back at the photographer as the flashbulbs explode in his or her face [pls. 71–72, fig. 16].

The Italians were certainly aware of the work of the American tabloid photographer Weegee (Arthur H. Fellig), who made his name during the war years in New York, and who, like them, focused his energies on starlets and socialites in the 1950s, when he briefly moved to Hollywood [pl. 73]. But the land of Marilyn Monroe and Jayne Mansfield was never as compelling to him as the tenements in New York. Celebrity pictures were also taken by amateurs with handheld cameras. In New York in the 1950s the American amateur and fan Doris Banbury visited stage doors and waited on sidewalks with her friends to see and often talk to the celebrities—she recalls them as genuinely friendly people, appreciative of the attention but not soliciting it [pl. 67].[6] Her process and tender pictures are the diametric opposite of the aggressive stalking of Ron Galella, who made a career of pursuing Jacqueline Kennedy Onassis, who complained that she could not go out of her apartment building in New York without him following her. Onassis would invent ways to subvert Galella's pictures of her—she would put a bunch of flowers in front of her face, for instance, or run away from him, he in hot pursuit—and this dialogue between the photographer and his prey became the subject of his pictures [pl. 76]. Galella even disguised himself and landed on the private island of Skorpios, owned by Aristotle Onassis, to take pictures on her holidays (including her

honeymoon). He was finally forced by court order to desist pursuing her.[7]

John F. Kennedy became known to most Americans during the televised debates between him and Richard Nixon that took place in the fall of 1960. Kennedy's intelligence and glamour were very tangible factors in his winning the election. His death in Dallas in 1963 was also witnessed by millions on television, and the murder of his assassin as well. Thus, for his wife Jackie, the issue of privacy was especially palpable: the nation that mourned its tragedy through hers was entranced still by her elegance, her children, her vulnerability, her very desire for a private life after the assassination, making the pictures that document her in the aftermath of the tragedy both conflicted and poignant [pl. 75].

In the 1960s the lessening of the distance between the star and his or her audience, and the resulting sense of accessibility, were the products of television, which brought famous people into private homes. The next technological invasion was the portable video camera (Sony introduced its Portapak in 1967). This became Andy Warhol's instrument of choice. As discussed in the previous section, Warhol understood that our society had become indelibly marked by the camera view that presumed to reveal intimacy and pain. Warhol was an almost mute philosopher of the culture of his time, and his pictures of celebrity, sex, death, and disaster, so reliant on the impersonal nature of the media, are integral to the concept of this exhibition.[8] Warhol was notorious in the 1960s and 1970s, emphatically a celebrity, and a victim of that celebrity when he was shot by an admiring, demented follower. He was photographed baring his scars like an identifying mark by Richard Avedon [pl. 77].

As the tactics of photographers in search of newsworthy material became ever more invasive, the state of California, home to Hollywood stars, considered the "balance between the people's right to know versus a person's right to privacy."[9] The so-called anti-paparazzi statute of 1999 made unposed pictures of celebrities more difficult to publish and recognized the evolution of new, highly invasive technologies that Justices Brandeis and Warren never could have imagined when they established the right to privacy one hundred years ago. However, the culture has also embraced a blurring of distinctions between reality and what could be called fantasy. Celebrity photographs are made not only by

professional photographers but by amateurs with camera phones, often by children. Like the Italians of the 1950s, these photographers try to stage conflict to get the celebrity's attention and make the predetermined point of the picture. Even celebrity photography by professionals seems increasingly designed to show the worst in famous people, as when the Vietnamese American photojournalist Nick Ut, who distinguished himself when he photographed a little girl burned by napalm in Vietnam in 1972, brought us another iconic picture exactly thirty-five years later: a tearful Paris Hilton on her way to court [pl. 79]. Alison Jackson's hilarious, fictional views (real photographs made with look-alike models) of the pampered pets of the British Queen and of movie stars in domestic disarray remind us of our seemingly endless desire to see the foibles (and worse) of figures whom we know in only the most remote way [pl. 80]. These are not normal people, Jackson seems to say, but neither are they interesting people. As much as celebrities are famous for their public faces—their beauty, their power, their talents, their money—they are also known for their meanness, spitefulness, banality, and absurdity, all eagerly captured for us by an increasingly efficient public dissemination system.

For all our cultural ambivalence about celebrities, the invasion of their personal lives carries moral implications that impinge on broader issues. The California law, written to curb the excesses of the paparazzi after the death of Princess Diana in 1997, has taken on a certain irony after the events of 9/11 enabled the government itself to exercise enormous power to invade private lives. As Justice Brandeis, who was alert to the invasive power of photography, cautioned in his dissent for *Olmstead v. United States* in 1928, "Experience should teach us to be most on our guard to protect liberty when the Government's purposes are beneficent. . . . The greatest dangers to liberty lurk in insidious encroachment by men of zeal, well-meaning but without understanding."[10]

1 See Pierre Apraxine and Xavier Demange, *"La Divine Comtesse": Photographs of the Countess of Castiglione* (New Haven, CT: Yale University Press in association with the Metropolitan Museum of Art, 2000), especially Pierre Apraxine, "The Model and the Photographer," 22–51, from which much of this information is obtained. Any discussion of celebrity portraiture must acknowledge Richard Brilliant, "Introduction: Images to Light the Candle of Fame," in Gordon Baldwin and Judith Keller, *Nadar—Warhol, Paris—New York: Photography and Fame* (Los Angeles: J. Paul Getty Museum, 1999), 15–27.

2 Both pictures are in the archive of one of the earliest news picture agencies, the Bain News Service, housed in the George Grantham Bain Collection at the Library of Congress.

3 See Nicholas Hiley, "The Candid Camera of the Edwardian Tabloids," *History Today* 43 (August 1993): 17.

4 Ibid.

5 Salomon's first camera was an Ermanox, a small and lightweight camera with a very sharp lens, which used plates. Most of his younger contemporaries in Germany, however, used Leicas.

6 As relayed by her daughter, Lorrie D. Sargent, in a conversation with the author, November 3, 2004.

7 Galella v. Onassis is discussed in "Privacy, Photography and the Press," *Harvard Law Review* 111, no. 4 (February 1998): 1086, 1089.

8 Warhol's detachment was especially marked in his experimental films, which often reveal a kind of surveillant remoteness. In Branden W. Joseph, "Nothing Special: Andy Warhol and the Rise of Surveillance," in *CTRL [Space]: Rhetorics of Surveillance from Bentham to Big Brother* Thomas Y. Levin, Ursula Frohne, and Peter Weibel, ed. (Cambridge, MA: MIT Press, 2002), 236–51, the author quotes an interview between Warhol and *Tape Recording* magazine in which Warhol says that the two things people can do with their home video recorder is "make the best pornography" and "spy on people," 248.

9 Quoted in "Privacy, Technology, and the California 'Anti-Paparazzi' Statute," *Harvard Law Review* 112, no. 6 (April, 1999): 1367.

10 Quoted in Melvin I. Urofsky, *Louis D. Brandeis: A Life* (New York: Pantheon Books, 2009), 631.

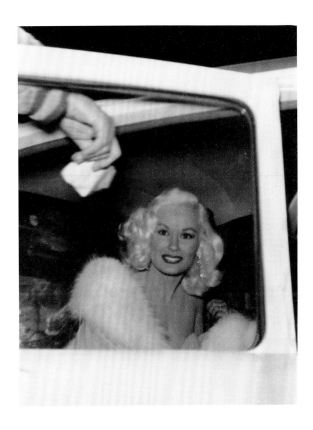

67 Doris Banbury, *Mamie Van Doren*, 1950s

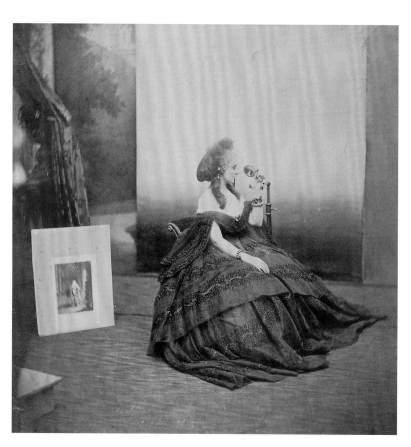

68–70 Pierre-Louis Pierson and Christian Bérard, *Les yeux* (The Eyes) (detail); *Scherzo di Follia* (Game of Madness) (detail); *La comtesse en buste dans un cadre pleurant dans son mouchoir* (The Countess of Castiglione weeping into her handkerchief) (detail), 1863–66. From an album composed in 1930 of eighteen photographs of the Countess of Castiglione and three gouaches inspired by her in 1863 and 1866

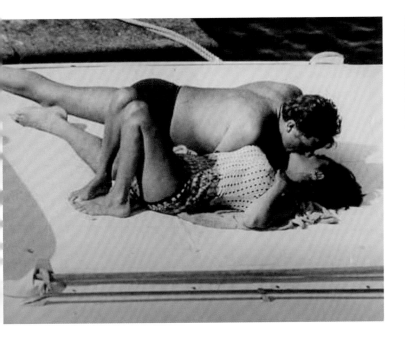 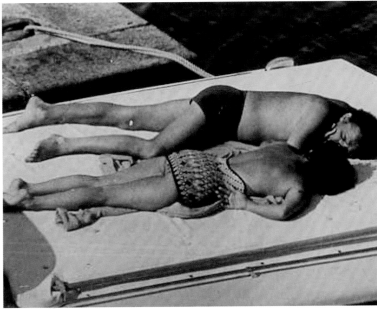

71 Marcello Geppetti, *Elizabeth Taylor and Richard Burton*, 1962

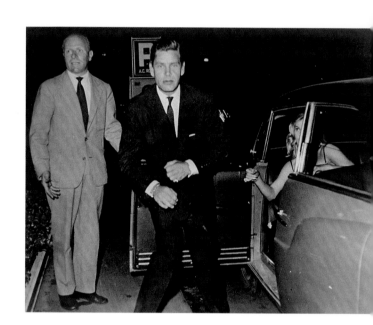

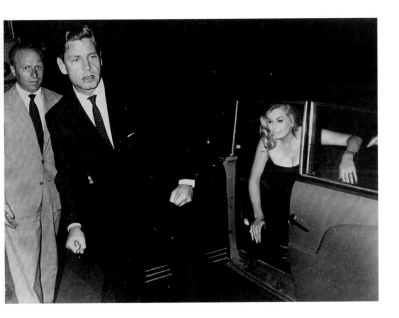 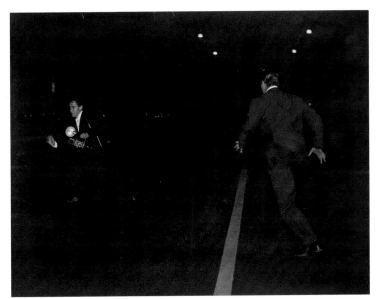

Tazio Secchiaroli, *Anita Ekberg and Husband Anthony Steel, Vecchia Roma* (detail), 1958

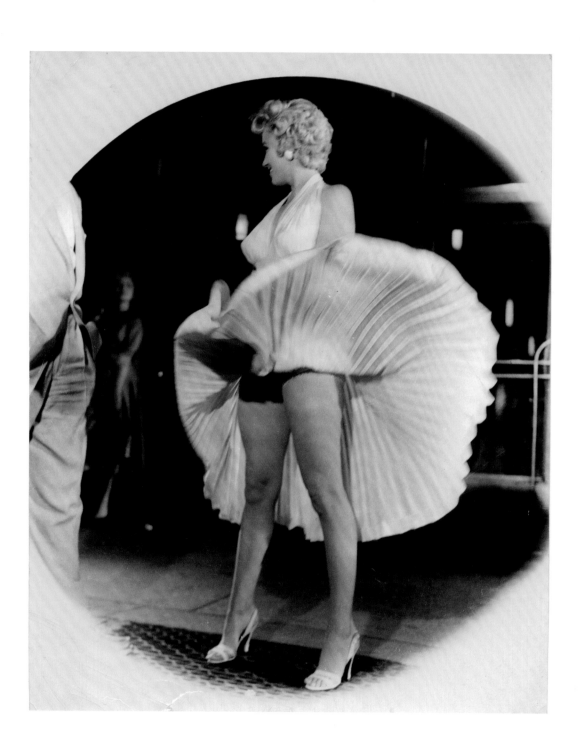

73 Weegee (Arthur H. Fellig), [Marilyn Monroe], 1950s

74 Leonard McCombe, [Eyes right is executed with almost military precision by dining car males aboard New York bound
20th Century Limited as Kim Novak eases into a seat], 1956

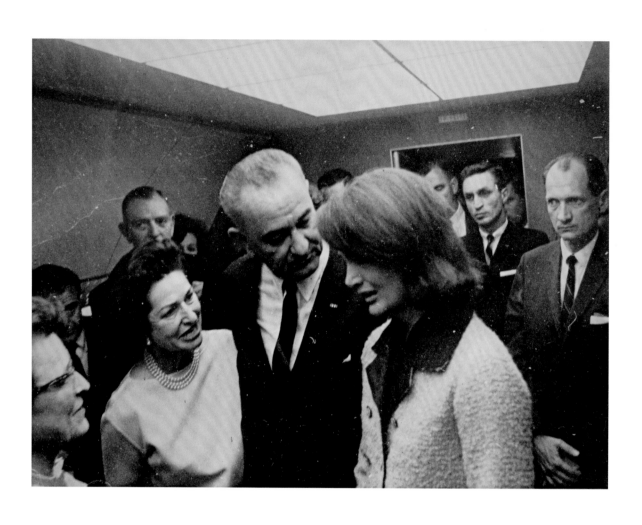

75 Cecil Stoughton, *Lyndon Johnson, flanked by Lady Bird Johnson and Jacqueline Kennedy, aboard Air Force One*, 1963

76 Ron Galella, *What Makes Jackie Run? Central Park, New York City, October 4, 1971*, 1971

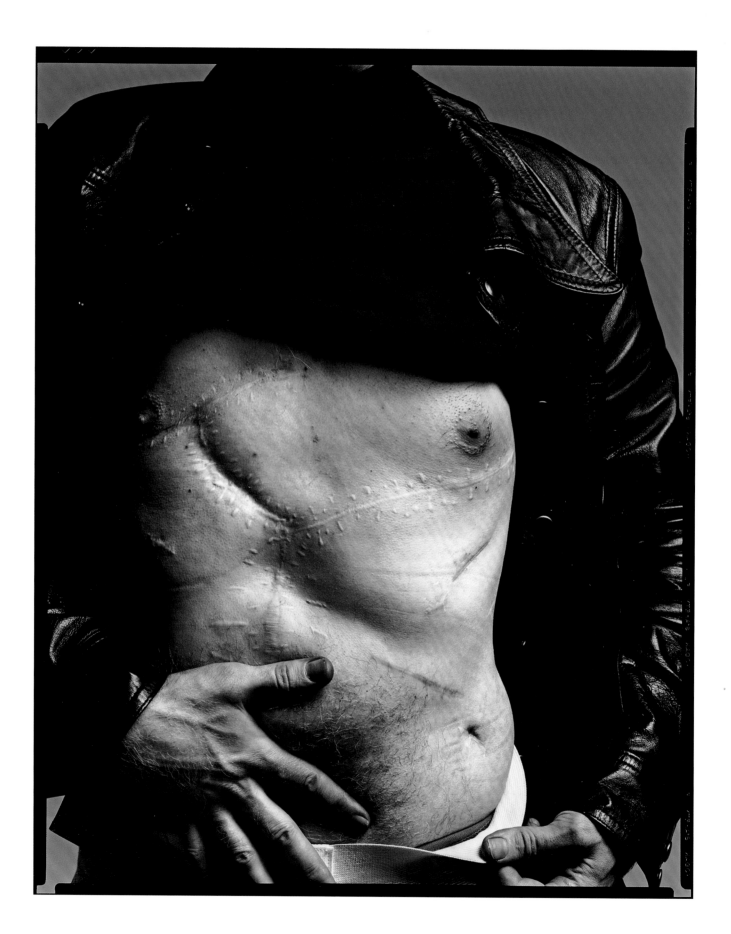

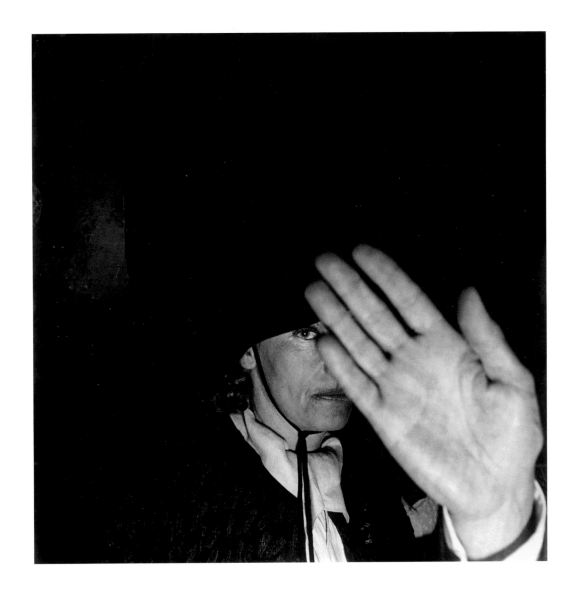

77 Richard Avedon, *Andy Warhol, artist, New York, August 20, 1969*, 1969

78 Georges Dudognon, *Greta Garbo in the Club St. Germain*, 1950s

79 Nick Ut, *Paris Hilton is seen through the window of a police car as she is transported from her home to court by the Los Angeles County Sheriff's Department in Los Angeles on Friday, June 8, 2007,* 2007

80 Alison Jackson, *The Queen plays with her Corgies,* from the series *Confidential,* 2007

WITNESSING VIOLENCE

ON OCTOBER 20, 1862, an article appeared in the *New York Times*:

> Mr. Brady has done something to bring home to us the terrible reality and earnestness of war. If he has not brought bodies and laid them in our dooryards and along the streets, he has done something very like it. At the door of his gallery hangs a little placard, "The Dead of Antietam." Crowds of people are constantly going up the stairs; follow them, and you find them bending over photographic views of that fearful battle-field, taken immediately after the action. Of all objects of horror one would think the battle-field should stand preeminent, that it should bear away the palm of repulsiveness. But, on the contrary, there is a terrible fascination about it that draws one near these pictures, and makes him loth to leave them. You will see hushed, reverent groups standing around these weird copies of carnage, bending down to look in the pale faces of the dead, chained by the strange spell that dwells in dead men's eyes.[1]

The "terrible fascination" of looking at suffering and death, the moral ambiguity of the act, is as pertinent now as it was during the American Civil War. The captivated, almost aggressive looking at both sexual and violent subjects that photography permits, and violence's amoral allure in particular, was of special interest to Susan Sontag.[2] Her book *On Photography* was originally a series of articles written in the early 1970s in reaction to the disconcerting role photography had assumed at the time; it was now presented as art in galleries and museums, notably the Museum of Modern Art, New York. Sontag found the medium's openness and seeming lack of judgment problematic, especially in Diane Arbus's work. Although Sontag was certainly very aware of the ambition of photographers like Arbus to be identified and discussed as artists, she brought photography back into a social discourse, and seemed most interested in understanding the moral uncertainties within the medium.

Sontag momentously described her own life as divided between childhood innocence and the self-consciousness spurred by her coming across pictures of Bergen-Belsen and Dachau in a Santa Monica bookstore, totally by chance. She was riveted, but she found it troubling that the photographs had not done what she wanted them to—stand as a cautionary example, change the attitude of human beings, eliminate unjust violence, stop wars. "Once one has seen such images, one has started down the road of seeing more—and more. Images transfix. Images anesthetize."[3] She was not only speaking of World War II; she was also thinking about Vietnam. In her later book, *Regarding the Pain of Others*, she seemed more accepting, coming around to the idea that pictures of cruelty need not be only anesthetizing, and could even be important as evidence on behalf of the victims of violent acts.[4] She drew a line of continuity between Francisco Goya, an artist who was shaped by the ideals of the French Revolution—that individuals have rights, and that people suffer in wars in shocking ways—to Robert Capa, the twentieth-century combat photographer (discussed later) who identified the common soldier as hero.

Pictures of violence that invade the privacy of the person who has suffered are rarely taken by artists, though often appropriated by them: Andy Warhol made paintings not only of Jackie Kennedy's face in shock, but of violent car crashes and suicides and the electric

chair.[5] Like pictures of sex, pictures of violence are part of photography's early history. From the time of the Civil War onward, the issue of propriety in death, usually violent death, has remained open to debate: Who should look at these pictures? Can we justify intruding upon another's violent death, and to what end? Can we equate looking at a dead gangster with looking at evidence of the gruesome evisceration of a political prisoner in a remote part of Nicaragua? [pl. 101] Is it necessary to see news pictures of women jumping to their deaths as a hotel goes up in flames? [pl. 100] Is the experience of looking at them on the same order as viewing pictures of lynching victims, photographs that seem to have been made as a kind of trophy, to ensure that the races would remain separated?[6] [pl. 84]

The nineteenth-century public had different expectations of the representation of death than we do today; they were both more and less comfortable with it. For instance, it was entirely appropriate, even sacred, to photograph loved ones in death. At the same time, the first photographer to depict war, Roger Fenton, in 1855, made pictures of Crimea very much in keeping with the codes of British propriety, so none of the terrible wastefulness and destructiveness of that conflict were portrayed; besides, Prince Albert had commissioned the pictures. In any case the technology was not yet available to photograph battles in action, and only two of his suggestive photographs of the aftermath of battle remain, their meaning still unclear.[7] Horrifying pictures of unvarnished disaster were soon made in other parts of the world, however. It was acceptable to take pictures of the bleached bones or rotted corpses of mutineers littering the courtyard at Lucknow during the so-called Indian Mutiny, or the abundant corpses around the fort at Taku, of Chinese who resisted the British Imperial presence in the Second Opium War. Since these were considered the savage enemies of civilization, they could be represented savagely. Victims of the 1876–78 famine in Madras, India, were similarly photographed by William Willoughby Hooper—they were poor Indian peasants [pl. 83]. But this chronicler of gallant British soldiery (his other work is sometimes comically surreal, showing the hunting exploits of British officers in India) documents a disaster almost without rhetoric, with terrible clarity and sympathy.

The photographers of the American Civil War, as we have seen, included pictures of the dead as well as the preparations for battle and its grim aftermath [pl. 81]. In some cases, most notably that of Alexander Gardner, these pictures were accompanied by editorializing text. To make the Confederacy seem more threatening, Gardner moved a corpse around and added a rifle fallen at his side (the wrong rifle, as it happens).[8] Sontag noted that war pictures are often ambiguous and cannot be trusted, and that there are instances where the same photograph has been used to prove the evil nature of both sides—only the identifying label changes.[9]

Pictures of violence became more widely disseminated with the rise of the popular press. The same voyeuristic impulses that impelled photographers to make pictures of royalty and famous people and to publish them in the tabloids also impelled the press to photograph and publish its first execution, the electrocution of the murderess Ruth Snyder in 1928. Tom Howard, commissioned by the *New York Daily News*, was outfitted with two cameras: one for under his jacket, easily discovered and removed by the guards, and the other in his pant leg, which he had to raise slightly as he released the shutter, using a long cable release that went from the camera to his pocket [pl. 89]. The tabloids also recorded less sensational but no less morbid subjects such as the charred victims of the persistent tenement building fires. Pictures of the dead and injured in the great anarchist riots that erupted in New York before World War I, as well as other troubles with labor throughout the country, were recorded and frequently reproduced in the illustrated press as cautionary examples of the appropriate end to bad political allegiances [pl. 85]. Occasionally the press unintentionally helped change political history, as when Victor Console's picture of police beating a suffragette while a gentleman tried to assist her caused a furor when it appeared in the London *Daily Mirror* in 1910.

Photography's oft-stated claim to objective truth made it a powerful tool for furthering particular causes, for demonstrating what was good and clarifying its opposite. During the 1930s, Robert Capa and his colleagues portrayed certain wars as rightful and democratic, glorifying the efforts of the common soldier under fire. In this way Capa, and those who followed him to form the agency Magnum, personalized the experience of battle. Whether by design or luck, some of the most compelling pictures made during World War II evidence

the role of the individual in the fighting, thanks to the increasing speed of film and the easy availability of the camera. Many memorable pictures of that conflict, however, were made by people we have never heard of—the Army man who photographed the death of a traitor [pl. 86], or the unknown photographer who recorded the bodies of those who had tried to escape the SS prisons [pl. 87]. Lee Miller, a professional war photographer, made pictures that lack the heroic rhetoric found, for instance, in Capa's best work—her pictures tend to be more ambiguous and perhaps more horrifying. She wrote about the beautiful teeth of a young woman, the daughter of the Leipzig Bürgermeister, who killed herself before the entry of the Allied troops [pl. 88].[10]

While war raged in Europe, Weegee made pictures for the tabloid press of the gangs that operated in lower Manhattan and Brooklyn [pl. 97].[11] His most famous pictures were of corpses newly felled, pictures as blunt as the cigar stuck perpetually between his teeth, as resonant as a body in the glare of the headlights. Weegee's pictures are sympathetic to the common people and their trials—their small pleasures but more frequent anxieties, the street violence that appeared commonplace in certain neighborhoods, the kids who grew up under these conditions. He also photographed people jumping to certain death from buildings on fire, the beginning of a tradition that was still in evidence when the World Trade Center was struck.[12] Weegee's manner, his style even, can be seen today in the classic tabloid photography of the Mexican photographer Enrique Metinides [pl. 99] and of the Sicilian duo Letizia Battaglia and Franco Zecchin, who made pictures of the terrible violence of the Mafia in Palermo in the 1970s.

Perhaps no photographs are more shocking than the iconic pictures from Vietnam: Malcolm Browne's picture of the monk who immolated himself before American TV cameras [pl. 90], Eddie Adams's shot of the quick and casual execution on the street of a suspected Viet Cong [pl. 91], or the children burned by napalm running desperately on a country road while soldiers stand in the distance, hardly noticing, as captured by Nick Ut. With such pictures, a generation of viewers began to question the role not only of their government, but also of photography. These images represent the antitheses of the "concerned photographer." In some cases photojournalists relished the moral ambivalence of their position as a way

of embodying the marginality and anguish they saw in Vietnam and Cambodia—Bill Burke is an example [pl. 104].[13] What is remarkable is that the tradition of journalistic photography did not, could not, change the conversation any more than it had for Susan Sontag in Santa Monica. The humanist ideal was a casualty of the spirit of the country.[14] The brutal decade of the mid-1960s and early 1970s saw not only the assassination of John F. Kennedy but an uncheckable stream of violence that flowed from it: Civil Rights protests and student unrest, the murders of Martin Luther King Jr. and Robert Kennedy [pls. 92–95], and the Vietnam War as it escalated, stalemated, and finally ended, strangely and abruptly. The disconcerting violence of that war played on, day after day, over the family television set at dinnertime in the United States; the later conflicts in Central America drew upon not only the rhetoric of the earlier violence, but also its inane despair [pl. 101]. Gilles Peress has been a major figure among those attempting to find a new equivalent to Capa's example in pictures of conflicts that Westerners would prefer to forget [pl. 103].

As print journalism in the United States has declined, Metinides's work as well as that of many Magnum photographers has been discovered by American art galleries and reprinted in elegant book format. Perhaps no one photographer embodies the complexities of the social history of the 1970s and the evolving art market as well as Larry Clark, an artist-photographer who documented speed freaks in Tulsa as an outlaw tribe, of which he was a member [pl. 107]. Twenty years later his work was appropriated by the art world, embraced alongside Nan Goldin's [pl. 64].

Still, the idea of making photographs of violence as proof of something that should be seen persists, and witnessing dangerous events can include recording even the photographer's own demise, as John Hoagland did in El Salvador. During the sectarian violence that preceded the secession of Bangladesh from India, two photojournalists found themselves photographing men being tortured to death. One of them, Horst Faas, made pictures to represent the violence in international news media. The other, Marc Riboud, wrote about the events more personally:

There was no questioning but only torturing. I can't even describe. I left when I saw blood coming out of the eyes and the mouths of the prisoners. A group of soldiers was competing

in being the most violent. The bayonets were piercing the faces and the bodies. . . . Men, women and children were watching. It was a kind of a coronation, a big meeting to celebrate the liberation. The son of the leader of Bangladesh was [in] the first row. . . . At the beginning I was shooting a few pictures. But after a short while I could not bear it anymore. I left and tried to look for Indian officers, the only ones who could have stopped the torture to death. But no Indians were around.[15]

Photographs of suffering have the potential to be politically explosive, which is why governments have been so interested in controlling who gets to see what. Most of us can instantly recall the single, anonymous man standing up to the line of tanks in Tiananmen Square in June 1989; this picture has served as a cautionary example for regimes that do not want such photographs outside their power. With the advent of digital technology, such subversive pictures play an ever more pervasive and powerful role.[16] The Iranian government attempted to repress pictures of any kind from 2009's widely contested elections. For a few weeks, the only available photos and first-hand accounts came not from professional media organizations but from private cell phones. Amateur videos and pictures of Neda Agha-Soltan, the young woman killed by the security forces during a demonstration, signified the change in information dissemination, and with it, the potential to witness repression worldwide.

1 "Brady's Photographs," The New York Times, October 20, 1862, 5. See also Roland Barthes, Camera Lucida: Reflections on Photography, trans. Richard Howard (New York: Hill and Wang, 1982), 111, where he comments on the strange power of the subject looking into the eye of the beholder: "For the Photograph has this power—which it is increasingly losing . . . of looking me straight in the eye."

2 Susan Sontag, On Photography (New York: Farrar, Straus and Giroux, 1977), 13–14.

3 Ibid., 20.

4 "What is the evidence that photographs have a diminishing impact, that our culture of spectatorship neutralizes the moral force of photographs of atrocities?" Susan Sontag, Regarding the Pain of Others (New York: Farrar, Straus and Giroux, 2003), 105. See also David Campbell, "Horrific Blindness: Images of Death in Contemporary Media," Journal for Cultural Research 8, no. 1 (January 2004): 55–74, for a discussion of Sontag and pictures of violence.

5 For discussions of Warhol's Death and Disaster series, see Thomas Crow, "Saturday Disasters: Trace and Reference in Early Warhol," in his Modern Art in the Common Culture (New Haven, CT: Yale University Press, 1996), 49–68; and Hal Foster, "The Return of the Real," in his The Return of the Real: The Avant-Garde at the End of the Century (Cambridge, MA: MIT Press, 1996), 127–70.

6 Dora Apel and Shawn Michelle Smith, Lynching Photographs (Berkeley: University of California Press, 2007), 46.

7 Phillip Lopate, Notes on Sontag (Princeton, NJ: Princeton University Press, 2009), discusses the Fenton pictures and Sontag's misinterpretations of them, 213–14.

8 See Alexander Gardner, Gardner's Photographic Sketchbook of the Civil War (New York: Dover, 1959); and William A. Frassanito, Early Photography at Gettysburg (Gettysburg, PA: Thomas Publications, 1995), 268–73.

9 Sontag, Regarding the Pain of Others, 10.

10 David Edward Scherman, "Foreword," Lee Miller's War: Photographer and Correspondent with the Allies in Europe, 1944–45, ed. Antony Penrose (Boston: Bulfinch Press, 1992), 176.

11 Weegee's work was known and admired by his contemporaries, some of whom claimed him as an artist-photographer, and was essentially rediscovered by Diane Arbus after his death. See Richard Meyer, "Learning from Low Culture," in Anthony W. Lee and Richard Meyer, Weegee and Naked City (Berkeley: University of California Press, 2008), 35.

12 See for instance Andrea D. Fitzpatrick, "The Movement of Vulnerability: Images of Falling and September 11," Art Journal 66, no. 4 (Winter 2007): 85–105; and Tom Junod, "The Falling Man," Esquire, September 2003, 177–81, 198–99.

13 See also Robert Hamilton, "Shooting from the Hip: Representations of the Photojournalist of the Vietnam War," Oxford Art Journal 9, no. 1 (1986): 49–55, which discusses the career of Tim Page, a photojournalist who was antiheroic in the sense of Capa's "concerned photographer."

14 See John Szarkowski, Mirrors and Windows: American Photography since 1960 (New York: Museum of Modern Art, distributed by New York Graphic Society, 1978), 13: "For most Americans the meaning of the Vietnam War was not political, or military, or even ethical, but psychological. It brought us to a sudden, unambiguous knowledge of moral frailty and failure. The photographs that best memorialize the shock of that new knowledge were perhaps made halfway around the world, by Diane Arbus."

15 Email to the author, February 28, 2008.

16 See the very thoughtful essay by Martha A. Sandweiss, "Image and Artifact: The Photograph as Evidence in the Digital Age," The Journal of American History 94, no. 1 (June 2007): 193–202.

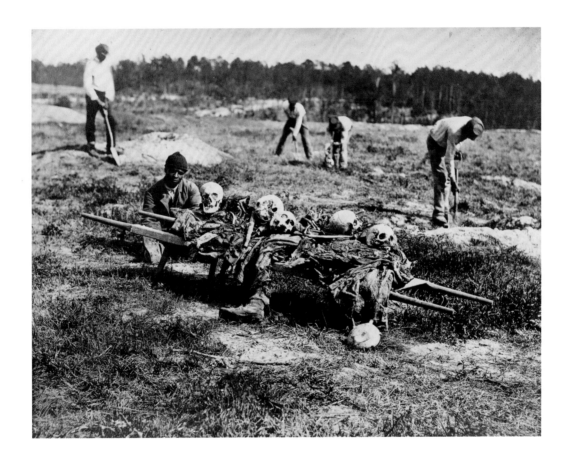

81 John Reekie, *Incidents of the War: A Burial Party, Cold Harbor, Virginia, April, 1865*, 1865

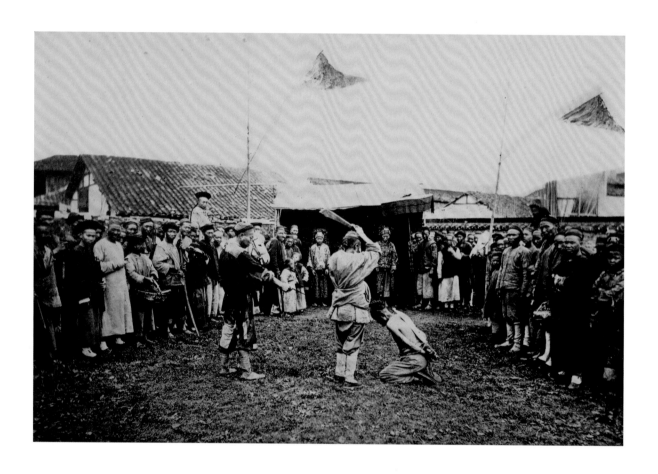

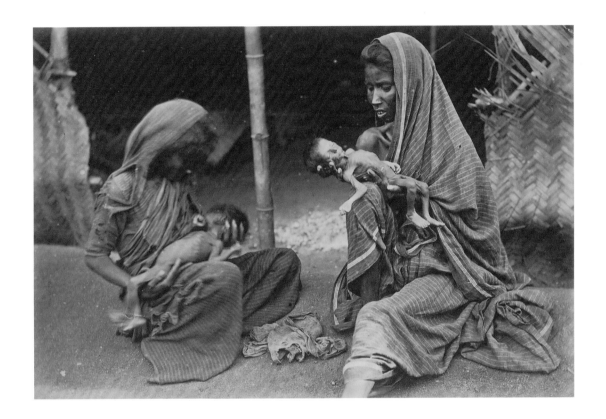

82 William Saunders, *Chinese Execution*, 1860s

83 William Willoughby Hooper, *Child born of famine-stricken mother. Age 3 mos. Weight 3 lbs.*, ca. 1877

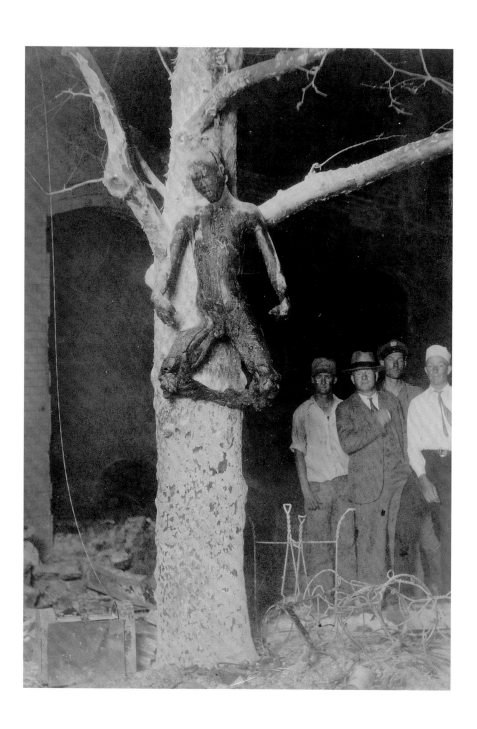

84 Unknown, *[Body of George Hughes hanging from a tree, Sherman, Texas]*, 1930

85 Unknown, *[Dead man, killed by bomb at Anarchist riot, Union Square, New York City, March 28, 1908]*, 1908

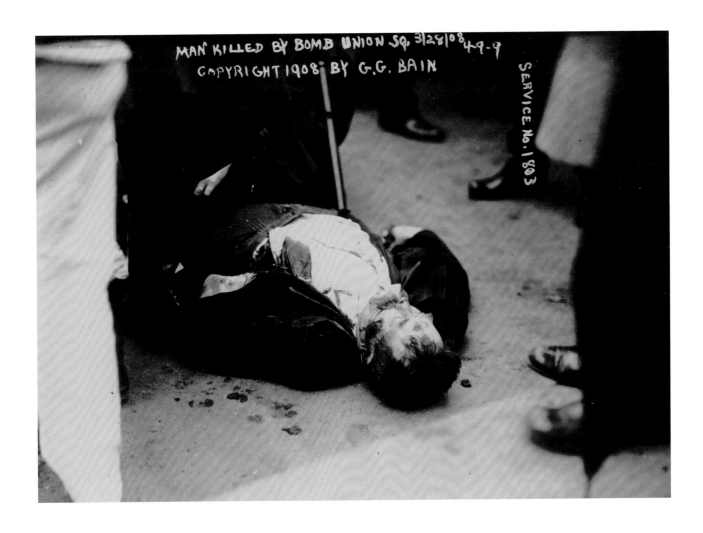

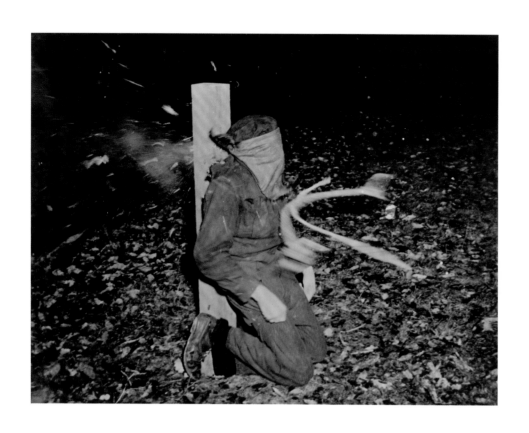

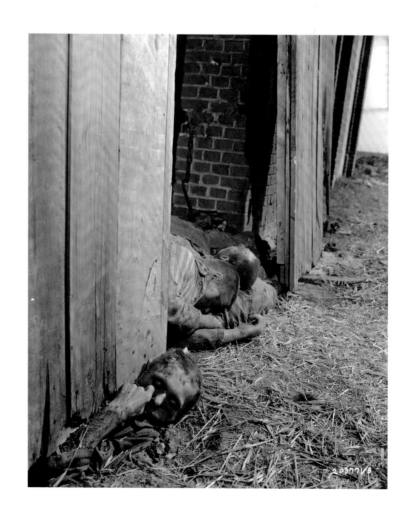

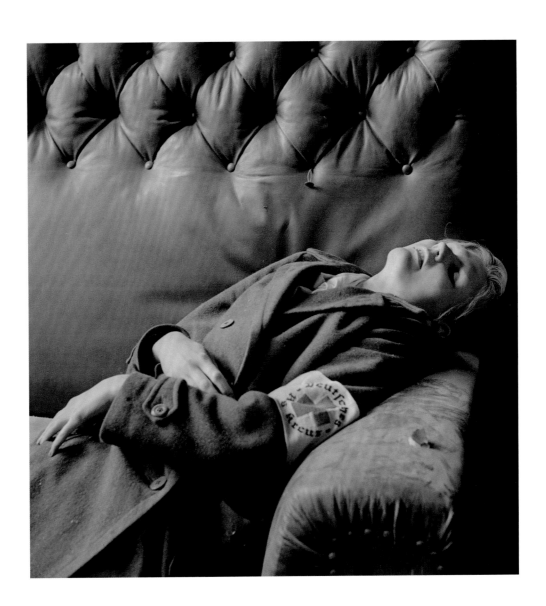

86 United States Army, *Rennes, France, Death of a Traitor*, 1944

87 Keystone Pictures, Inc., *The Nazis Burn the Living* [Gardelegen, Germany], 1945

88 Lee Miller, *Bürgermeister of Leipzig's Daughter, Suicided*, 1945

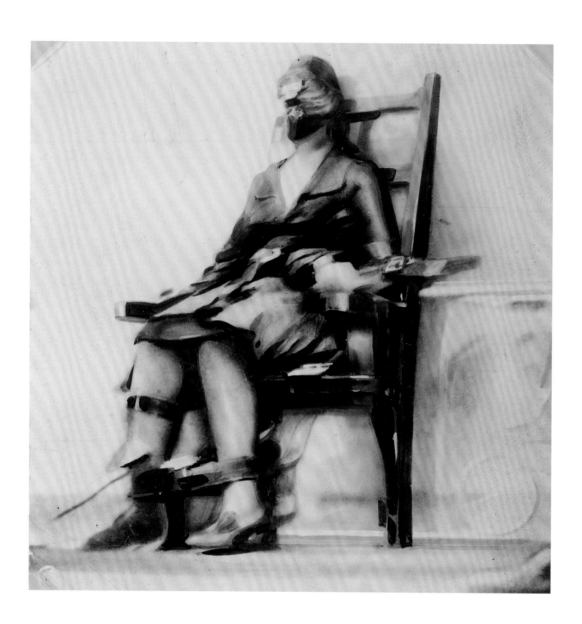

89 Tom Howard, *The Electrocution of Ruth Snyder*, 1928

90 Malcolm Browne, *Thich Quang Duc, Buddhist priest in Southern Vietnam, burns himself to death*
 to protest the government's torture policy against priests, June 11, 1963, 1963

91 Eddie Adams, *Viet Cong Officer Executed*, 1968

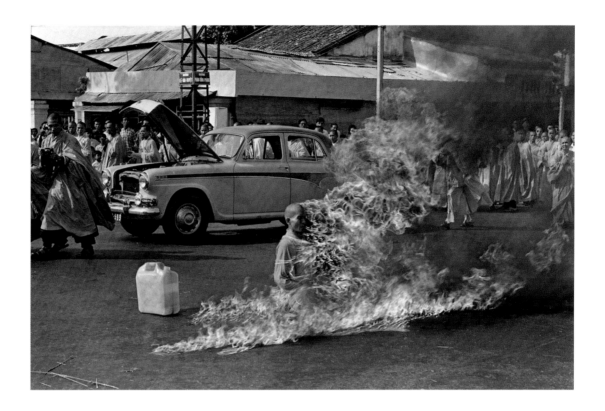

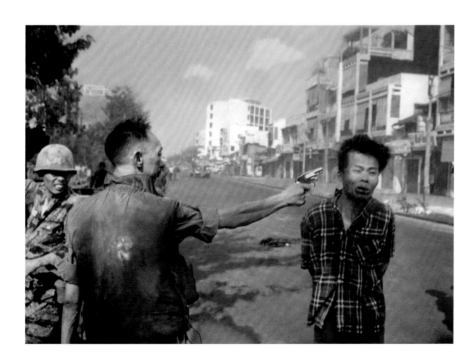

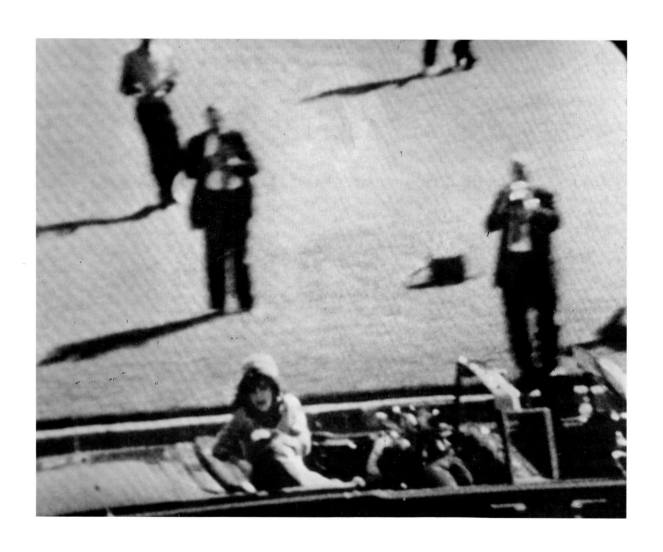

92 Abraham Zapruder, *Assassination of John F. Kennedy, November 22, 1963*, 1963

93 United Press International, *Suffolk, Virginia, Race Confrontation, May 6, 1964*, 1964

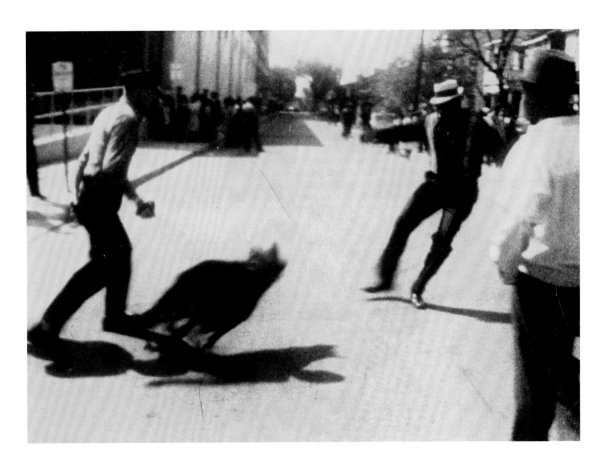

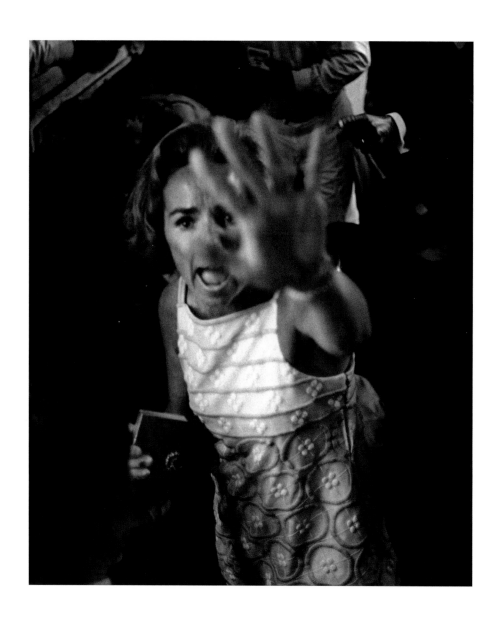

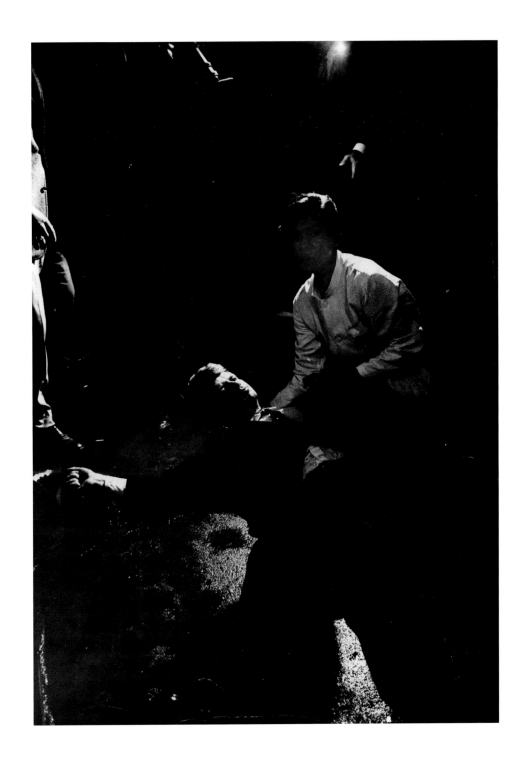

94 Harry Benson, *Los Angeles, Ethel Pleads on Kennedy's Behalf,* 1968

95 Bill Eppridge, *[Juan Romero, busboy at Ambassador Hotel in Los Angeles, kneels to help fallen Senator Robert F. Kennedy after he was shot by Jordanian fanatic Sirhan B. Sirhan],* 1968

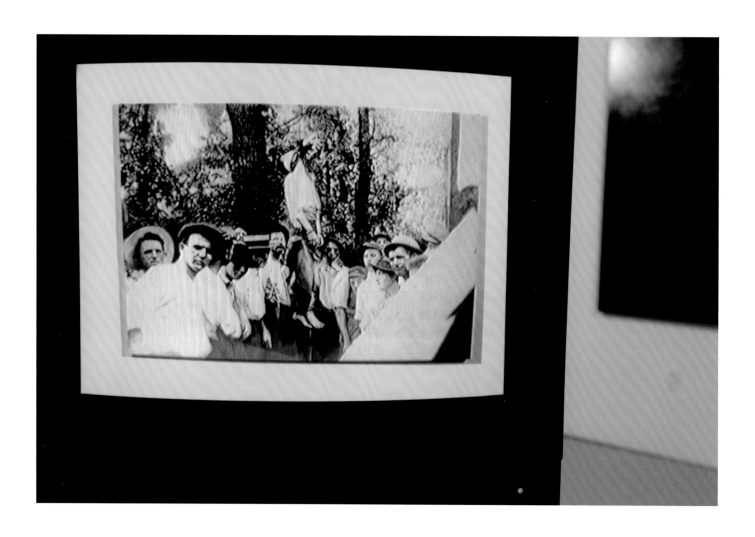

96 Oliver Lutz, *The Lynching of Leo Frank* (installation view, artist's studio), 2009

97 Weegee (Arthur H. Fellig), *Murder in Hell's Kitchen*, 1935–45

98 Associated Press, *Johannesburg, South Africa—On the Edge*, 1975

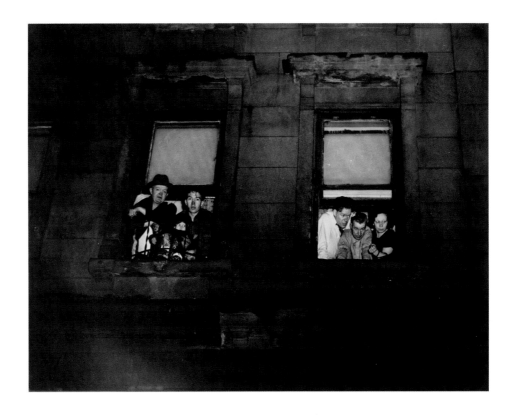

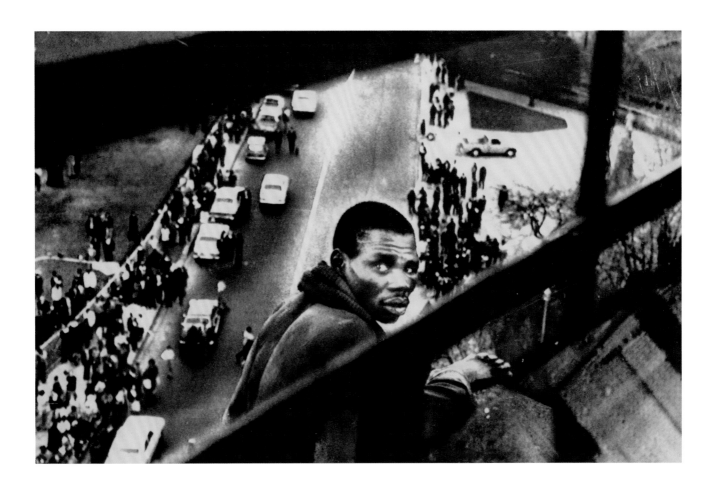

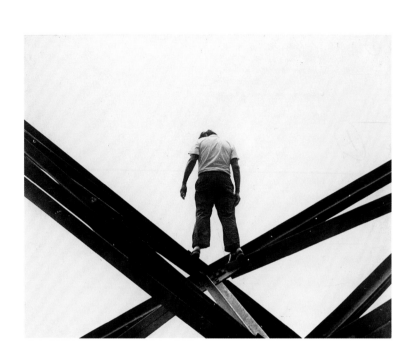
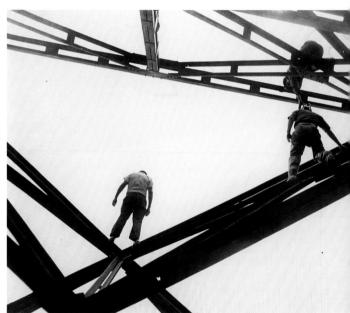
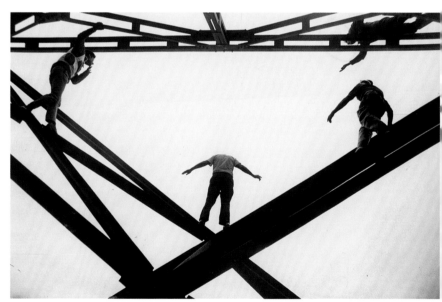

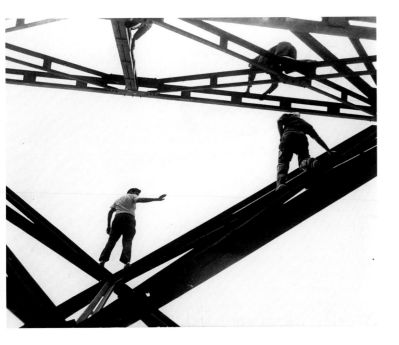

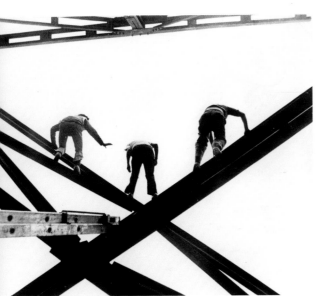

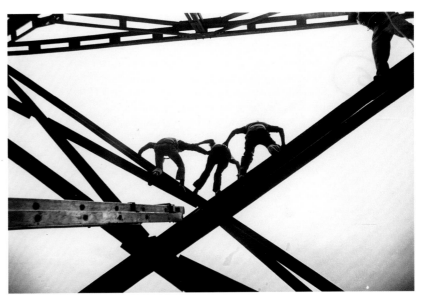

99 Enrique Metinides, *Secuencia rescate de un suicide en la cúpula el toreo* (Suicide rescue from the top of the Toreo Stadium), 1971

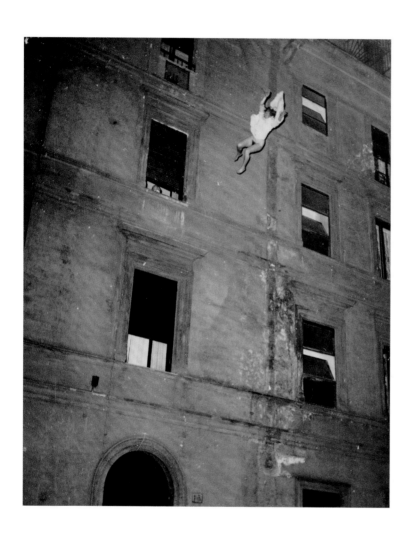
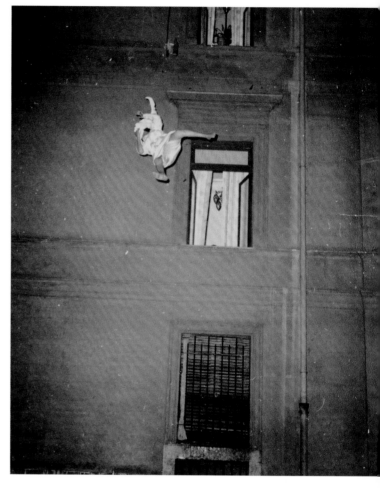

100 Marcello Geppetti, *Albergo Ambasciatori (Incendio)* (Fire at the Hotel Ambassador) (detail), 1959

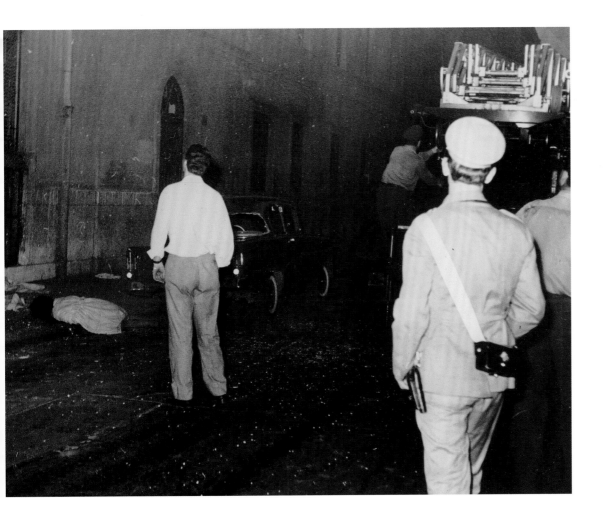

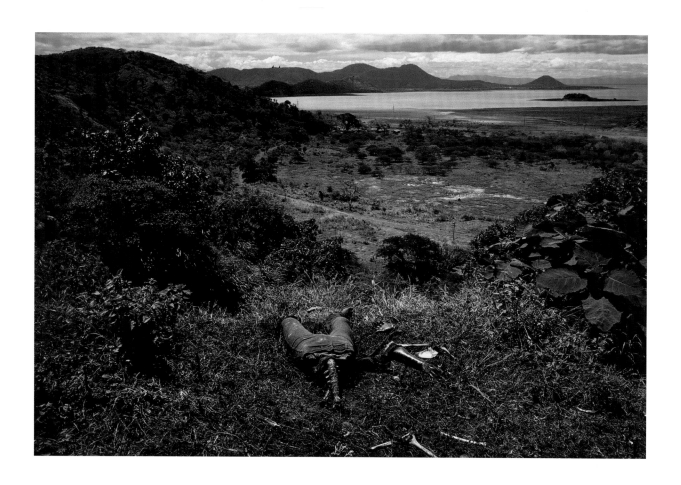

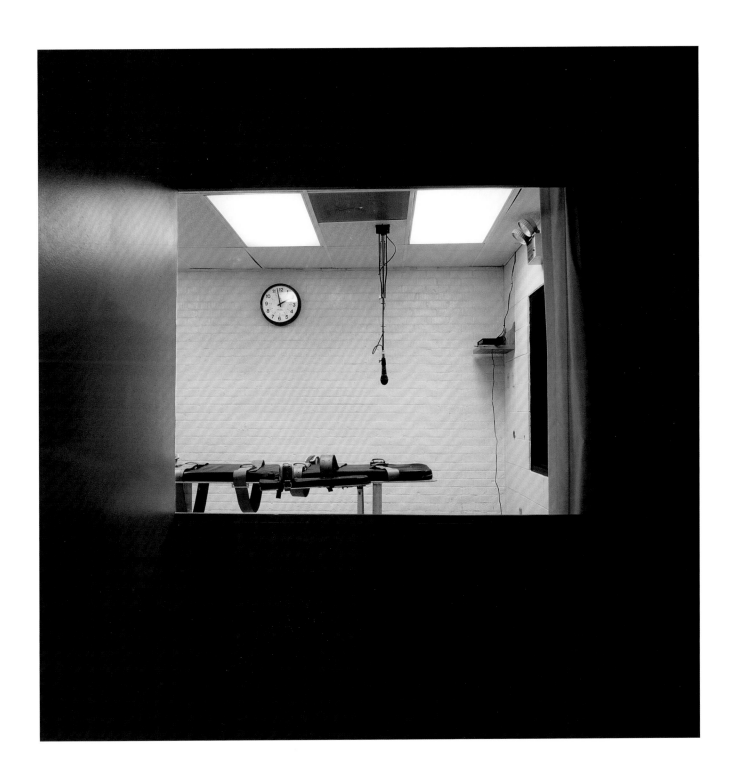

101 Susan Meiselas, *"Cuesta del Plomo," a well-known site of many assassinations carried out by the National Guard, where people searched daily for missing persons, Managua, Nicaragua,* from the series *Nicaragua,* 1981

102 Lucinda Devlin, *Lethal Injection Chamber from Family Witness Room, Parchman State Penitentiary, Parchman, Mississippi, 1998,* 1998

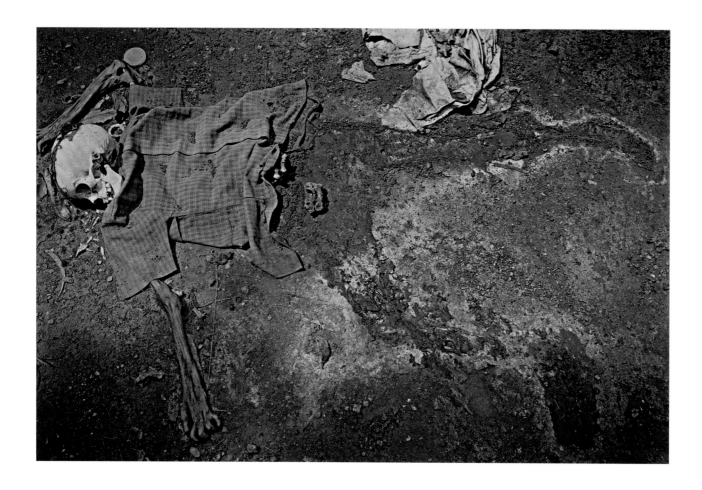

it was unclear at the outset as to whether norms prohibiting "crimes against humanity" were intended to overlap with norms prohibiting war crimes or whether they were supposed to be independent juridical concepts.

111. Article 6 (c) of the Nuremberg Charter does narrow the concept of "crimes against humanity" considerably. As Sunga 1/ states:

"In particular, the acts must have been committed against civilians rather than soldiers (whereas norms prohibiting war crimes restrict actions against soldiers as well), and the acts must have been committed 'either before or during the war' (although what period of time before the war is not specified). A Protocol of 6 October 1945, done in Berlin, amended the original version of article 6 (c). The original provision contained a semicolon which followed the word 'war' which seemed to imply that murder etc. could be considered as crimes against humanity independent of the jurisdiction of the Tribunal. However, the semicolon was replaced with a comma by the Protocol. The result was to imply that crimes against humanity were to be interpreted to import liability only for acts connected to the war."

Moreover, the United Nations War Crimes Committee on Facts and Evidence in 1946 sought to clear up any ambiguity by stating that:

"...'crimes against humanity as referred to in the Four Power Agreement of 8th August 1945, were war crimes within the jurisdiction of the [United Nations War Crimes] Commission." m/

112. Consequently, "crimes against humanity" were interpreted by the Nuremberg Tribunal as offences that were connected to the Second World War, rather than any situations that might have existed prior to it.

13. If the normative content of "crimes against humanity" had remained from its Nuremberg form, then it could not possibly apply to the situation in that existed between 6 April and 15 July 1994 because there was not

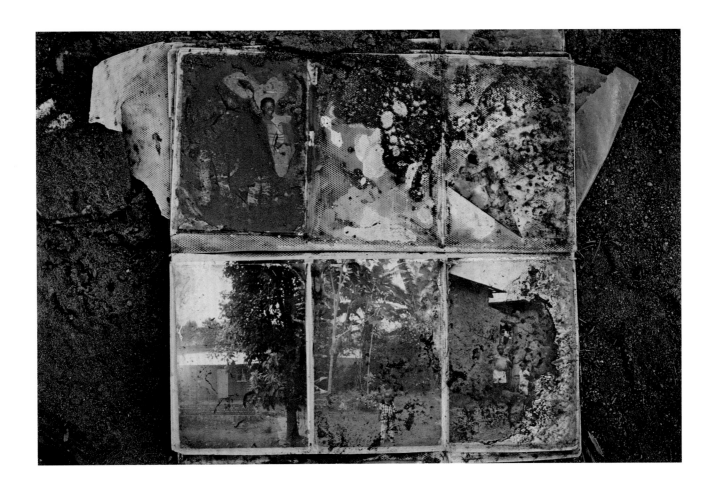

103 Gilles Peress, *Nyarubuye*, from the series *The Silence*, 1994

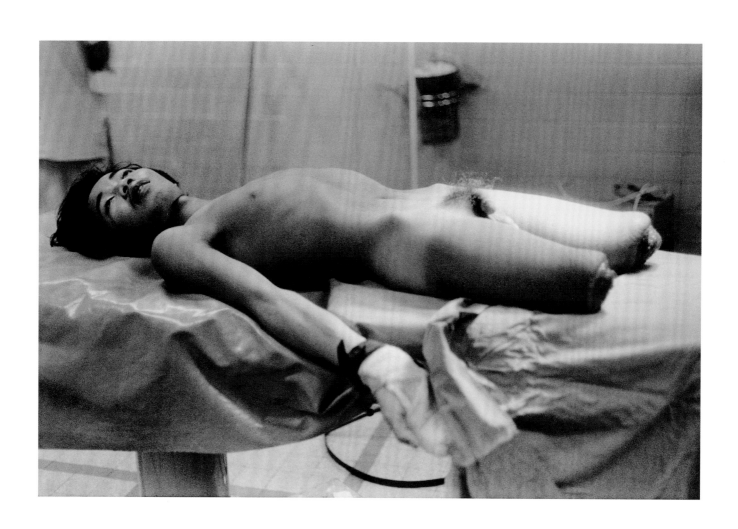

104 Bill Burke, *Hôpital Calmette, Phnom Penh*, ca. 1990

105 Stephen Shames, *IRA Gunman, Ireland, 1971*, 1971

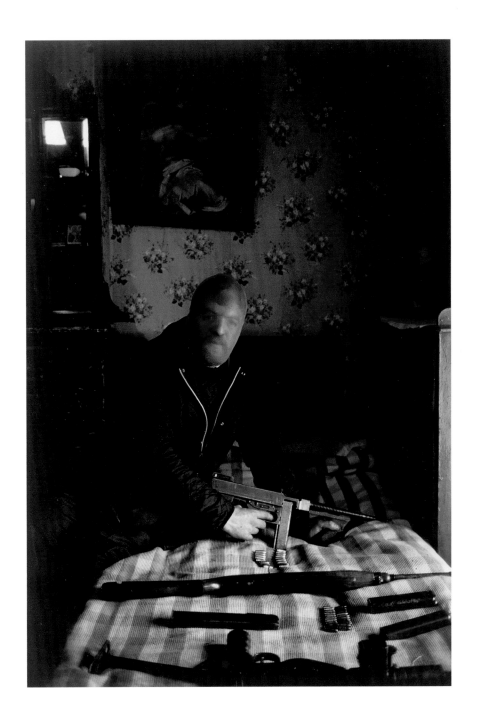

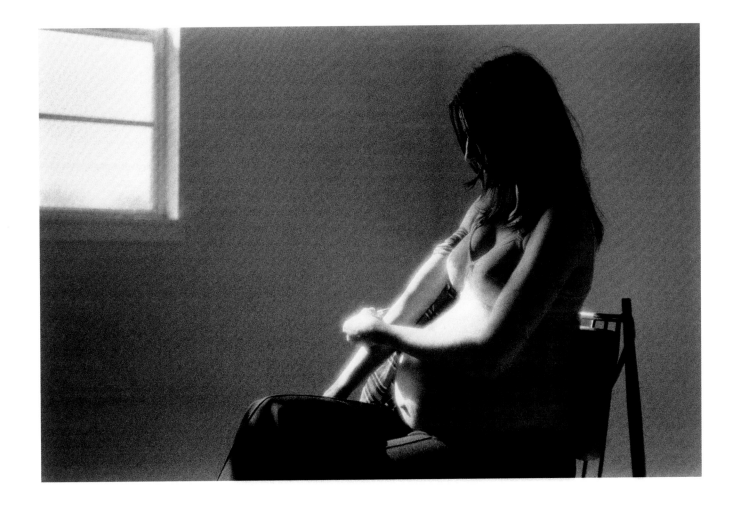

106 United States Atomic Energy Commission, *Diablo Shot, fireball, July 15, 1957,* from *Atomic Tests in Nevada,* 1957

107 Larry Clark, *Untitled,* from the portfolio *Tulsa,* 1971

SURVEILLANCE

SURVEILLANCE PICTURES ARE VOYEURISTIC in anticipation, seeking deviance from what is there: the creeping presence of enemy activity; telling changes in the landscape below; evidence of incriminating behavior, such as spying, crossing borders illegally, or accepting bribes. Such pictures today are most often made by unguided machines that only watch, and often do so from a great distance, like the unseen and immutable Eye of God. Not all surveillance is so abstract; distance also serves to protect the individual voyeur, who may use long lenses or night-vision scopes to peer without recrimination. In the hands of dissidents and artists, importantly, such potential instruments of oppression can become instruments of resistance.

War has long fed the drive for new surveillance technologies, to gain advantage over one's enemies. A picture from around the time of the American Civil War shows a gathering of Union soldiers on Lookout Mountain, on the Georgia-Tennessee border, evidently trying to ascertain the enemy's position in the absence of such technology (a view camera can be seen on the right side of the picture) [pl. 117]. In peacetime, the nineteenth-century sport of ballooning provided an early vehicle for the photographer's impulse to see and record everything. In Paris, Félix Nadar successfully made photographs from his own balloon in 1858, and two years later James Wallace Black photographed Boston "as the eagle and wild goose see it," as Oliver Wendell Holmes Sr. wrote.[1] Attempts to take surveillance photographs of the enemy during war from that vantage met with no success, however, until it became clear that airborne photography could be achieved more safely and effectively without the photographer's presence—whether by balloon, kite, or even carrier pigeon.

Far more accurate and specific pictures could be made from airplanes, and this was the platform for most aerial photographs before the job was taken over by satellites. In 1911, flying over South San Francisco, George E. Kelly recognized the military potential in the shots he took of the ground below, and it was this military usefulness that provided the money to develop the technology [pl. 108].[2] During World War I the Allied forces were able to make pictures of the trenches and enemy activity, and by World War II aerial reconnaissance photography was so efficient and widespread that the beaches of Normandy were photographed only hours before D-Day, showing the exact location of mines that would be invisible at high tide. As the United States moved inexorably into the Cold War, any compunction about spying was diminished by the CIA's discovery of Russian-built missiles in Cuba in 1962 [pls. 110–11]. The beauty of these two photographs—they resemble abstract expressionist pictures in their delicacy and vigor, respectively—is not intentional, but the aggressiveness of the later picture, in profound contrast to the earlier one, is expressive of a creeping and frightening antagonism. The pictures made an irrefutable case when Adlai Stevenson, the U.S. Ambassador to the United Nations, presented them as evidence of Russia's aggressive intent in America's backyard. But the event that provoked the Russian presence, the CIA-backed Bay of Pigs invasion of Cuba after the Castro revolution, offers evidence of a photograph's ability to lie. Faked surveillance pictures were used to convince Stevenson that the adventure was not supported by the CIA.[3]

An intermediate surveillant distance such as that provided by a window view also has a political role, allowing one to see events as patterns, and people as objects or types, while providing protection to the photographer. Alexander Gardner's series of photographs from a government window looking out on the hanging of the Lincoln assassins is a historic event abstracted, too far away to understand until the caption is read; the subject was considered too dangerously provocative to permit an official record [pl. 118]. Americans would later become agitated over anarchist activities, and many World War I–era photographs of anarchist demonstrations, the violent aftermath of their meetings, and police attacks on them can be found in the George Grantham Bain Collection at the Library of Congress [pl. 119]. During the Vietnam War protests, still- and motion-picture cameramen voluminously documented antiwar activities, sometimes from the roof of the Pentagon, far enough away to be safe and to get good coverage of the massive crowds; there are also pictures of agents making photographs on the ground [pl. 144]. Recent photographs from Iraq by embedded journalists have much the same intermediate character: we can recognize the action just enough to be engaged. Made from tanks, sometimes with night-vision equipment, the pictures appear as if the photographers were looking into a television monitor [pl. 129].

At ground level, the small, hidden camera served spy and witness alike. In the 1940s, Weegee photographed movie theater audiences in America, using "invisible light," the new infrared bulbs, to spy on lovers taking advantage of the dark [pl. 145]. His subjects were unaware that they were being observed, let alone photographed. At the same time, concealed cameras were used to track the Nazis in Holland by a group calling themselves "the Hidden Camera." Needless to say, this activity was strictly forbidden and punishable by death, and only the titles of their pictures let us know what we see [pl. 122]. Cameras were also smuggled into the concentration camps at Dachau and Auschwitz, and the survival of these pictures is a testament to the importance their makers and enablers attached to them [pl. 121].

Photographs taken during the Cold War by FBI agents tracking suspected spies usually lack the cogency and evident drama of street photography—they are apparently random pictures of people on the street, or people in poor light and obscure places. The blurriness and crudeness of the images seem a mark of their authenticity [pls. 125–27]. Perhaps the very first use of this type of photograph was the capturing of suffragettes on film by the police [pl. 120]. These unauthorized portraits were printed on cards identifying the women so that they could be recognized by the authorities. What is especially strange about close-up surveillance pictures is that they seem trivial, meaningless in fact, except for the identity of the people in them and what they are doing, all of which needs to be captioned to make sense. In contemporary times such pictures are made automatically by cameras placed in public spaces; these cameras are on all the time, they record without direction or intent, and they never finish their job. The only way to shape the information is to extract it as evidence, as when a camera picks up the features of a bank robber complete with obvious disguise [pl. 147].

Close-up photographs of knowing but unwilling subjects are also used as a means of control, as governments routinely force people to sit for portraits in order to have a record of what they look like. The work Marc Garanger made of Algerian women in the 1960s illustrates a particularly invasive example of this type of surveillance. These women were customarily never seen outside their homes without their veils, their features unknown outside their immediate families. They were colonial subjects, however, and the French state required identity cards. The expressions of Garanger's subjects reveal their discomfort as they violate their own social mores to face the male photographer [pls. 130–31].

By the 1960s the technology of surveillance had advanced, and new, often aesthetic uses were found for these tools. Photographs published and exhibited in museums revealed to the public the abstract beauty of Earth as seen from above, the precursors of satellite photography and Google Earth.[4] *Frontiers of Photography*, a volume in the famous Time-Life series on photography in the 1970s, opens with a series of "portraits" of a young woman, Susan, showing examples of the most technologically up-to-date invasive photographic work: X-ray and Equidensity pictures, stereophotograms, sonograms, holograms, scanning electron micrograph imagery, and thermograms, as well as the more familiar night-vision pictures made with technology invented for the

Vietnam War.[5] Also around this time the zoom lens became ever lighter and more efficient, and was available in less expensive models. It was thus possible to take pictures from a great distance without a heavy lens on a tripod.

Artists put these innovations to use. In the 1970s, Alair Gomes began making pictures of young men on the beach in Rio, often shooting from his balcony with a powerful telephoto lens [pl. 157]. Gomes was an eccentric and brilliant philosopher and critic of art; his pictures celebrate the vibrancy and beauty of the male body, hinting at parallels with ancient Greek and Italian Renaissance sculpture. It was important that the pictures were not posed, and that the subjects were unaware of his camera.

Twenty years later, John Gossage employed special film developed for surveillance purposes and a long lens to photograph the beach at Tijuana from California, a few miles away [pl. 151].[6] Still newer technology in telescopic lenses and alternative light sources developed by the military is now used to observe border crossings at night; Thomas Ruff employed such night-vision goggles, with their characteristic green imagery, to create his dystopian pictures of European cities in the 1990s [pl. 142]. A picture Trevor Paglen produced more recently, looking into the space of the military's secret biological weapons experiments, was taken forty-two miles from the site with a high-powered telescopic lens, and the light is as mysterious as that in a Rothko painting [pl. 115].

Indeed, surveillance has become especially compelling to contemporary artists working in photography and media, perhaps because it engages a certain anxiety felt in the culture. What characterizes most surveillance photographs is a spirit of distance, abstraction, and a certain placid ambiguity. By definition, they are without affect. Most often we have to be taught or told what these pictures mean.[7] In this, too, they resemble conceptual art.

Simon Norfolk has photographed the transmitter—a web of tiny wires, an almost invisible net—that governments can tap to capture cell phone conversations [pl. 114]. He writes: "Warfare is becoming increasingly intangible. It is a paradox that whilst 'rolling news' and 'embedded journalists' saturate us with the showbiz of war, the really interesting developments: submarine warfare, space weapons, electronic warfare and electronic

eavesdropping are essentially invisible."[8] Other artists examine the sites of surveillance activity: Andreas Magdanz documented Pullach, a village in southern Germany that was the center for spying on the Eastern Communist countries, financed and run by the United States. Its pristine banality is the only clue to the real work undertaken behind the tidy exterior [pls. 136–37].[9] Peter Piller acquired a series of pictures of middle-class homes in Germany shot from helicopters for use by real estate agents. Displayed in a grid format akin to that favored by the minimalist photographers Bernd and Hilla Becher, the photographs are not formal as much as they are documents of a disconcerting if unintended curiosity on the part of the viewer [pl. 133]. Shai Kremer, an Israeli artist working in New York, has made panoramic photographs of the Urban Warfare Training Center, Tze'elim, located in the Negev [pl. 116]. This model town built for training American and Israeli troops was based on surveillance photographs of representative Arab villages. The Palestinian artist Emily Jacir personalized surveillance pictures. After detecting a camera recording activities on the main square in Linz, Austria, she injected herself into the view (she is barely noticeable) as the autumn became winter, the light changed, and the fountain in the center of the square was boarded up against the cold. She then captioned the pictures with diaristic commentary [pl. 143].

Shizuka Yokomizo's richly unsettling photographs investigate the idea of voyeuristic seeing with the subject's consent. She makes pictures of people looking out of their windows into the night: they have received the photographer's written invitation to appear there at an appointed time, and have had no other contact with her (those who do not accept close their blinds). She sees them, but they see only her shadowy presence outside their window [pls. 155–56]. Barbara Probst takes pictures of her subjects with cameras set up in different spots and timed to release exposures at the same moment; in the juxtaposition of viewpoints we discover that cameras can be pernicious—they can see too much [pl. 159]. More direct examinations of surveillance have also proved to be resonant motifs for photographers. In 1946 *Life* magazine photographer Yale Joel used a one-way mirror to trick people into posing for him [pls. 148, 150]—a kind of static version of the television series that would shortly become popular called *Candid Camera*,

where a hidden camera would photograph people's amusing mistakes. In 1999 Merry Alpern took a videocam into women's dressing rooms in New York City [pl. 153]. In the same anthropological spirit, Laurie Long, an artist in Northern California, packed her videocam with her compact and hairbrush when she went out on dates [pl. 149].

Sophie Calle has used the camera to explore surveillance with tenacity and originality, and has made the inversion of public and private spaces her special territory. While her work of photographing people at their most vulnerable—asleep—was anticipated in the (very obscure) work of Ted Spagna [pl. 146], Calle has devoted a great deal of her creative energy to exploring the idea of voyeurism and its implications. She followed an unsuspecting man to Venice and trailed his activities; she requested that her mother hire a detective to follow *her* and documented that experience; and most notably and aggressively, she served as a maid in a fashionable Venetian hotel, opening up the guests' luggage, photographing the contents, and divining their lives from the evidence she found [pl. 154].

In surveillance pictures, as in other kinds of voyeuristic work, the way the picture is made is an expression of the circumstances in which the photographer finds him- or herself. We expect the picture made by a spy to be dark and unclear, for instance, for if it were in daylight and easily read it could not be surreptitious. Many of today's artist-photographers are drawn not only to the evolving technology of photography but to the subject of looking surreptitiously. In addressing photography's always-challenging identity with truth, they now grapple with what cannot be seen.

1 Quoted in Beaumont Newhall, *Airborne Camera: The World from the Air and Outer Space* (New York: Hastings House Publishers, in collaboration with George Eastman House, 1969), 24.

2 Ibid., 51.

3 See Adlai Stevenson Papers, 1861–1990 (bulk 1952–1965): Finding Aid MC124, http://arks.princeton.edu/ar:88435/sn009x77d, Biography. See also The Cuban Missile Crisis, 1962, National Security Archive, The George Washington University, http://www.gwu.edu/~nsarchiv/nsa/cuba_mis_cri/photos.htm, nos. 4 and 5 (accessed February 24, 2010).

4 William Garnett's photographs were published in Nathaniel Alexander Owings, *The American Aesthetic* (New York: Harper and Row, 1969); other examples are Hanns Reich, *The World from Above* (New York: Hill and Wang, 1966), and Newhall, *Airborne Camera*, which accompanied an exhibition.

5 "Clues to the Future: Thirteen Faces of Susan," *Frontiers of Photography* (New York: Time-Life Books, 1972), 18–30.

6 "The film is 2484 high-speed recording film from Kodak. This is a film that is not available widely, sold in Washington to the security agencies, among others. 6000 ASA is its recommended speed. The camera is a customized Nikon F with a specially configured 1800mm lens, handheld." John Gossage, email to the author, November 24, 2009.

7 In fact, most reconnaissance photographs cannot be read without instruction, and often, subjective interpretation. See Kim Sichel, *To Fly: Contemporary Aerial Photography* (Boston: Boston University Art Gallery, 2007), 14.

8 Simon Norfolk, "Ascension Island: The Panopticon (ECHELON for beginners)," http://www.simonnorfolk.com (accessed January 22, 2010).

9 Andreas Magdanz, *BND—Standort Pullach* (Cologne: DuMont Verlag, 2006), text on inside front of jacket.

108 George E. Kelly, [*View from a Wright Model B biplane over airfield near San Francisco, California, made with a folding camera*], 1911

109 United States Army Air Service, 1st Aero Squadron, *First Mosaic Photograph Taken in United States with Original Brock Aerial Automatic Camera, Fort Sill, Oklahoma, 1915*

110 U.S. Government, U-2 Reconnaissance Aircraft, *Completed SA-2 missile site showing characteristic*
Star of David pattern, 1962

111 United States Air Force, *SA-2 antiaircraft site, Havana, Cuba, August 29, 1962*, 1962

112 Dave Gatley, *Ghostly view thru an older U.S. military version truck-mounted, cryogenic-cooled, thermal infrared imaging scope showing U.S. Border Patrol vehicles moving on a dirt road along the U.S./Mexico Border,* ca. 1983

113 Sophie Ristelhueber, *FAIT,* 1992

114 Simon Norfolk, *The BBC World Service Atlantic Relay Station at English Bay*, from the series *Ascension Island: The Panopticon*, 2003

115 Trevor Paglen, *Chemical and Biological Weapons Proving Ground / Dugway, UT / Distance ~42 miles / 10:51 a.m., 2006*, 2006

116 Shai Kremer, *Urban Warfare Training Center, Panorama, Tze'elim*, 2007

117 Unknown, *View on Top of Lookout Mountain, Chattanooga, ca. 1864*

118 Alexander Gardner, *Execution of the Presidential Conspirators, Lowering the Bodies, July 7, 1865, 1865*

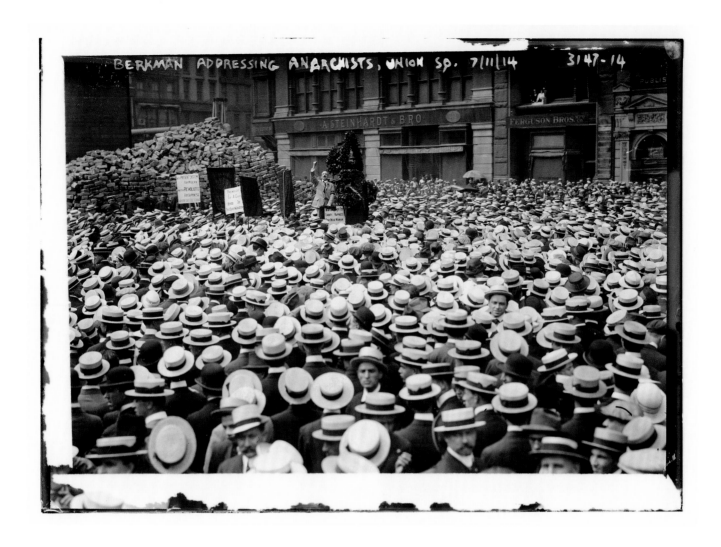

119 Unknown, *Berkman Addressing Anarchists, Union Square, July 11, 1914*, 1914

120 Criminal Record Office, Great Britain, *Surveillance Photograph of Militant Suffragettes*, ca. 1913

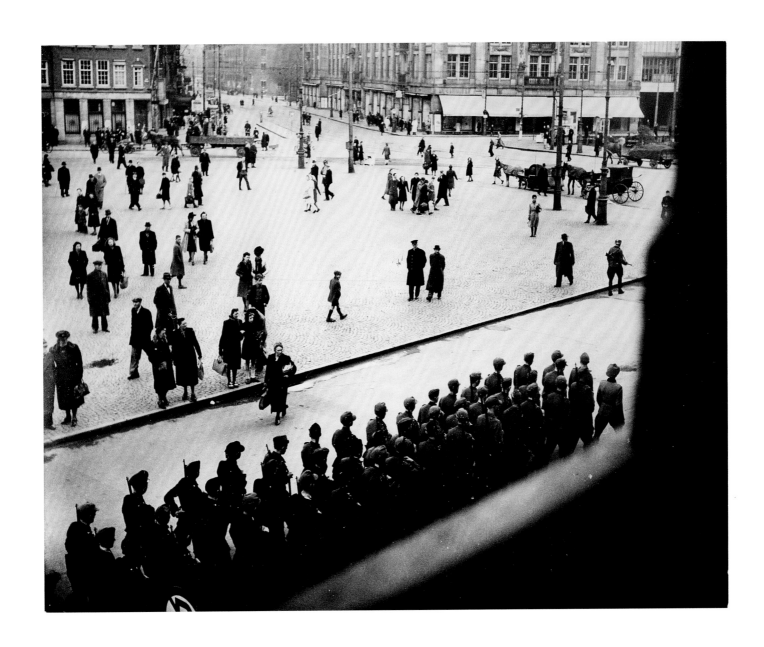

121 Rudolf Cisar, *[Clandestine photograph taken at Dachau]*, 1943

122 Ad Windig, *Laatste groep Duitse soldaten marcheert over de Dam, kort voor de intocht van de Canadezen* (The last German troops march across Dam Square shortly before the arrival of the Canadians), ca. 1945

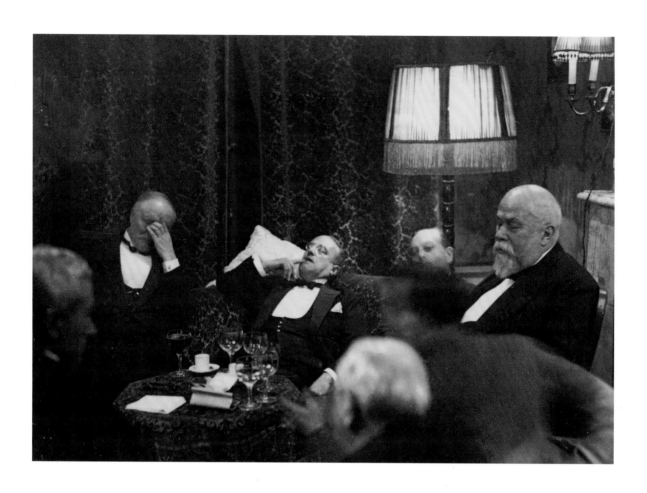

123 Erich Salomon, *Hague Conference*, 1930

124 Erich Salomon, *Genf, Völkerbund. Zwei Zuschauerinnen auf der Publikumstribüne, die an Daumier erinnern. Aufnahme mit Telekamera aus 22 m Entfernung.* (Geneva, League of Nations. Two spectators in the public gallery who reminded me of Daumier. Taken with a telecamera at a distance of 22 meters.), 1928

125 Unknown, *[Photograph taken from television monitor on September 28, 1962, showing Nelson Cornelius Drummond opening a locked file cabinet containing classified documents]*, 1962

126 Rudolph Herrmann (Dalibar Valouschek), *[FBI surveillance photograph, Soviet KGB agent at dead drop (meeting place), Westchester, New York]*, ca. 1980

127 Unknown, [*Maksim Grigorlevich Martynov case, Martynov speaks in code, FBI files, Russian spy*], ca. 1954

128 Bill Eppridge, [*At lamppost on Broadway and West 71st Street, Karen, heroin addict and prostitute, does some drug peddling, New York*], 1965

129 Benjamin Lowy, *Iraq Perspectives II #8*, 2003–7

130 Marc Garanger, *Femme Algérienne*, 1960

131 Marc Garanger, *Femme Algérienne*, 1960

132 Thomas Demand, *Camera* (video still), 2007

133 Peter Piller, *Schlafende Häuser* (Sleeping Houses), from the series *Von Erde schöner* (More Beautiful from the Ground), 2000–2004

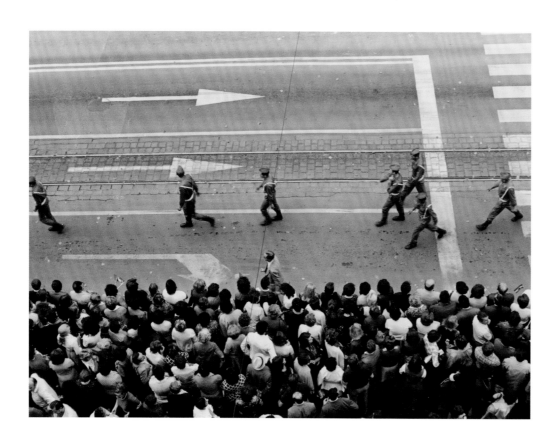

134 Sanja Iveković, *Triangle* 2000+ (detail), 1979

135 Jonathan Olley, *Golf Five Zero watchtower (known to the British army as 'Borucki Sanger'), Crossmaglen Security Force Base, South Armagh*, from the series *Castles of Ulster*, 1999

136 Andreas Magdanz, *Rechter Teil der Haupteinfahrt, im Hintergrund der ehemalige Busbahnhof* (Right side of the main entrance; in the background is the former bus station), 2005

137 Andreas Magdanz, *Linker Teil der Haupteinfahrt, im Hintergrund Parkplatz auf dem so genannten Bunker Hagen* (Left side of the main entrance; in the background is the parking area of the so-called Hagen Bunker), 2005

138–40 Jules Spinatsch [left to right]
Hotspot_A1_North_Entry_280103_14h10
Hotspot_A4_Promenade_230103_19h35
Hotspot_A1_North_Entry_270103_19h20
from the series *Temporary Discomfort, Chapter IV, World Economic Forum WEF, Davos-CH*, 2003

141 Harold Eugene Edgerton, *Pentagon*, 1940s

142 Thomas Ruff, *Nacht 15 II (Stellwerk Basel)*, 1994

October 19, 2003 12:00 hours

a star for Gregory Corso. last night i found out that he died on january 17, 2001.
he was buried in roma after all. in 1986, he came to our school and wrote on the board:
'a star is as far as my eye to me'. he repeated it out loud as he wrote.
it has been repeating in my head all this time.
(i came early today because i am going to vienna to film and will not be back by 18:00)

October 20, 2003 18:00 hours

walking in the fountain. a gloomy day in linz and the clouds are low. it seemed fitting that
when i arrived at the fountain it was empty. no more water.

October 21, 2003 18:00 hours

my beloved fountain!! look what they did!

143 Emily Jacir, *linz diary* (detail), 2003

144 Jimmie A. Duncan, U.S. Army Photograph Agency, *Anti-Vietnam Demonstration* [Cameramen, still and motion picture, document the anti-Vietnam demonstration at the Pentagon], 1967

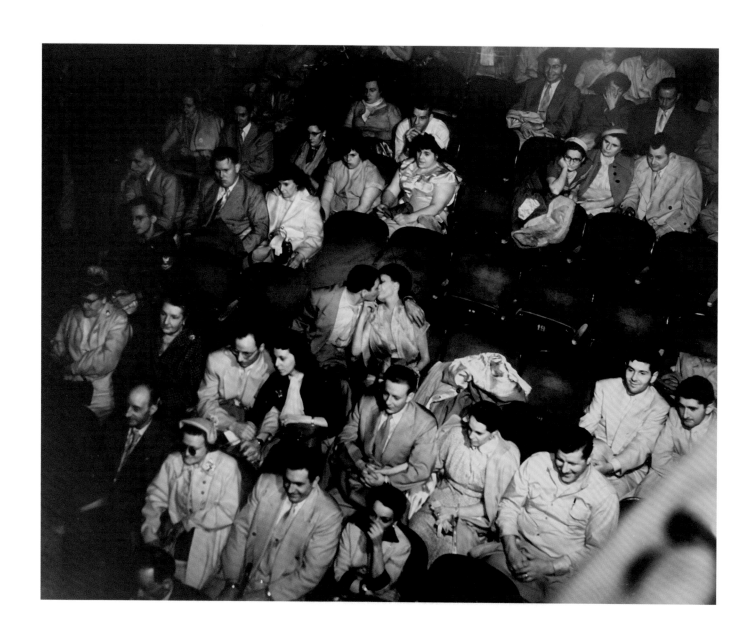

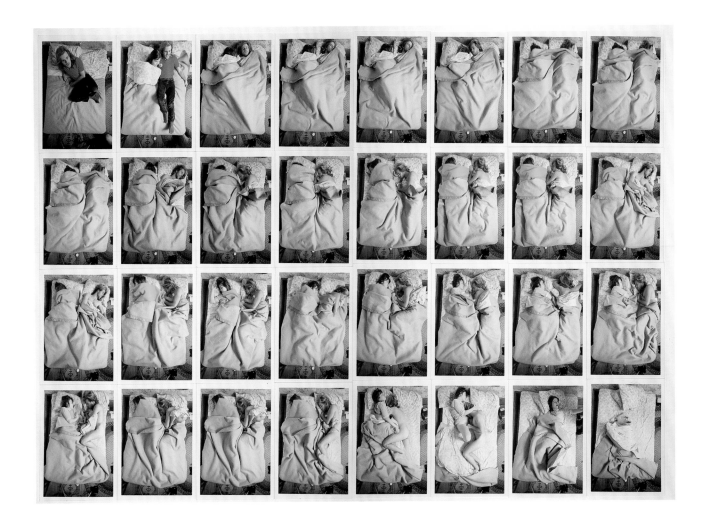

145 Weegee (Arthur H. Fellig), *Lovers at the Movies*, ca. 1940

146 Ted Spagna, *Untitled*, from the series *Sleep / People*, ca. 1980

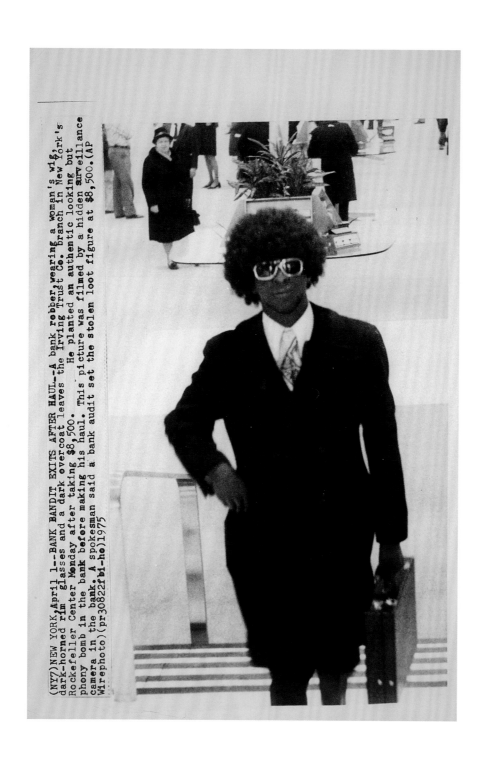

(NY8)NEW YORK,April 1.—BANK BANDIT EXITS AFTER HAUL.—A bank robber,wearing a woman's wig, dark-horned rim glasses and a dark overcoat leaves the Irving Trust Co. Branch in New York's Rockefeller Center Monday after taking $8,500. He planted an authentic looking but phony bomb in the bank before making his haul. This picture was filmed by a hidden surveillance camera in the bank. A spokesman said a bank audit set the stolen loot figure at $8,500.(AP Wirephoto)(pr30822fw1-ho)1975

147 Associated Press, *New York—Bank Bandit Exits After Haul*, 1975

148 Yale Joel, *[Man adjusting overcoat and grimacing while looking in trick one-way mirror, in lobby of Broadway movie theater, Times Square, New York]*, 1946

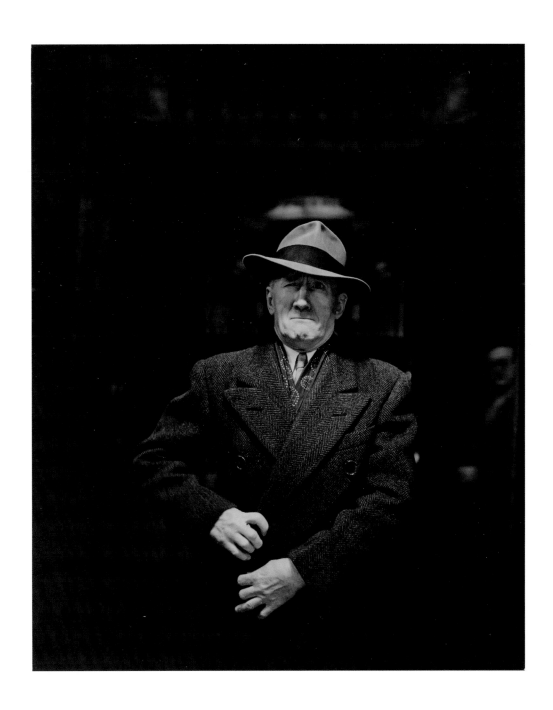

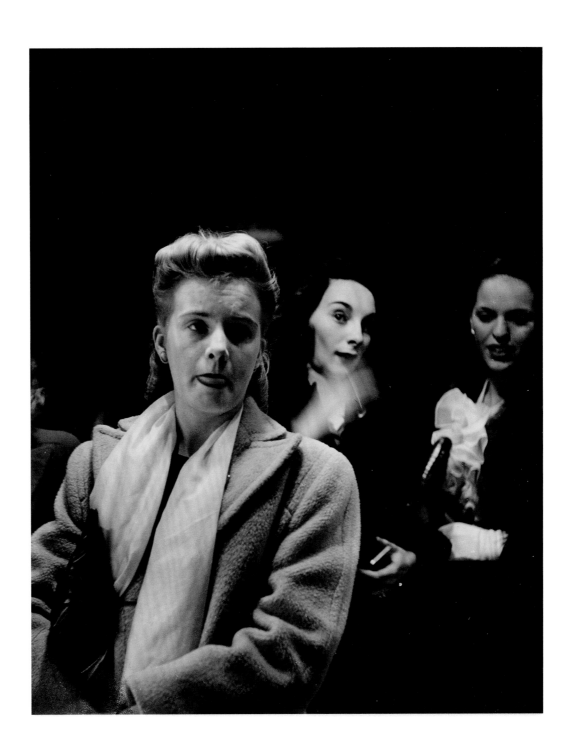

149 Laurie Long, *Compact*, from *The Dating Surveillance Project*, 1998

150 Yale Joel, *[Woman moistening her lips, as others are checking out their own profiles, while looking in trick one-way mirror, in lobby of Broadway movie theater, Times Square, New York]*, 1946

151 John Gossage, *Untitled*, from *There and Gone* [Cover], 1996

152 Mark Ruwedel, *Crossing #14*, 2005

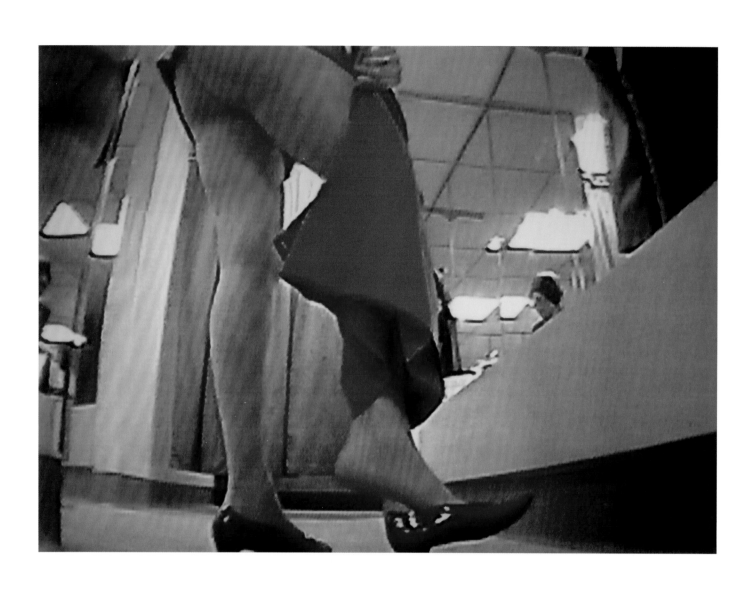

153 Merry Alpern, *Shopping #16*, 1999

154 Sophie Calle, *Room 25*, from the series *The Hotel*, 1981

ROOM 25

Monday February 16, 1981. 9a.m. I go into room 25. The only room on the floor with a single bed, and the first one I enter. The sight of the crumpled navy pyjamas with the light blue piping left on the bed, and the brown leather slippers does something to me. The occupant is a man. There are a few clues by the wash-basin: a dirty comb with missing teeth, a toothbrush, toothpaste, and Mennen deodorant. On the table: the Times, the Herald Tribune, and a book, The Moon and Sixpence, by Somerset Maugham, with a marker at page 198. On the windowsill outside are apples and oranges in two paper bags. On the night table I find a hardcover notebook, his travel log. I go through it. "Friday: Rome... Tuesday: Florence..." and under yesterday's date, these lines: "...arrived in Venice this morning... up to my room, had a bath, a couple of oranges + apples + will crash. I have told the desk to wake me up at 8:30 + will go to the market which Rob says is ex". I also find two Paris addresses: Count and Countess M., and Ambassador O. I stop reading. I don't want to take it all in today. I make the bed and leave. It is 9:15 a.m.

Tuesday 17. 9:30a.m. Today I open the closet. Few clothes. But good quality ones: tweeds, woolens...subdued colors: grey, navy, brown. A pair of large white underpants lines the bottom of the drawer. In a corner of the closet, a nearly empty toilet kit: it contains some nightcream for pimples, needles and thread inside a lipstick case—I see there is no razor—and a list of the clothes he is traveling with. That tells me that today he is wearing blue trousers, a blue tee-shirt and a windbreaker. I clean the room, and start to read his diary. His handwriting is poor, heavy, irregular. I reread his remarks about Venice: "Sunday 15. We arrived in Venice this morning. We took the train. It is really spectacular. No cars, just pretty little streets and small bridges over the canals. We sat outside and had drinks of various strange things. We went back to the hotel. I am in a tiny room by myself. Ran out and bought a kilo of oranges and apples and put them on my windowsill. We went out and had a very good walk. I ate a good soup, noodles in tomato sauce and drank a lot of white wine. Went to Plaza San Marco, had a grappa. Made me feel not too good. Went back to Hotel C. Some went to sleep. Rob + I went strolling. Stayed at a bar + had a beer. Came back. Rob went up. Got a postcard from the desk + went to hotel bar + had a beer + cig. + wrote a long postcard to Ol. Up to my room, had a bath, a couple of oranges + apples + will crash. I have told the desk to wake me up at 8:30...". Sounds in the hallway. I close the diary. As I put it down, someone enters the room. I pick up my rags, my bucket (where my camera and tape recorder are hidden), lower my gaze and leave. He is dressed the way I thought he was, about 28, with a weak face. I will try to forget him.

Wednesday 18. 9:40a.m. He has finished the apples and oranges. The wastebasket is full of peels. He's still on page 198 of S. Maugham's book. Nothing has changed in the room. So I have a look inside the bag of dirty laundry hanging on the door, and empty it on the bed. I go back to the diary. Nothing for the 16th, but for the 17th there are these lines: "Yesterday I walked around. Went to restaurant. Had excellent lasagna. Today we went and had a lunch at Harry's Bar which is supposed to be the best restaurant in the world. And it was good. I had good green noodles with excellent sauce. In the afternoon, went to see Steve McQueen in Italian. I had a beer in a square. Then some guy tried to pick me up. I think I will have a bad dream about it tonight." And that's it. I also find a postcard addressed to someone named Olivier R. (no address). In it the occupant of room 25 describes in detail the menu of his latest meal.

Thursday 19. Noon. He is gone. He has left his orange peels in the wastebasket, three fresh eggs on the windowsill, and the remains of a croissant which I polish off. I shall miss him.

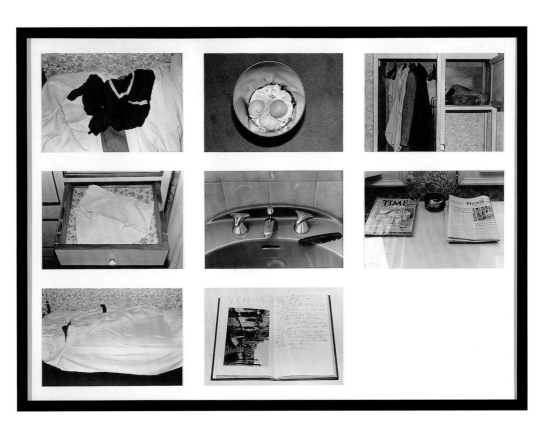

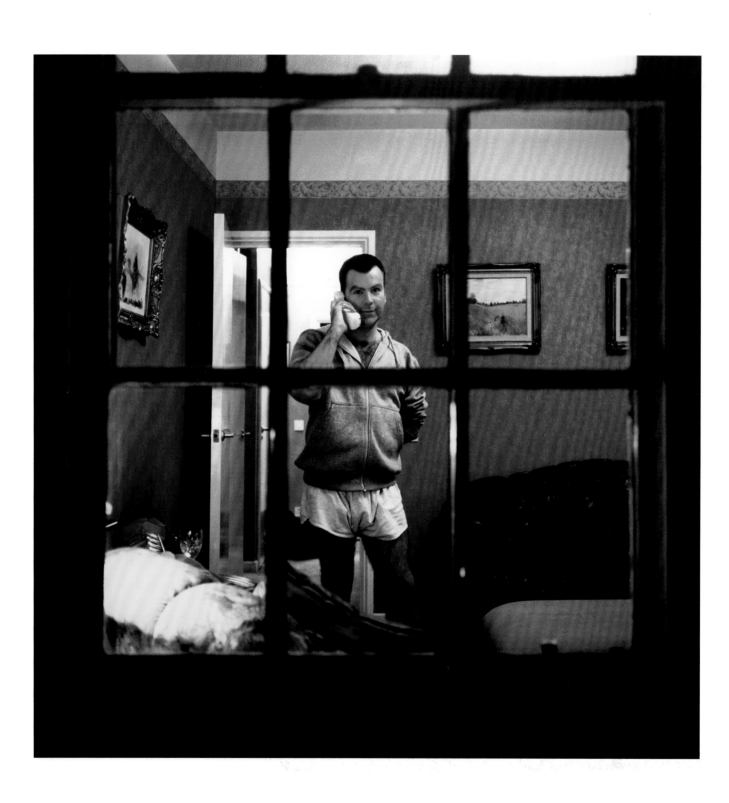

155 Shizuka Yokomizo, *Stranger No. 1*, 1998
156 Shizuka Yokomizo, *Stranger No. 2*, 1999

157 Alair Gomes, *Beach Triptych no. 7*, ca. 1980

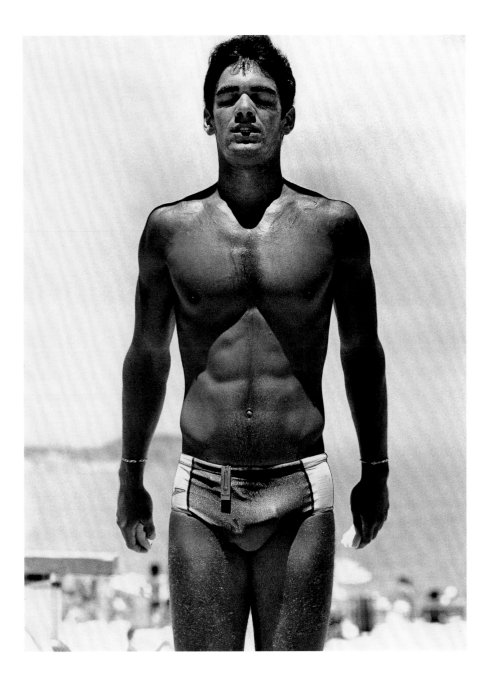

158 Mitch Epstein, *Untitled, New York #22, 1997*, from the series *The City*, 1997

159 Barbara Probst, *Exposure #11A: N.Y.C., Duane & Church Streets, 06.10.02, 3:07 p.m.*, 2002

160 Harun Farocki, *Eye/Machine II* (video still), 2002

161 Michael Klier, *Der Riese* (The Giant) (video still), 1982–83

162 Jordan Crandall, *Drive, Track 3* (video stills), 2000

163 Bruce Nauman, *OFFICE EDIT I (Fat Chance John Cage) Mapping the Studio* (video still), 2001

164 Richard Gordon, *San Francisco,* 2004

165 Marie Sester, ACCESS (installation view at Ars Electronica, Linz, Austria), 2003

UP PERISCOPE!
PHOTOGRAPHY AND THE
SURREPTITIOUS IMAGE

SIMON BAKER

Two of the very earliest images ever successfully captured with a camera, fixed on shiny metal plates by the French artist and entrepreneur Louis-Jacques-Mandé Daguerre, were views of the Boulevard du Temple in Paris. Daguerre included these tiny, precious, precise, and unique pictures as part of an elaborate triptych, presented to King Ludwig I of Bavaria in 1839 as proof of the invention of the daguerreotype.[1] Both pictures were taken from above, through an open window in Daguerre's house. The picture on the left-hand side of the triptych is a view showing the street below strangely emptied of life. However, this is neither an image of a deserted dawn or dusk nor a fleeting snapshot of a brief moment of calm; with photographic technology in its infancy, Daguerre would have needed bright sunlight and plenty of time to capture an image. In other words, when we look at this peculiarly empty street we do not see what Daguerre saw from his window, unnoticed by the Parisians below. The second version of the same scene helps to clarify this fact, for in the right-hand picture on the triptych we see the same street, slightly closer this time (Daguerre presumably having increased the power of the lens) and likewise almost deserted—but now only *almost* deserted [fig. 3]. In the lower left of the frame, on the broad pavement beside a large house, is a recognizable human figure: a man having his boots polished. As an early viewer of Daguerre's work pointed out, "his feet were compelled, of course, to be stationary for some time, one being on the box of the boot-black and the other on the ground."[2] To register on the daguerreotype, anyone in the street would have had to be stationary for a significant portion of the lengthy exposure time: just enough time, as it turns out, to have your shoes polished in 1830s Paris.

At the moment of the birth of photography in France, then, the practice was inaugurated—even celebrated, in the quasi-religious form of a triptych—with a surreptitiously made image. Given that when Daguerre produced this picture very few Parisians would have been aware that they could be (let alone would be) photographed, the man in the street is hardly likely to have known that his picture was being, in a very real sense, "taken." But today, with closed-circuit television (CCTV) cameras a fact of everyday life in many parts of the urban, developed world, this surreptitious looking continues, thrives in fact, with the critical difference that nowadays we *all* register on camera whether we like it or not. This intrusive technology, which we are often told will help to keep us safe, rarely registers as obviously and as directly to us as we do to it. The politics of surveillance is bound up with these acts of covert looking: no longer are cameras as rare and exceptional as in Daguerre's day, but neither are they as obviously visible as they are ubiquitous. It is highly unusual, as Jonathan Olley's striking photographs of security installations in Northern Ireland make clear, for surveillance to be rendered physically manifest—to embody, as it were, the seismic shift that it has introduced into social, political, and ethical conventions [pl. 135]. Olley's characterization of his subject matter as *Castles of Ulster* deliberately evokes a medieval context, where the construction of huge, dominant, impenetrable structures enabled the oversight (and oppression) of one section of the population by another. Today, however, acts of surveillance more often form an imperceptible backdrop to life, as invisible and as seemingly inconsequential as Daguerre's missing Parisian crowds.

Between these two photographic bookends, the origins of photography in Paris and the practice of a contemporary photographer such as Olley, there is a long and complex history of clandestine image making within which photographers working in urban environments have been forced to think carefully and strategically about their relationship to

OPPOSITE

FIGURE 3. Louis-Jacques-Mandé Daguerre, *Huit heures du matin* (Boulevard du Temple, at eight o'clock in the morning), ca. 1838. Daguerreotype, 8 1/2 x 6 1/2 in. (21.5 x 16.5 cm). Bayerisches National-museum, Munich

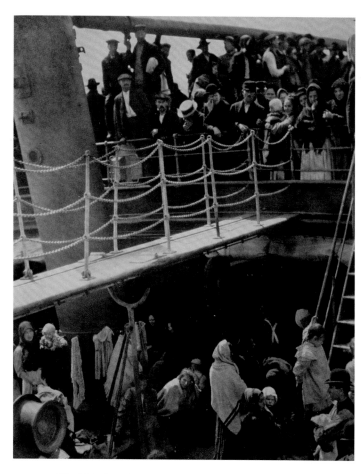

FIGURE 4. Alfred Stieglitz, *The Steerage*, 1907. Photogravure print, 12 11/16 x 10 3/16 in. (32.2 x 25.8 cm). George Eastman House, 1974

these two well-known contemporaries, one a Frenchman self-deprecating to the point of gnomic mystery, the other a confident champion of the new art of photography on the American East Coast, there are some revealing differences and contradictions. Atget appears to have been less interested in what we would now describe as the aesthetic characteristics of his photographs than in the aim and use of his pictures, "for artists."[4] He famously described examples of his work to Man Ray, in one of his few recorded statements, as "simply documents I make."[5] Stieglitz, on the other hand, was very much interested in the formal properties of his photographs: their composition, the effects of light and shadow, and the power of these qualities to communicate emotional states. Writing about precisely these issues (albeit with the benefit of hindsight) in a short essay called "How *The Steerage* Happened," Stieglitz said: "A round straw hat, the funnel leaning left, the stairway leaning right, the white draw-bridge with its railings made of circular chains. . . . Could I photograph what I felt, looking and looking, and still looking? I saw shapes related to each other. I saw a picture of shapes and underlying that the feeling I had about life."[6]

Like Atget photographing door frames, but for very different reasons, Stieglitz describes a strangely disconnected, even purposefully obtuse attitude to the people that would populate his finished work. Where for Atget the blurry half-presence of passing figures was simply irrelevant to the photographer's immediate aim, for Stieglitz it was vital that the subjects of his photograph conform to his view of the world and take their places within it. He described how he raced back to the scene with his camera, "wondering whether the man with the straw hat had moved or not. If he had, the picture I had seen would no longer be. The relationships of shapes as I wanted them would have been disturbed and lost."[7]

The history of surreptitious photography is fraught with these kinds of problems, which are both aesthetic and ethical in nature: for things to look "natural" in the way a photographer sees them, the subjects of a picture must either be or seem unaware of his or her presence. For Stieglitz, leaning down from above like Daguerre from his Paris window, this was easy. But for Atget, out on the street, the presence of its more distracting and distracted characters could be hard to avoid,

their subjects, as cameras have become an ever more present feature of metropolitan life. Within the canonical history of photography as it is usually understood, some of the most important and celebrated photographers have engaged processes that either deliberately or inadvertently result in capturing their subjects without their knowledge, or in unguarded moments. We might think, for example, of the ghostly traces of people passing through the Parisian photographs of Eugène Atget, spectral figures left in the frame as the photographer sought to document fine architectural details or shop-window displays. Or that most iconic of photographs, Alfred Stieglitz's *The Steerage* of 1907, in which the well-heeled photographer points his camera down from the luxurious upper decks of an ocean liner onto the crowded "economy-class" passengers in the steerage section below—stealing from the assembled, oblivious crowd what he later claimed as a "milestone in photography" [fig. 4].[3] Between

FIGURES 5–7. Ilya Ehrenburg, *My Paris* (Moscow: IZOGIZ, 1933). Left to right: cover, photomontage and design by El Lissitzky; frontispiece, photomontage and design by El Lissitzky; *Paul and Virginia*, page 203

to the point that for his topographical and architectural albums he frequently toured the city at the crack of dawn, with the streets at their very emptiest, that is to say, when they most resembled Daguerre's lifeless Boulevard du Temple. In Atget's photography, then, as for Daguerre in that early instance, the citizens of Paris were visible only when they took their time while the photographer took his picture.

If Atget and Stieglitz represent two very different attitudes to photography, they also herald different traditions of natural, candid, apparently unposed photography that can be traced, even as they weave about one another, from the end of the nineteenth century to the dawn of the twenty-first. In this essay I attempt to understand these competing practices through projects conceived and authored by photographers themselves, within which they explain in their own ways (or in their own words, like Stieglitz) how and why they took their pictures.

We start with two distinctly different photobooks made in urban centers, both of which have, as statements of intent, cover images that suggest how their authors worked: Ilya Ehrenburg's *My Paris* [fig. 5] and Bill Brandt's *Camera in London* [fig. 8].[8] *My Paris*, published in Moscow in 1933 by a Russian communist writer who had been based in Paris for many years, is open and honest from the outset, with Ehrenburg on its cover using a camera with a lateral (sideways) viewfinder. This means that as the author and photographer stands facing the left-hand side of the book cover, his camera lens is actually facing the viewer. A brilliant frontispiece, designed by El Lissitzky, explains why this is so, turning a monumental image of Paris (a postcard of

a war memorial) upside down to reveal the flip side of this conventional view of the city: a disabled (legless) man, a war veteran perhaps, slumped on a park bench, photographed by Ehrenburg without his knowing [fig. 6]. On the page opposite we see Ehrenburg again, still with his lateral viewfinder, but this time in an El Lissitzky montage that links his use of this special vision to his hand on the keys of a typewriter—the second string of the author's technological bow. Chapter one of *My Paris* is called "The Lateral Viewfinder" and begins with a close-up of the camera itself, and the following words (which are worth quoting at length):

> A writer knows that to see people, he must remain unseen. The world changes when you stare straight at it: cowards become heroes, and heroes puppets. This second world can be studied in the shop window of any provincial photographer: the frozen pupils, the feelings combed back like hair, and that undemanding game which none can resist. . . . But what's one to do with a camera? A camera is clumsy and crude. It meddles insolently in other people's affairs. The lens scatters a crowd like the barrel of a gun.[9]

Having described the problem, the facade produced by posing, Ehrenburg is then up front about both his solution and its implications:

> For many months I roamed Paris with a little camera. People would sometimes wonder: why was I taking pictures of a fence or a road? They didn't know that I was taking pictures of them. Now and then, those in front of me would turn away or smarten themselves up:

they thought they were being photographed. But I was photographing others: those to the side. . . . It's an exceptionally cunning device. It bears the affectionate name, Leica. The Leica has a lateral viewfinder. It's constructed like a periscope. I was photographing at 90 degrees.

I can talk about this without blushing; a writer has his own notions of honesty. Our entire life is spent peeping into windows and listening at the keyhole—that's our craft.[10]

Predictably perhaps, given his explicit desire to overturn touristic conventions, the Paris that Ehrenburg sees in this way, "his Paris," is predominantly one of banality, poverty, age, and destitution. His subjects, given in the headings of his chapters, are typically Parisian street subjects, albeit in a down-at-heel sort of way: concierges, street benches (often with people sleeping rough on them), old women, workers, the homeless, pissoirs, hawkers, drunkards, and flea markets. And while, admittedly, he includes some subject matter with more romantic potential, such as art, lovers, flowers, fairs, dance halls, and dreaming women, even "Paul and Virginia" (a sly reference to the characters of a famous novel) are stripped of their sentimental potential, framed by graffiti, and set alongside one of the ubiquitous, indolent men that Ehrenburg catches everywhere in the crosshairs of his "periscope" [fig. 7].[11] Unsurprisingly, Ehrenburg's commentary is equally caustic: in a thinly veiled dig at Surrealists like André Breton, who prized the chaotic potential of flea markets, he describes them as places where "snobs" meet, and captions his sneakily obtained and unflattering photograph of a genuine flea market customer, "Poke around! You'll find some wonderful boots . . ."[12]

In Ehrenburg's hands—as with now-better-known exponents of the lateral viewfinder such as Walker Evans and Ben Shahn—the surreptitious ninety-degree gaze was a way of reaching and recording a deep social truth, looking into the heart of a city that beat behind its well-ordered parks, shop windows, and even the "feelings combed back like hair"[13] of its inhabitants. With its author committed to an abrasive and unsentimental view of the decadent and iniquitous capital of Western Europe framed by both the radical revolutionary politics of the Soviet Union and an awareness of its human cost, Ehrenburg's Paris had simply to be unmasked, photographed without her makeup.

His was not the only account of this subject to render it in this way; when the Swiss photographer Robert Frank photographed Paris in the aftermath of World War II, he too sought to capture the face that it usually turned away from the tourist's gaze (although without the benefit of a lateral viewfinder). Frank, it should be noted, did not publish these images in book form at the time, but would go on, in their wake, to produce arguably the most significant (French) photobook of his era with his 1958 work *Les Américains*, or *The Americans*, as we now know it, completing the shift from an account of place to one of the people that inhabit it.[14]

Back in Europe in 1948, the German-born but London-based photographer Bill Brandt published his own vision of the city he had lived in for many years under the title *Camera in London*. Like Ehrenburg, Brandt occupies the cover of his book, the tool of his trade in hand: a determined, perceptive, but perhaps slightly aloof figure, pointing his much larger and more conspicuous camera down across a montage of London rooftops and facades. According to the conventions of the time, and the *Masters of the Camera* series in which he published, Brandt lists his equipment precisely, specifying both cameras and lenses, as well as recording the exposure and lighting conditions for each image.[15] This information is fascinating, in that it enables us to identify some of the operational features of Brandt's practice. Knowing, for example, how few of the images in the book are the result of telephoto lenses (only three) means that in every other case we can assume Brandt to have been relatively close to his subjects, even in apparently intrusive circumstances.

The "apparently" here is very much at issue in the production of the photographs, for Brandt was notorious for his skill in setting up and posing what appear to the viewer to be entirely spontaneous and "natural" scenes. What is most remarkable about *Camera in London*, however, beyond its value as a record of London in the 1930s and 1940s, and the evident quality of Brandt's work, is the commentary provided within the book on exactly how Brandt made pictures with titles like *Making it up* or *Having it out*, photographs that appear to show candid and intimate scenes but were in fact often carefully staged, almost cinematic *mises-en-scenes*: *Having it out* [fig. 9], for example, previously captioned "Street Scene" in Brandt's 1938 book *A Night in London*,

 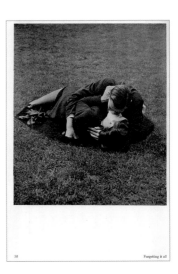

FIGURES 8–10. Bill Brandt, *Camera in London* (London: The Focal Press, 1948). Left to right: cover; *Having it out*, page 57; *Forgetting it all*, page 58

is now known as "Ester and Rolf Brandt," in acknowledgment of the fact that the models were, in fact, the photographer's sister-in-law and brother.[16] Where Ehrenburg resorted to the underhanded and misleading use of the lateral viewfinder, Brandt produced the effect of images surreptitiously taken, but with no attempt to mislead or deceive the subjects, the better to convince his *viewers*. What is more, Brandt switched between naturalism and stagecraft without missing a beat, captioning and situating his works as though they were interchangeably authentic. In relation to an openly voyeuristic (and quite likely staged) photograph of a passionate horizontal embrace, the commentary suggests that "Of course Bill Brandt asked the couple in *Forgetting it all* if they objected to his photographing them as they were. They did not object. Maybe he did not seem very real to them at the moment. Maybe they felt that his presence and his job made the occasion more legitimate"[17] [fig. 10].

The comparison between the kinds of intimacy recorded by Ehrenburg and by Brandt—between practices involving misleading or surreptitious scrutiny and consciously given or tacit consent—takes on contemporary relevance when it is transposed onto the work of photographers working today in an increasingly self-conscious and self-reflexive context. The somewhat outdated language used to describe and excuse Brandt's illusions of intrusive activity, the means by which he got exactly the image he wanted, is redolent of the language of manners and propriety that we associate with the 1940s and 1950s: "Of course" Brandt asked the couple if he could photograph them, and of course "they did

not object." But the apparent result of this negotiation, this waving of the conventional boundaries of privacy to produce an image of unselfconscious abandon in 1948, could easily be used to describe scenes from Nan Goldin's more complex and brutally honest *The Ballad of Sexual Dependency*, begun in 1976 [pl. 64]. Maybe Goldin too "did not seem very real" to her subjects at the moments that she took their pictures, and maybe they too felt that her presence legitimized their acts in some way. Her work, after all, speaks to a level of intimacy that transcends the social conventions and consequent intrusions of Ehrenburg's *My Paris* or even Brandt's *Camera in London*, yet it offers something very much like, or equivalent to, *her* New York in the years that the work was made.

Goldin's *Ballad*, taken as a whole, offers a master class in rendering the photographer's agency unreal through the collapse of the boundaries usually associated with intimacy and voyeurism. This, it might be argued, is achieved over time by way of the spectator's developing relationship to the subject—from a position of uneasy intrusion to a more conspiratorial and collusive engagement. By making photobooks, both Ehrenburg and Brandt aimed to give a cumulative view of the cities they photographed, an overall sense of both the things they saw and the way they saw them. Ehrenburg, for example, seems as keen to disabuse his readers of the notion that Paris is a city for lovers as Brandt is to cast London in its place. It is through the process of turning the pages, reading the captions, and then drawing connections and analogies from photographs grouped together that these publications work.[18] It is no surprise, then, that

Goldin, despite being engaged in a process aligned more closely with portraiture than documentary, conceived *The Ballad of Sexual Dependency* in a similar way, publishing it in 1986 as an artist's book.[19] In the gallery, however, the dramatic and theatrical installation of the work as a cinematic slide show amplifies and complicates the effect of accumulated detail, with the soundtrack substituting for captions in suggesting thematic connections or interpretative perspectives. Where Ehrenburg collated and captioned "dreaming women" or Brandt "the kids" of London, Goldin presents images of self-reflection beneath the sounds of the Velvet Underground's "I'll Be Your Mirror" and assembles brutal injuries (including her own) under The Crystals' "He Hit Me (and It Felt Like a Kiss)."

The Ballad of Sexual Dependency is a tough and graphic work, documenting intimate relationships both within and around a consistent group of friends. It works because we see the same people repeatedly, in different positions, contexts, and activities (some of which we might identify with, and some not): bathing, dressing, laughing, partying, taking drugs, making love, or experiencing moments of solitude or thoughtful repose. These recurring characters evidently have close bonds with one another; they seem bound together in Goldin's work (whether book or slide show), not only by the variety of situations in which we see them, but by the concept of sexual dependency, the title offered as an overall frame for the various ways in which they are depicted. But the spectators of the work are cast in a difficult position nonetheless: can we, as Ehrenburg put it, "talk without blushing"[20] about this material, in the way that Goldin is able to do so eloquently? This moral and ethical dimension of viewing the photographs is complicated, rather than resolved, by Goldin's familiarity with and access to her subjects: they seem, absolutely in some cases, to have forgotten or internalized the presence of the photographer in their most intimate activities and private moments. Perhaps her success in making the work lies in having ceased to appear real to her subjects, as Brandt could only claim to have done for the embracing lovers in *Forgetting it all*. It is easy for spectators of *The Ballad of Sexual Dependency*, as the slides follow one another and the music plays, to forget that Goldin was there at all.

There is a key issue, then, regarding the nature of surreptitious photography that reverberates from Daguerre, to Stieglitz, to Ehrenburg, to Brandt, and on to Goldin. The fact that the photographer (like Brandt or Goldin) has the subject's consent or permission—that they have entered into some kind of agreement resulting in a knowing presentation of candid or natural activity (therefore, a kind of performance)—does not necessarily mean that the resulting representation of intimacy will be any easier for the viewer to accept. On the contrary, it might be that we prefer to turn away from this "second world" of appearances as Ehrenburg did, and look, surreptitiously, through a lens that remains unseen.

This complicated relationship between the comfort afforded intrusive spectatorship and its effect on the depicted subject also lay at the heart of the landmark legal case that followed the exhibition of an important series of works titled *Heads*, made in 2001 by another New York–based photographer, Philip-Lorca diCorcia. The trial, which reached the New York State Supreme Court, concerned a man named Erno Nussenzweig, and more specifically, diCorcia's First Amendment right to exhibit a photograph of Nussenzweig that had been taken without his knowledge (diCorcia prevailed).[21] If Nan Goldin produces the appearance of surreptitious intimacy through genuine familiarity with her subjects—obtaining their trust and their permission to take Brandt's ethical position further in the direction of portraiture—diCorcia does the same with Ehrenburg's strategy of overt duplicity. In an almost direct rethinking of the Soviet writer's complaint in the 1930s that "the lens scatters a crowd like the barrel of a gun," diCorcia works with a complex system of zoom lenses, multiple flashes, and remote triggers to produce what he first described as *Streetwork* in the late 1990s, and which culminated in 2001 with *Heads* [pl. 32].

In both cases, diCorcia worked by carefully staking out a chosen site and planting his zoom-lens camera and a series of powerful, carefully directed flashes in such a way that he could take the picture without being detected by his subjects.[22] For *Streetwork*, diCorcia framed a view of the city street, but isolated specific passersby by triggering a focused burst of flash, so that the chosen individual literally "stood out" from the crowd. Essentially, diCorcia worked like a hunter in a hide or lair, waiting for his prey to appear directly in the crosshairs of his sight. Where

Ehrenburg moved around Paris to catch his subjects unawares, diCorcia stayed put, letting his targets stroll in blissful ignorance, right into the center of the frame.[23] The effect is perhaps more remarkable in *Heads*, however, as all obvious signs of the urban context (buildings, shop fronts, and sky) have been obliterated. *Streetwork* singled out walking figures, but in *Heads* diCorcia focused solely on their faces, picking them out with a powerful spotlight flash that leaves the surrounding space strikingly dark (almost night-like) by contrast. The resulting photographs are alluring but disturbing, as one might expect from what are essentially completely candid and natural portraits of individuals who were utterly oblivious (and perhaps would have been resistant) during the process of their making. As the ensuing court case underlined, these pictures were very deliberately "taken" by diCorcia. If Goldin offers us an uncomfortably intimate vision of people that she knows well, but that we do not, diCorcia offers instead unblinking insight into the unguarded, distracted faces of total strangers, capturing moments of absolute, impenetrable introspection onto which we can only project our own assumptions.

DiCorcia's work, perhaps unsurprisingly, has been discussed in relation to Charles Baudelaire's poem "À une passante" (To a Passerby) of 1857, in which the writer singles out a beautiful grieving woman in a crowd as the focus of his desire.[24] But while the logic of picking a face from the throng remains apposite, the sensitivities of the people doing the looking are clearly very different. Baudelaire's romantic gaze is driven by a longing for emotional engagement, while diCorcia exploits and reflects the impossible riddle of voyeuristic looking: the fact that, as Ehrenburg put it, the world changes when you stare at it. At their most striking and most powerful, then, diCorcia's *Heads* relate not to the poetic vision of Baudelaire, but to a more equivocal, alienated, and ambiguous form of spectatorship. Alongside Baudelaire we might place a second touchstone for diCorcia's practice in nineteenth-century Paris: the daguerreotype of the Boulevard du Temple with which we started. For despite the 160 years separating diCorcia and Daguerre, the two photographers offer us the same awkward but privileged view of the world: melting through the city crowd as though it didn't exist, so that we too can look, without blushing, at the man on the street.

1 For more on this process with a reproduction of the triptych, see Quentin Bajac, *The Invention of Photography* (London: Thames and Hudson, 2002), 24–25.

2 Samuel Morse, cited in ibid., 24.

3 Alfred Stieglitz, "How *The Steerage* Happened," in *Stieglitz on Photography: His selected essays and notes*, compiled and annotated by Richard Whelan (New York: Aperture, 2000), 195.

4 Atget's business card or *carte-de-visite* listing his services *pour artistes* is reproduced in Molly Nesbit, *Atget's Seven Albums* (New Haven, CT: Yale University Press, 1992), 21.

5 Ibid., 1.

6 Stieglitz, "How *The Steerage* Happened," 194–95.

7 Ibid., 195.

8 *My Paris*, text and photographs by Ilya Ehrenburg, photomontage and design by El Lissitzky (Moscow: IZOGIZ, 1933). The facsimile edition (Paris: 7L / Gottinghen, Germany: Steidl, 2005) contains a full English translation of the text by Oliver Ready. Bill Brandt, *Camera in London*, with commentary by Norah Wilson, from the series *Masters of the Camera*, ed. A. Kraszna-Krausz (London: Focal Press, 1948).

9 Ehrenburg, *My Paris*, 2.

10 Ibid., 2.

11 Ibid., 203. The reference is to *Paul et Virginie* (or *Paul and Virginia*) by the eighteenth-century writer Jacques-Henri Bernardin de Saint-Pierre, an interesting choice for Ehrenburg, as the novel contains a description of a society based on the equal division of labor and resources.

12 Ibid., 19.

13 Ibid., 2.

14 See Ute Eskildsen, *Robert Frank: Paris* (Gottinghen, Germany: Steidl, 2008) and Robert Frank, *The Americans* (Gottinghen, Germany: Steidl, 2008), first published as *Les Américains* (Paris: Robert Delpire, 1958).

15 An Automatic Rolleiflex (1.5cm. Tessar f.3.), or where a telephoto lens was needed a Reflex-Korelle camera (with a 6-inch Dallon Tele-Anastigmat f.5.6. lens or a 25cm Tele Tessar). Brandt, *Camera in London*, 89.

16 Brandt, *Camera in London*, 56–57. See also Paul Delany, *Bill Brandt: A Life* (London: Janathan Cape, 2004), 119–31.

17 Ibid., 44.

18 The history of the photobook and its relation to contemporary practice are clearest perhaps in the collection and work of the British photographer Martin Parr. See Martin Parr and Gerry Badger, eds., *The Photobook: A History*, 2 vols. (London: Phaidon, 2004–6).

19 Nan Goldin, *The Ballad of Sexual Dependency* (New York: Aperture, 1986).

20 Ehrenburg, *My Paris*, 2.

21 For more on diCorcia and this case, see Bennett Simpson, *Philip-Lorca diCorcia* (Boston: Institute of Contemporary Art / Gottingham, Germany: Steidl, 2007).

22 Ibid., 19–25.

23 I am grateful to Philip-Lorca diCorcia for confirming the process by which these images were obtained—with, as he puts it, "no collusion."

24 Bennett Simpson makes this connection, and qualifies it, as I have done here, in the essay "Philip-Lorca diCorcia: The Exploded View," in *Philip-Lorca diCorcia*, 20.

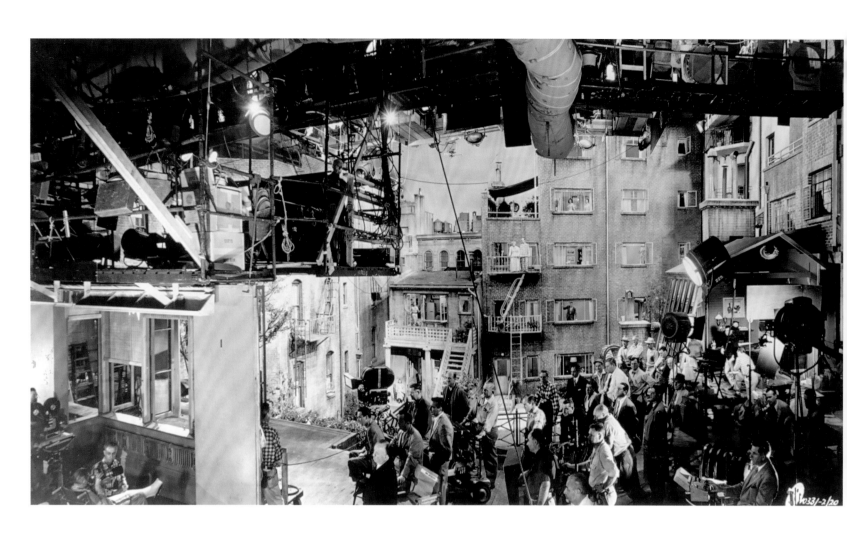

A WINDOW ON THE WORLD
STREET PHOTOGRAPHY AND THE THEATER OF LIFE

PHILIP BROOKMAN

We've become a race of peeping toms. What people ought to do is get outside their own house and look in for a change. Yes sir. How's that for a bit of homespun philosophy?
—STELLA TO L. B. JEFFRIES IN *REAR WINDOW*[1]

The eponymous window in Alfred Hitchcock's brilliant 1954 film acts as a transparent barrier between truth and fiction, between the theater of life outside the home and a photographer's vivid imagination. In *Rear Window*, the protagonist is a photographer who is both entertained and hypnotized by other people's problems; he is both a voyeur of and a participant in the emotional relationships that unfold before his eyes. Hitchcock's film provides an apt window through which to view the complex and fragmented conceptual connections between street photography during the Cold War years of the 1950s and the voyeuristic outlook of the period. In the decades following World War II—fueled by fear of known and unknown political enemies—spying was common around the world. It became a tremendously popular subject for filmmakers and photographers of the era.

James Stewart's character, L. B. Jeffries, is stranded inside his apartment and spends his days (and nights) looking out the back window onto a courtyard bounded by neighboring buildings [fig. 11]. A plaster cast encases his leg after he broke it while shooting too close to the action of a car race; unable to leave his room, he is cared for by a visiting nurse, Stella (Thelma Ritter), and his beautiful but unadventurous girlfriend, Lisa (Grace Kelly). Played cool and composed by Stewart, Jeffries is a mixture of Robert Capa and Weegee, a globe-trotting photojournalist who lives out of a suitcase, always on the prowl for the next big news. Now, the window that allows his only access to the action outside his home also separates him from it, imprisons

him, framing and mediating his point of view until, climactically, he is literally thrown through it when the truth he is seeking finally is revealed.

When the film opens, Jeffries is watching through binoculars as a woman wearing a bathing suit dances in her kitchen, as if in a peep show. Soon, however, he is caught up in issues played out across a stage incorporating many lives and private spaces. At the same time, Jeffries is trying to come to grips with his relationship with Lisa, who wants him to settle down and get married. In order to sublimate his inability to forge a lasting relationship in his own life, the photographer looks in on everyone else's [fig. 12]. He conjures their roles in a theatrical way, creating stories in his mind from within the context of his own life-drama. But things are happening on the outside that propel him to act: he construes that one of his neighbors, Lars Thorwald, has committed a grisly murder. Still, the evidence doesn't all add up. Here we enter Jeffries's personal world and get caught up in his observations; we become engaged as voyeurs alongside the film's characters, even as we are watching them watch their neighbors.

As the mystery compounds and Jeffries steps up his surveillance, he stops to question his own motives: "I wonder if it's ethical to watch a man with binoculars and a long-focus lens. Do you suppose it's ethical even if you prove he didn't commit a crime? . . . Of course, they can do the same thing to me—watch me like a bug under glass if they want to." He then uses a sequence of before-and-after photographs of a plant in the suspect's

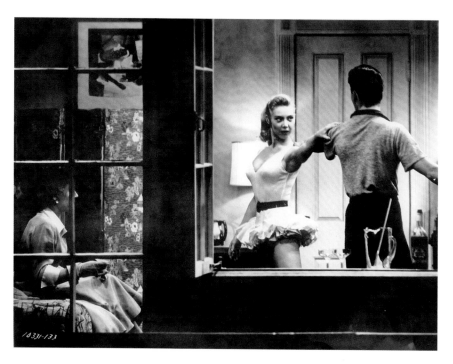

FIGURE 12. *Rear Window* (Alfred Hitchcock, 1954), publicity still. Universal Pictures

garden to prove that something really is amiss. Only when Lisa goes out on the street to enter the apartment across the courtyard in an attempt to recover hard evidence does Jeffries fully acknowledge his emotional attachment to her. Now they are both in real danger.

Rear Window is all about the relationship between the spectator and the image, the viewer and the viewed. Hitchcock uses a classic cinematic structure—over and over we see a character, then we see what the character sees, and finally we see the character react to what he or she has seen—not just to weave together his story but to implicate us in the ethical predicament of the photographer. Almost always, we know what he knows, nothing more.[2] We see from his point of view—through the window of the photographer—and become engaged by the story at the same time as its main character. As if finely tuning the strings of a violin, Hitchcock creates a melodic tension between observer and image that resonates as the story unfolds for both the characters and the audience of his film.

For Hitchcock, the window is an aesthetic signifier that performs multiple functions. It serves as a literal framing device akin to a photographer's lens, and the filmmaker uses this metaphorically to compose and focus *Rear Window*'s narrative arc. The window separates Jeffries from the world outside his apartment, isolating and protecting

him, yet it also illuminates his internal space, letting in both light and information. By framing what we see in this way, Hitchcock gives meaning to the scenes that occur within that border, calling attention to what might otherwise pass without notice. Like a photographer on the street, he focuses our vision on details that we must assemble in our thoughts. As the story turns toward its conclusion, the events we observe with Jeffries become increasingly specific and evidentiary until Thorwald—the suspect and object of the photographer's surveillance—invades Jeffries's apartment to confront him. The photographer fights his enemy with flashbulbs, temporarily blinding him. When Jeffries is hurled out the window his physical passage through the frame not only leads to the apprehension of the criminal, it also suggests a symbolic take on the role of the photographer and his voyeuristic actions. Jeffries is able to solve the mystery because he harnesses his appetite for careful observation to the task of discerning what is beneath the veneer of everyday life. To accomplish this he gives up photography to become a spy, abandoning critical distance and aesthetic vision to pursue evidence and confirm his suspicions about the world. He has crossed through Hitchcock's symbolic barrier and now moves more easily between his inside and outside selves to determine what is real.

Realism is not enough—there has to be vision, and the two together can make a good photograph. It is difficult to describe this thin line where matter ends and mind begins. —ROBERT FRANK[3]

n the mid-1950s, at the same time as Hitchcock released *Rear Window*, a few photographers began to look at the world in a new kind of way. Robert Frank was among them. Their pictures primarily depicted life on the streets and questioned the mediated sentimentality that was typical then of small-camera photography. Frank in particular was making new sorts of pictures that expressed his own experiences and opinions, and that grew increasingly subjective as he began to "speak of things that are there, anywhere and everywhere—easily found, not easily selected and interpreted."[4] Like Hitchcock's *Rear Window*, Frank's photographs evoked a feeling of discontent that had not yet emerged in the mainstream culture of the nation. Specifically, his pictures posed subtle questions about how corporations and government institutions represent people's lives, and how one might live outside their growing influence.

Competing social agendas posed by the Photo League and the Farm Security Administration's photography program in the 1930s had set the tone for younger artists like Frank, whose rethinking of photography's meaning responded to both American and European documentary traditions. In the 1930s and 1940s, Ben Shahn, Walker Evans, and Helen Levitt had each looked at their nation through its people. Their pictures depict concatenations of figures, many anonymous, found on farms or city streets, on lonely rural roads or New York's bustling subway system. Linking rich and poor with old and young, their photographs epitomize the idea that images of people hold within them something poetic and truthful about the viewer. We can learn something new about ourselves by looking intently at the hidden lives of others, they seem to say. To achieve a sense of spontaneous realism in her work, Levitt learned to use a right-angle viewfinder, which allowed her to observe people without looking directly at them and compose her pictures without interfering with the scene [pls. 26–27]. Shahn, who had photographed people on New York streets with a similar device in the early 1930s, achieved the look of "living theater," where

the street was his stage and his "characters" were oblivious to his presence [pls. 22, 25].[5] Levitt and Evans worked together at times between 1938 and 1941, and she accompanied him while he used a miniature, hidden camera to photograph people on the subway without their knowledge [pls. 17–18]. Levitt, like Frank, later began to make cinematic images, using a film camera to record a more sustained, engaged, and scripted depiction of life on the streets.

Like abstract painting, which came to signify postwar American art in the late 1940s and early 1950s, Robert Frank's photographs grew less composed and freer, less sentimental and more personal. By the mid-fifties he had transformed the old documentary conventions to instill sweeping connections between the shifting cultural and social landscape of America and the changing emotions of its population. Frank described his process of photographing for his 1950s masterpiece *The Americans* as "a kind of spying affair." He wanted to photograph without being seen and learned to shoot quickly while on the move. "I just go and watch the people and photograph them and I try not to do it so people see me. . . . It's a way of photographing. It's very quick. . . . That's one of the reasons I think the pictures succeed. None of [the subjects] is really conscious of the camera."[6]

Sometimes he confronted his subjects in the straight on, documentary manner of Evans. While traveling through Port Gibson, Mississippi, in November 1955, Frank stopped at the high school to photograph young people. He watched a football practice and encountered a group of white teenage boys lounging in the shade of a tall tree after school, drinking soda and shooting the breeze [fig. 13]. Frank looked closely at the cluster, searching their faces for clues to their world. He sensed their isolation and mistrust of outsiders, their need to strike a defensive posture. In the pictures there is a real feeling of tension between their traditions—football and cheerleaders and the camaraderie of school culture—and their futures to be found in a world in which segregation and the Cold War were battlegrounds of ideology and principle.

The kids were comfortable sitting on the hood of an old car but their posing belied their welcome. As they questioned the photographer's purpose in making pictures, there was an undertone of fear; one accused him of being a communist, shouting, "He looks like one. Why don't you go to the other side of town and watch the niggers play."[7] A few days before, Frank had been arrested as a spy—a "suspicious foreigner"—while driving through Arkansas. A police report stated: "This officer investigated this subject due to the man's appearance, the fact that he was a foreigner and had in his possession cameras and felt that the subject should be checked out as we are continually being advised to watch out for any persons illegally in this country possibly in the employ of some unfriendly foreign power and

the possibility of Communist affiliations."[8]

For Frank, the camera itself generated suspicion, bringing out an inherent tension between the photographer and the subject of his pictures. "Most people looked at you and the camera and their reaction was, 'You're a communist,'" Frank later recalled. "I think it's easier to encounter that reaction than the reaction today . . . a mistrust [of] being photographed."[9] From the photographer's point of view his subject is symbolic; it depicts something real but also reveals a set of symbols or signs that stand for something more. In *The Americans*, Frank established a dichotomy between the observer and the subject of his images by calling attention to the picture itself. He destabilized his images, breaking many of the established rules of photography. His

FIGURE 13. Robert Frank, *Port Gibson, Mississippi*, 1955. Gelatin silver print, 9 1/4 x 13 5/8 in. (23.5 x 34 cm)

pictures were dark, edgy, emotional, and technically raw, composed like a shifting glance to mimic the emotions and attitudes of the people he depicted. The mood unleashed in *The Americans* is one of intense conflict between the past and the future, and between real experiences and those manufactured by the camera. Although visually frozen in the moment, his subjects seem caught between their dreams and real lives. In *San Francisco* (1956), a black man and woman seated in a park look back at Frank's camera, clearly angered by his intrusion. They are turned harshly away from the view they came to enjoy and engage the photographer on his own terms. By recording the scene, Frank calls attention to his own dilemma; as a photographer he is spying to gain insight into the internal world of others. He himself was conscious of his own foreignness while he traveled through America, and he identified with the outsider status of some of those he photographed.

When he had applied for project support from the John Simon Guggenheim Memorial Foundation in 1954, Frank proposed "the making of a broad, voluminous picture record of things American, past and present."[10] He set out to complete his project with certain overarching themes in mind, each of which had a major impact on the American social fabric: patriotism, politics, money, race, religion, music, landscape, cars, and the more abstract inspiration of the open road itself. But he was searching for a way to describe these subjects by breaking down documentary traditions and seeking more expressionistic, symbolic points of view. One photograph he took at the time, *New York City* of 1954 [pl. 1], was shot on the fly; the photographer was unseen by his subjects, working quickly and out of view so his intent remained hidden and the depiction on film was simply what remained of his glance—a memory. A ghostly dark figure fills the left side of the view, headless and striding out of the frame. In the distance a legless man on a trolley propels himself forward into the rainy scene, resolute in his movement, careening into view from the top of the frame. Their destination is immaterial; their motion and direction on the street are everything we know about the two figures. The ambiguity of the view is magnified by the anonymity of the featureless subjects, as if the walking man were shadowed by something inside himself. Nonetheless, the photograph is infused with a timeless pathos, tempered

by the determination of motion in these figures that appear as dark shapes silhouetted against a light ground. Frank later said, "Black and white are the colors of photography. To me they symbolize the alternatives of hope and despair."[11]

In 1955 and 1956 Frank traveled throughout the United States, roaming the back roads of the countryside and the main streets of the cities, shooting over eight hundred rolls of film. He began to seek in America the syncopated jazz-like rhythms of the individual, laid bare, in stark contrast to the overpowering weight of Cold War nationalism. In *NYC* of 1955 [fig. 14] he gazed through a window at a woman in a drugstore packed with merchandise. Centered in the frame but lost in the hazy whirl of marketing images, barraged by postcards, masks, and the cheerless neon illumination of her shopping experience, she is actually focused and acutely aware of her situation. Theatrically measured against the blurry, mediated face of a dowdy cleaning lady appearing on a sign in a foreground window display, the lost woman maintains a spark of independence as her head begins to turn toward the window and Frank's camera, which remains unseen. She gains character and personality, and becomes an individual in the context of the place. Her glance signals her desire to be free; her liberation in Frank's proposal lies in the panorama of the open road, in contrast to the five-and-dime inferno in which she is trapped. In this way Frank portrays the search for freedom by everyday people, along with a broadly defined group of rebels—the outsiders who ride motorcycles or stand coy and joyous looking right at the photographer. In one of the most exultant images he chose to publish, he depicted three gays posed on a Lower East Side street corner in *New York City* of 1955 [pl. 45].

Robert Frank also described the institutions of power that influenced the direction of 1950s American culture, and this focus is at the heart of the story that emerges in *The Americans*. In July 1955 he received permission to visit Ford Motor Company's River Rouge Plant, a massive assembly line that he described as "God's factory. . . . [A]ll the cars come out at one end. . . . At the other end, the beginning of the Plant, ships bring Iron-ore and from then on the whole car is built."[12] At the same site where Charles Sheeler had pictured the modernist melding of design and manufacturing in the late 1920s, Frank

exposed its dehumanizing effects by peering in at unidentified workers, lost among the mechanics of industrialization that fueled the country's love affair with cars. In one image, a husky figure stares straight at the camera from behind his mask of protective goggles as he labors to assemble engine parts; his defensive, angled posture seems to connect his protected body to the robotics of the plant.

Politics stand for raw power in Frank's images from *The Americans*. In August 1956, he photographed the ritual pomp and parades of the Democratic National Convention in Chicago. These pictures coalesce as behind-the-scenes peeks into the illusions that reveal

FIGURE 14. Robert Frank, *NYC*, 1955. Gelatin silver print, 13 3/8 x 9 1/4 in. (34 x 23.5 cm)

how political ideologies were constructed during the Eisenhower era. There are images of politicians making speeches and bands playing at rallies; fat cigars and political posters are everywhere. It is, however, Frank's sophisticated and amusing visual analysis of the image-making apparatus of the convention that lays bare the machinery of political power. A group of sated delegates is surreptitiously photographed through a restaurant window, while a passing parade trumpets "ADLAI" from a sign held aloft and reflected in the glass. The image of the photographer making the picture is also mirrored in the window, creating three distinct layers of imagery that, seen together, question what is true and what is an illusion. In another photograph, Jackie Kennedy sits poised and nervous—a solitary, pensive individual boxed in at the edge of the media swarm—looking away from it all for one reflective moment. Meanwhile a poster of Senator John Kennedy's face lies upside down in an empty hall, unceremoniously dumped into a row of empty seats. The political institutions of the convention serve as a backdrop to Frank's personal interest in laying bare the complex visual symbolism of the nominating process.

The Americans was published first in France in 1958 and then in the United States the following year. Frank spent the summer of 1958 photographing people on the streets of New York through the windows of public buses. His camera was literally in motion as he attempted to extract a sense of unassuming moments from a larger whole. He focused on people's movements, gestures, and expressions, divining the torque of the body as it moves in relation to everything else within the urban environment. The photographer worked anonymously, hidden behind the windows of the bus. Hence the people in these photographs are also nameless and mysterious; they exist in the space of the picture but their identity is connected only to the moment observed. They are symbolic elements within the frame. Like Jeffries, Robert Frank is looking through glass at the world, cognizant of his role as a voyeur. But Frank had grown dissatisfied with the ability of a single, still photograph to convey the depth of his vision. *From the Bus* of 1958 was the last series he completed before turning away from photography for a time to make films.

When *The Americans* was first published in the United States, one critic described

Frank's photographs as "images of hate and hopelessness, of desolation and preoccupation with death."[13] Yet they subsequently inspired generations of artists, not only for their astute visual power, complex narrative structure, and pointed interrogation of authenticity and illusion in the culture, but also because they told a personal story. He had defined a new sort of street photography, one that oscillated between voyeurism and the inside view. *The Americans* can be read as one man's search for the locus of his own creative process. Frank intuitively deconstructed the descriptive aspects of his previous work and replaced these with expressive elements. His personal experience is represented on the surface in these pictures by the stark contrast of black and white, austere tones, grainy surfaces, as well as cropped and tilted compositions. In 1958 he wrote, "It is always the instantaneous

reaction to oneself that produces a photograph."[14] Looking inside and outside at the same time, he had transformed his work from an art about the narrative possibilities of looking at the "street" to a more symbolic, experimental project of personal and social scrutiny. Only when his images became something else—when they transcended an evidentiary depiction, for example, and were presented metaphorically, as in his photographs from *The Americans*—did they express the certainty behind the observation. And because he relentlessly pursued a new visual form, without compromise, Frank succeeded in changing the way we see the world today. Disabusing us of the notion that photography is by its own nature documentary in form, he took us with him through that window frame that separates illusion from reality, and made us complicit in the photographer's act of surveillance.

1 *Rear Window*, Paramount Pictures, 1954, directed by Alfred Hitchcock; screenplay by John Michael Hayes, based on the short story "It Had to Be Murder" by Cornell Woolrich.

2 There is one brief moment when we learn something that Jeffries does not know. While Jeffries sleeps, Thorwald's female accomplice is seen through the window.

3 Quoted in Edna Bennett, "Black and White Are the Colors of Robert Frank," *Aperture* 9, no. 1 (1961): 22.

4 Robert Frank, "John Simon Guggenheim Memorial Fellowship application," in *Robert Frank: New York to Nova Scotia*, ed. Anne Wilkes Tucker and Philip Brookman (Houston, TX: Museum of Fine Arts, Houston / New York: New York Graphic Society, 1986), 20.

5 Ben Shahn's street photographs were first published in "Scenes from the Living Theater—Sidewalks of New York," *New Theater* 1 (November 1934), 18–19. This was a periodic feature in the magazine intended to "present social concerns from the vantage point of the person on the street." Deborah Martin Kao, "Ben Shahn and the Public Use of Art," in Deborah Martin Kao, Laura Katzman, and Jenna Webster, *Ben Shahn's New York: Photography of Modern Times* (New Haven, CT: Yale University Press, 2000), 56.

6 Frank, "Guggenheim Fellowship application."

7 Robert Frank, *The Lines of My Hand* (New York: Lustrum, 1972), unpaginated.

8 Letter from R. E. Brown, Arkansas State Police, December 19, 1955, reproduced in Tucker and Brookman, *Robert Frank: New York to Nova Scotia*, 24.

9 Robert Frank interviewed by Charlie LeDuff, May 16, 2008, Lincoln Center, New York City, attended by the author.

10 Frank, "Guggenheim Fellowship application."

11 Bennett, "Black and White Are the Colors of Robert Frank," 22.

12 Robert Frank, letter to Mary Frank, July 1955, in Tucker and Brookman, *Robert Frank: New York to Nova Scotia*, 22.

13 Bruce Downs, "An Off-Beat View of the U.S.A.," *Popular Photography*, May 1960, 104–6.

14 Robert Frank, "A Statement," in *U.S. Camera Annual 1958* (New York: U.S. Camera Publishing Corp., 1975), ed. Tom Maloney, 115.

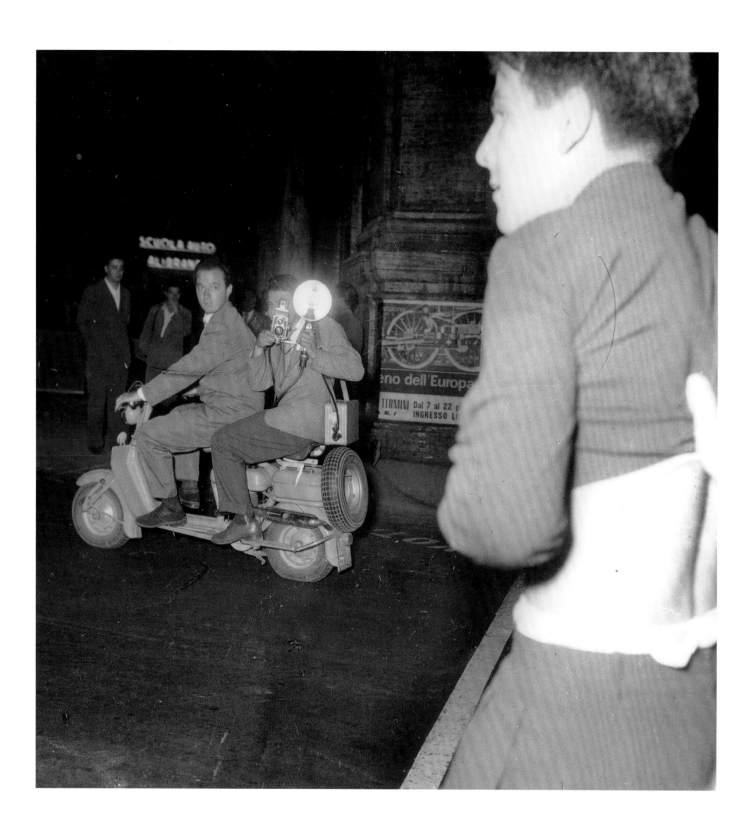

ORIGINAL SIN
THE BIRTH OF
THE PAPARAZZO

CAROL SQUIERS

When Tazio Secchiaroli shot a handful of embarrassing photographs of the actress Anita Ekberg and her husband in Rome in 1958, he couldn't have foreseen the phenomenon he was helping to create—a multibillion-dollar industry that became known as paparazzi photography—and the cultural changes it would come to represent. From the beginning, paparazzi traded on the minor flaws, perceived missteps, and sometimes outrageous transgressions of entertainers and other public figures, both major and minor. This frenetic form of celebrity photojournalism has continued long past its late-fifties flowering on Rome's Via Veneto and lives on into the twenty-first century on an international scale. Secchiaroli claimed the title "Greatest of the Paparazzi" for himself, but that is an obviously vexed honor that even he tried to leave behind many years before his death in 1998.[1]

Although paparazzi photography is considered a bastard branch of editorial photography in which pecuniary gain and social outrage outstrip any concern with aesthetics or content, there has nevertheless developed a history and even a canon of these tawdry celebrity depictions. Tazio Secchiaroli is a founding figure in that history, which begins before the moniker "paparazzo" was even coined.

Like most of the Italian paparazzi, he was from modest circumstances. Born in 1925 on the outskirts of Rome, he left school at fifteen when his father died. After a year of backbreaking labor on the railroad, he got a job as an errand boy at Cinecittà, the film studios that Benito Mussolini had inaugurated in 1937. Secchiaroli's introduction to the moviemaking industry would shape the rest of his career. In 1944, the teenager began to work as a *scattino*—one of a legion of itinerant photographers who scoured Rome looking for paying subjects—taking American soldiers as

his most common target, along with families and young couples enjoying themselves at the beach. When the war ended and the soldiers evacuated, tourists took their place. Secchiaroli photographed in this provisional way for nearly five years, barely scraping by, until he was hired in 1951 as a photographer's assistant, at first acting as a driver. In a much-reproduced photograph he is seen in the driver's seat of a Lambretta scooter, ferrying Luciano Mellace as he photographs an anti-American demonstration [fig. 15].[2] Within months Secchiaroli too was photographing local news, eventually making his name in 1954 with a ruinous photo scoop involving a prominent Communist politician and a local brothel.[3] A few years later, Secchiaroli himself would be news.

One particular story about Secchiaroli and a series of then-famed victim/subjects has been repeated many times in the various accounts of this ephemeral craft: how, in the late evening and early morning hours of August 14 and 15, 1958, Secchiaroli instigated some pivotal photographic confrontations. In order to understand something about the peculiar logic of the history of paparazzi photography, we will examine the significance of the resulting group of pictures along with some of the founding incidents from which the lore and infamy of paparazzi grew.

The photographers were trolling for pictures on the eve of the Ferragosto holiday, which commemorates the Assumption of the Virgin Mary. The Roman streets were largely deserted except for the Via Veneto, the main strip of restaurants and nightspots frequented by entertainers, artists, and minor statesmen, and especially by foreign actors who were in Rome to make movies on the cheap in postwar Italy. Those foreign celebrities were especially tantalizing, and they were out that night, as always, diverting themselves with the usual complement of alcohol, romance, and

OPPOSITE
FIGURE 15. Franco Pinna, *Paparazzi ante litteram* [Tazio Secchiaroli and Luciano Mellace, Rome], 1952. Gelatin silver print, 3 7/8 x 5 7/8 in. (10 x 15 cm)

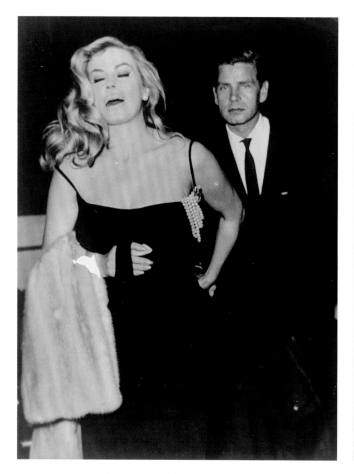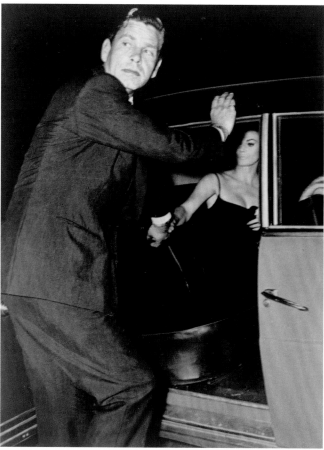

FIGURE 16. Tazio Secchiaroli, *Anita Ekberg and Husband Anthony Steel, Vecchia Roma* (detail), 1958. See also plate 72

flaring tempers. When even that combination didn't lead to any noteworthy images, the photographers knew how to create a dynamic scene.

Their first opportunity appeared when they came upon Farouk I, the exiled former king of Egypt. The nearly three-hundred-pound Farouk was in a café with a modest retinue when the photographers jumped from their car and began snapping away, repeatedly setting off their flashes. One of Farouk's companions later claimed the king was so frightened by the chattering bursts of light that he thought he was under mortal attack, which is a bit difficult to believe as he was often photographed in similar situations.[4] In response, Farouk jumped up and flung his hefty frame at Secchiaroli; he was joined by his bodyguards, who then wrestled the displaced potentate off the photographer.

After that scrimmage, the photographers kept moving. Secchiaroli and another photographer zeroed in on Hollywood film stars Ava Gardner and Tony Franciosa, following them to Bricktop's, a famed American-owned nightclub. Setting off his flash, Secchiaroli enraged Franciosa, a married man who probably didn't want his wife, Shelley Winters, to see evidence of him with the hard-partying diva Gardner. The same night Secchiaroli also got images of a frequent paparazzi target, Anita Ekberg, as she rode with her husband and another man in a sports car on the Via Veneto.

What is not normally discussed in the histories of the original paparazzi is that this allegedly important series of events yielded an incoherent bunch of lackluster, out-of-focus photographs. The shot taken by Secchiaroli that provoked Farouk shows the ex-king merely sitting at a café with four other people, arrayed in a single line behind a tiny table looking like wallflowers at a school dance. The famed clash was captured by a tardy Umberto Guidotti only as it was winding down in a photograph so dark and blurry it provides

virtually no visual description of any part of the event. By the time he snapped his frame, the heated tempers and flailing corpulence reported in the press had fizzled, replaced by a less energetic and much less photogenic face-off between three standing men; one of them is recognizable as Farouk because of his distinctive baldpate, glasses, and moustache. As for the Gardner/Franciosa confrontation, the picture later reproduced merely shows Gardner leaving the scene, with no depiction of the fight between the photographers and Franciosa. The situation involving Anita Ekberg with the two men simply depicts the trio jammed into the tiny front seat of a convertible with the top down. These three images constitute the unexceptional pictorial residue of the now-infamous night that began the legend of the paparazzi and of Secchiaroli himself.

Clearly, the paparazzi myth began to form around the stories of the photographers' encounters, rather than any shocking, titillating, or otherwise remarkable photographs. This is weirdly ironic in that paparazzi images ostensibly serve as visual evidence for a public hungry to *see* verification of the vulnerability, bad judgment, or outright adultery of the stars. Despite the absence of compelling photos, the Milanese daily *Il Giorno* featured a small front-page item on Secchiaroli's skirmishes, "Photographer Attacked by Farouk and Franciosa," which photography historian Diego Mormorio identifies as the item that initiated Secchiaroli's rise to fame.[5] Then the weekly newspaper *L'Espresso* ran a three-column story illustrated with three of the photographs described above, headlined "Ferragosto in Rome: That Terrible Night on the Via Veneto."[6]

It was the act of attacking—photographers attacking celebrities with their cameras and intrusive flashes, and celebrities attacking photographers with their fists—that crystallized the persona and role of the celebrity photographer on Rome's dark streets. Exactly when the attacks began is unknown, but that August night was a "eureka" moment for the photographers and the press outlets that bought their pictures.[7] Suddenly the news coverage was about the photographers, their tenacity, their belligerence, and their professionalism. The magazine *Epocha* in September 1958 quoted Secchiaroli's battle cry about the crusading photographers:

Nothing will stop us, even if it means overturning tables and waiters, or raising shrieks from an old lady . . . even if the police intervene or we chase the subject all night long, we won't let go, we'll fight with flashes, we'll help each other out. . . . The increasingly ruthless competition means we can't afford to be delicate; our duties, or responsibilities as picture-hunters, always on the lookout, and pursued ourselves on every side, make it impossible for us to behave otherwise. Of course, we, too, would like to . . . see via Veneto as a splendid international promenade, rather than one big workplace, or even a theater of war.[8]

In speaking about the "duties" and "responsibilities" of the "picture-hunters" in this "theater of war," Secchiaroli creates the impression that the photographers are reformers exposing social or cultural injustice, or the agonies of the battlefield, something that needs to be rooted out and shown for the evil that it is. Although that may seem laughably inflated rhetoric for a paparazzo, there was a sentiment in Italian culture that foreign influence, especially American popular culture, was having a negative impact on Italian society. An early example of this feeling is found in Giuseppe De Santis's neorealist film of 1948 *Bitter Rice*, in which he intended "to condemn the corruptive influences of American popular culture upon working-class values."[9] It is not too much of a stretch to see the aggressions of the paparazzi, especially against foreign stars, as at least obliquely participating in this critique. And all else aside, there was the money. According to Secchiaroli, "We found that with small events created on purpose we could earn 200,000 lira, while before we got 3,000."[10] The photographers began going out together to search for opportunities. "One photographer would take the pictures and the other takes pictures of the other photographer fighting to take the picture."[11]

Accounts of the famed Ferragosto eve in 1958 have always included the well-known series of pictures by Secchiaroli of Ekberg and her husband Anthony Steel seen here [pl. 72, fig. 16].[12] Yet they didn't appear among the pictures reproduced in *L'Espresso*'s account of the "terrible night," nor does Mormorio's 1999 book on Secchiaroli date them to that night, although they were taken in 1958.[13] This constitutes a historical revision of the

ongoing history of paparazzi. In it, judgments about photographs are made within the peculiar terms of the paparazzi canon, based on the image's quotient of outrage, humor, scandal, and timing, rather than on more conventional notions of historical accuracy, not to mention canonic qualities of originality, composition, or pictorial description.

The Ekberg/Steel images seem to constitute the longest sustained series of photographs of celebrities confronting and fighting with photographers in that era. They are not as aggressive as some of the other famous attack images, including those of the Italian actor Walter Chiari going after a camera-wielding, nimble-footed Secchiaroli. They are, rather, kind of dreamy and indeterminate. Secchiaroli later said that the three a.m. scene "practically looked like something out of De Chirico: just one policeman, the driver, another photographer, and me."[14] Rome was a somewhat provincial city in 1958, the year that marked the real beginning of Italy's economic recovery from World War II, and the Via Veneto had some of the only bright lights around. In the Ekberg/Steel photographs the two are seen leaving Vecchia Roma, a popular nightspot, the photographers' flashes lighting up Ekberg's white skin, blonde mane, and pale mink stole against the inky night [fig. 16]. Compared to most paparazzi images, these artfully capture fleeting human reactions with an unusual clarity of description. Hand gestures, facial expressions, and body postures are especially telling in this little tale of ambush and anger.

Although one magazine termed the scene "the last noisy squabble," referring to the couple's many public displays of temper, Ekberg seems protective of her unhappy spouse.[15] She leads him toward their car and tries to guide him into the backseat as he steadies himself with one hand [fig. 16]. But he foolishly turns to glare at the cameras and lets go of her hand, leaving her reaching for air. Pivoting into a laughable knock-kneed stance and wearing a dull, alcohol-dazed look on his face, he prepares to chase the photographers. As he struggles to focus, he balls up his fists and then lunges clumsily toward the cameras, his face stretched into an angry howl. In the final image he is seen from the back, sprinting after a fleeing photographer [pl. 72]. Of course, these exaggerated expressions and rubbery reactions were a gift to the hungry photographers lying in wait.

Perhaps because of his long apprenticeship in photography, which included covering soccer matches, Secchiaroli was able to make a series of pictures that precisely captured the individual moments of ill-advised action. The photos also fulfilled the dictum of his mentor and onetime boss, Adolfo Porry-Pastorel, who taught him "a picture is perfect when it doesn't need to have anything written under it."[16] Although Anthony Steel is long forgotten as a movie actor, he gives a memorable performance that lives on in the annals of the paparazzi. And Secchiaroli even creates an elegant composition in the final image: Steel is pictured racing toward a painted stripe on the street that extends off into the darkness, with two dotted lines of lights hanging in the black sky above the actor's head, anchoring him in a neat bit of abstraction as he bounds toward a paparazzo. This is the scene that Secchiaroli might have considered De Chiricoesque, with those few indicators of indeterminate space and celestial direction arrayed as if in a vaguely surreal sketch.

Pictures like these, along with the news coverage of the photographers, drew film director Federico Fellini's attention. He began watching the photographers at work and then asked a local press agent to arrange a dinner with a group of them. There he questioned them about their methods and discovered that Secchiaroli had taken a number of the pictures that were most compelling to him.[17] Although the character of Paparazzo in *La Dolce Vita* is most likely a composite portrait, it is commonly believed that Secchiaroli was the major influence on the portrayal of the intrepid photographer.[18] In any event, the name became a noun and forever after the most intrusive celebrity photographers were referred to as "paparazzi."[19]

It is easy to see why the images of Ekberg and Steel have been claimed as part of Secchiaroli's famous terrible night, as they include inebriated foreign celebrities abandoning all dignity and creating caricatures of themselves for the cameras. The duo was often photographed during their three-year marriage, and one of their specialties was drunken displays, which would come to an end with their divorce in 1959—the year Ekberg rose to fame in *La Dolce Vita*.

The Ekberg/Steel pictures are one example of the series in paparazzi photography, a kind of cinematic unfolding in which imprudent decisions and ungainly gestures are

sketched out over a number of images. Secchiaroli took other well-known series, including one of a scandalous impromptu striptease in a Roman nightclub that was used by Fellini as the basis for a long scene in *La Dolce Vita*. Still, Ekberg was a particular favorite of the photographers and she provided unforgettable images when, one night in 1960, she emerged from her Rome villa in her stocking feet to threaten photographers with a bow and arrow.[20] Those photos were taken by a younger paparazzo, Marcello Geppetti (1933–1998), who worked at one point for Roma Press Photo, the agency that Secchiaroli and Elio Sorci founded in 1955.

Like Secchiaroli, Geppetti got his start as a general news photographer. Born in the town of Rieti, he left school at eighteen to become a photographer. He made a name for himself on the Via Veneto, depicting tragedy, not farce: he photographed women jumping to their deaths to avoid a fire that started in the restaurant of the Hotel Ambassador [pl. 100].[21] But it was his paparazzo pictures that would bring him the greatest notoriety and profit. The 1960 incident with a grim-faced Ekberg wielding an archer's weapon escalated into hand-to-hand combat, and photographer Felice Quinto threatened to call the police. In response, Ekberg grabbed him by the head and jabbed one knee into his groin. Geppetti sold those photographs around the world. *Life* magazine gleefully spread them out over three pages, calling Ekberg "a primitive girl" and quoting a photographer saying that "she speaks the worst words in good Italian."[22]

By this time the competition among paparazzi was growing fierce, as more and more photographers realized the money that could be made. It took increasing ingenuity and patience to land big pictorial scoops. One of the biggest was Geppetti's series of images of Elizabeth Taylor and Richard Burton lying on the deck of a boat tenderly kissing, which confirmed in no uncertain terms their rumored adulterous affair [pl. 71].

The two stars were in Italy in 1962 to film *Cleopatra*, one of the most expensive movies made up until that time. Filming had begun, without Burton, at London's Pinewood Studios nearly two years earlier. There it was plagued by a lethal mix of incompetence, arrogance, and bad luck. Within a few months Taylor developed a series of illnesses and had to be rushed to a hospital several times, once for respiratory failure and an emergency tracheotomy. Her illness garnered reams of press coverage, some of it speculating that the star might die, and engendered widespread public sympathy for her. The London production of the movie was shut down after leading Twentieth Century-Fox to the verge of bankruptcy. But following Taylor's Oscar for *Butterfield 8* in 1961, Fox revived *Cleopatra*, threw more money at Taylor, and moved "Cleopatra II" to the Cinecittà studios outside Rome. Burton was brought in to play Marc Antony. Filming started again in September 1961, and again degenerated into a sprawling mess. (Director Joseph L. Mankiewicz summed up the film by saying that it was "conceived in a state of emergency, shot in confusion, and wound up in a blind panic."[23]) Taylor and Burton would only contribute to the unfolding disaster. They became acquainted during the early months of rehearsals and social events. By the time they filmed their first scene together in January 1962, Mankiewicz and others already knew that the two had developed a possibly explosive bond.

The sheer size and folly of the production and the money that was being spent to resurrect it ensured that paparazzi would dog the film's stars. Scores of photographers from Europe, the United Kingdom, and the United States were in Italy following their every move, especially once Taylor and Burton began having the affair. Celebrity adultery was big news in those conservative postwar years, especially where Taylor was involved.[24] According to Geppetti, it was predictably difficult to get the pictures that finally not only proved the romance between the actors, but that visualized it in a convincingly graphic manner. Other photographers had obtained isolated images of them that showed them smooching and dining out together, but the actors and the studio flacks had been successful at brushing off their importance.[25]

The gossip and speculation about the affair fueled the paparazzi in their quest to supply photographic evidence. In April, the lovers, newly reconciled following a tempestuous split, fled to the resort town of Porto Santo Stefano, north of Rome. Geppetti got photographs of the hapless couple inspecting their car after aggressive photographers had run it off the road. The same month the Vatican City weekly *L'Osservatore della Domenica* published an "open letter" to "Dear Madam" clearly aimed at Taylor, warning that she would end in "erotic vagrancy."[26] Taylor was rushed to the hospital for a drug overdose that spring, not for the first time.

FIGURE 17. Marcello Geppetti, *Elizabeth Taylor and Richard Burton* (detail), 1962. See also plate 71

FIGURE 18. Bert Stern, *Elizabeth Taylor and Richard Burton on Boat*, 1962. Gelatin silver print, 16 x 20 in. (40.6 x 50.8 cm). Staley-Wise Gallery, New York

Fox executives moved to shut down the misbegotten extravaganza, and production moved to the Italian island of Ischia, near Naples, to shoot some final scenes on the water. Geppetti and a gang of photographers pursued the two harried actors to the island. One day, while the other photographers staked out the set of the movie, Geppetti hid in the hotel where the stars were staying. Somehow, he alone was able to catch them kissing and caressing in the sun in a series that unmistakably showed their intimacy, photographs that went around the world [pl. 71, fig. 17].[27] The coupling the stars referred to as *le scandale* had been convincingly captured on film.

One intriguing aspect of those Geppetti photographs is their resemblance to a series that Bert Stern took of the two actors when he was the set photographer on *Cleopatra*. For Stern's obviously posed images, Taylor dons a ruffled bikini instead of the more modest one-piece suit she wears in the Geppetti shots. In one image they swim toward the photographer, who angles the camera down to capture her in the lead, cutting through the light-dappled water. For another she arrays herself on the edge of the boat, arching her upper body to emphasize her bust as she intently gazes up at Burton, who stands with his back to the camera [fig. 18]. It is undiluted Hollywood publicity, the female preening for both the camera and her leading man. This image could easily be confused with Geppetti's candid shots simply because of the setting and attire. But in Geppetti's photos the two stars are obviously relaxed, talking and snuggling with little regard for their surroundings.[28]

Ironically, the publicity pictures are more obviously sexually provocative than the paparazzi images that caused a storm. Perhaps the most revealing scene in Geppetti's photos is one in which Taylor is lying on her stomach with the top of her swimsuit pulled down [fig. 17]. Although nothing but her bare back is visible, the sight of her partially unclothed and displaying herself in public next to a married man suggests their carnal familiarity even more than the images of them kissing do. This is one of the pleasures provided by paparazzi photographs—a libidinal excitation that teases and arouses the imagination, stoking the fantasy that the viewer has glimpsed some fleetingly true and private moment in the life of a celebrity. For a split second, that recognition seems to bridge the impossible

distance between the routine life of the viewer and the charmed life of the famed, providing an imaginary visceral knowledge that is obtainable in no other way.

Fellini's *La Dolce Vita*, for all its critique of corrupt bourgeois Italian society, solidified the idea and practice of paparazzi photography, giving it a name and a certain respectability. Photographers flooded into this wayward wing of the profession after the movie came out. Secchiaroli dated the emergence of paparazzi on the Via Veneto to about 1956, but noted, "After ten years everyone was doing it and it was over. The provocations were happening all over the place, but they weren't real—they were set up. By the mid-1960s there were a hundred photographers around doing an imitation of the movie."[29]

Of course, it wasn't over. But the Taylor/Burton affair was the moment when paparazzi photography outgrew the Via Veneto and began its long metastasis into today's ruthless, global business where young men (and sometimes women) of modest means can make a career out of all the aggression, absurdity, and intrusion a camera can buy. In retrospect, the endless permutations of revelation, degradation, and voyeurism that are played out daily on the internet are a logical outgrowth of that early paparazzi photography. With the coming of MySpace and Facebook, the consumers of this kind of journalism have turned the camera on themselves, desperate to reveal their own longings and desirability in a perpetual seduction of an unknown but voracious audience.

1 A substantial book on Secchiaroli was on press when the photographer died: Diego Mormorio, *Tazio Secchiaroli: Greatest of the Paparazzi*, trans. Alexandra Bonfante-Warren (New York: Harry N. Abrams, Inc., 1999). Secchiaroli gave up paparazzi photography and became a photographer on film sets and for film stars after Federico Fellini's *La Dolce Vita* was released in 1959.

2 The 1952 image, by Franco Pinna, is usually reproduced with the man they are photographing—a demonstrator being arrested—cropped out of the picture, making the subject the photographers who were originally in the background. For the story of the photo see ibid., 8–9.

3 The story is recounted in ibid., 14–16.

4 According to Secchiaroli, Farouk simply didn't like being photographed. Interview with the author, Rome, May 8, 1994, translation by David Secchiaroli.

5 Mormorio (*Tazio Secchiaroli*, 23) indicates that the item was dated August 19, 1958.

6 This article, "Ferragosto a Roma: La terribile notte di via Veneto," is reproduced in Andrea Nemiz, *Vita, Dolce Vita* (Network Edizioni: Rome, 1983), 20. See also Mormorio's extended description in *Tazio Secchiaroli*, 23–24.

7 For Mormorio, "The most poignant era of clashes between photographers and celebrities began in 1949." He goes on to discuss the affair between the director Roberto Rossellini and the actress Ingrid Bergman, which split families and caused international condemnation. Mormorio, *Tazio Secchiaroli*, 25–26. Most of the photos of such interactions that are now reproduced, however, date between 1954 and 1962.

8 Ibid., 22–23.

9 Quoted in Peter Bondanella, *Italian Cinema: From Neorealism to the Present* (New York: Continuum, 1990, reprint of 1983), 83.

10 Quoted in David Schonauer, "The Great Chase, Then and Now," *American Photo*, July/August 1992, 50.

11 Tazio Secchiaroli, interview with the author, Rome, May 8, 1994.

12 The best selection of these images is reproduced in Paolo Costantini, Silvio Fuso, Sandro Mescola, and Italo Zannier, *Paparazzi Photografie, 1953–1964* (Florence: Fratelli Alinari, 1988), 44–49. The story is also included in my own "Class Struggle: The Invention of Paparazzi Photography and the Death of Diana, Princess of Wales," in *OverExposed: Essays on Contemporary Photography*, ed. Carol Squiers (New York: New Press, 2000), 279.

13 Mormorio, *Tazio Secchiaroli*, 26. Mormorio only says they were taken "later" in 1958.

14 Quoted in ibid., 26.

15 Nemiz, *Vita, Dolce Vita*, 21, reproduces one of the images and a text headlined "L'Ultima Canara."

16 Secchiaroli, interview with the author, Rome, May 8, 1994.

17 Ibid. There are many variations on paparazzi stories. This is the one the photographer told the author.

18 Costantini et al., *Paparazzi Photografie*, 143. Jennifer Blessing, "Paparazzi on the Prowl: Representations of Italy circa 1960," *Italian Metamorphosis, 1943–1968*, organized by Germano Celant, preface by Umberto Eco (New York: Guggenheim Museum Publications, 1994), 325. Hollis Alpert, *Fellini* (New York: Atheneum, 1986), 123.

19 There has been much speculation about the origin of the name Paparazzo. See Squiers, "Class Struggle," 278; Italo Zannier, "Naked Italy," in Costantini et al., *Paparazzi Fotografie*, 10–11; Alpert, *Fellini*, 125; *French Photo*, March 1973, 63; Blessing, "Paparazzi on the Prowl," 325.

20 This situation is discussed in Squiers, "Class Struggle," 285–88. The photographs are reproduced in Costantini et al., *Paparazzi Fotografie*, 62–65.

21 Marcello Geppetti, interview with the author, Rome, May 10, 1994.

22 "Swings and Arrows of Outraged Ekberg," *Life*, October 31, 1960, 28–30.

23 Quoted in David Kamp, "When Liz Met Dick," *Vanity Fair*, April 1998, 386.

24 Taylor had already been painted as a homewrecker and tramp because of her adulterous affair with and subsequent marriage to Eddie Fisher after the death of her husband, Mike Todd, in a 1958 plane crash.

25 For a brief description of these other photos see Squiers, "Class Struggle," 289.

26 Dick Sheppard, *Elizabeth: The Life and Career of Elizabeth Taylor* (New York: Doubleday & Co., 1974), 304.

27 Geppetti, interview with the author, Rome, May 10, 1994.

28 This confusion can be seen in C. David Heymann, *Liz: An Intimate Biography of Elizabeth Taylor* (New York: Birch Lane Press, 1995), 250. Heymann quotes Stern as saying, "I took that notorious photographic series of them in their bathing suits while they smooched on the deck of a boat." This seems to conflate his photographs and Geppetti's and implies that Stern verified the affair.

29 Secchiaroli, interview with the author, Rome, May 8, 1994.

DARE TO BE FAMOUS
SELF-EXPLOITATION AND
THE CAMERA

RICHARD B. WOODWARD

One of the most unusual pictures from photography's early years, Hippolyte Bayard's *Autoportait en Noyé* (Self-portrait as a Drowned Man), has in recent decades become one of the most celebrated [fig. 19]. The French civil servant and amateur scientist posed for this suicidal melodrama one day in October 1840 as a protest against what he perceived to be a lack of official recognition for his invention of the direct-positive photographic process. Especially irksome to his mind were the honors bestowed by the Académie des sciences and the French government on Louis-Jacques-Mandé Daguerre for his rival picture-making system, soon dubbed the daguerreotype, a national triumph that had been announced in Paris on August 19, 1839.

Bayard's photograph portrays a seated man stripped to the waist, a sheet covering his lower regions, his eyes closed. A sun hat hangs on the wall behind. This mélange of elements could be seen as entirely benign (are we looking at a man dozing after a swim or bath?) or perhaps merely baffling, were it not for notation on the back of the print that spells out how we should interpret the scene: "The corpse which you see on the other side of this picture is that of M. Bayard, inventor of the process here shown to you, or the wonderful results of which you will soon see. To my knowledge, this ingenious and indefatigable researcher has spent three years perfecting his invention. . . . The government, which has supported M. Daguerre more than is necessary, has said it could do nothing for M. Bayard, and the unhappy wretch drowned himself."[1]

A recursive legal and scientific document (the photograph is an example of the process Bayard claims to have invented) and one of the first semi-nudes, male or female, in the annals of photography, the picture is also a macabre joke (the suicide note is

authored by a living corpse) that points back to the graveyard poetry of the late eighteenth century and ahead to the theatrics of Grand Guignol. The author of the note helpfully indicates that the darkened parts of the body in the picture should be read as signs of rigor mortis: "Ladies and gentlemen, let's discuss something else, lest your sense of smell be offended, for as you have probably noticed, his face and hands have already started to rot."

If Bayard intended his stunt to sway public opinion and shame the powers that be, he failed. Although his French contemporaries hailed his talents as an artist[2] and the government awarded him the Légion d'honneur in 1864, his contributions to photography were not fully appreciated until the second half of the twentieth century. The first lengthy monograph on his life and work was not published until 1986,[3] and his name is still less familiar to English-speaking museumgoers than that of his supposed enemy Daguerre or his fellow inventor William Henry Fox Talbot.

In his intuition of photography's potential for self-dramatization, however, Bayard outdid them both. *Self-portrait as a Drowned Man* reveals him to have been a prophet, in some ways nearer to our time than to his. Costuming himself for his imagined audience, a sarcastic prankster who highlights his aggrieved message by baring his flesh, applying makeup, and playing dead, he could be mistaken for a performance artist with a chip on his shoulder or an internet grandstander.

Exhibitionism has not received the scrutiny it deserves from photography scholars and theorists. But as Bayard's picture illustrates, a strain of titillating self-promotion was present at the medium's invention. A staged picture of a half-dressed suicide surely would have piqued the voyeuristic curiosity of 1840 viewers. Tableaux of nudity and death, especially ones in which the artist exploits

OPPOSITE

FIGURE 19. Hippolyte Bayard, *Autoportait en Noyé* (Self-portrait as a Drowned Man), 1840. Direct positive print, 7 3/8 x 7 5/8 in. (18.7 x 19.3 cm). Collection Société française de photographie, Paris

his own body, are usually designed to incite maximum controversy, whatever the era.

That Bayard's self-portrait never created even a minor sensation is perhaps best explained by the technical limitations of photographic reproduction during his lifetime. How many people viewed this picture before his death in 1887 is unknown. But the number who *might* have seen it and shared his sense of humor and injustice was minuscule by our standards, a result of the fact that the direct-positive process yields only a single print (halftone reproductions were not commercially viable until the end of the nineteenth century).

Today, the negligible cost of making pictures and uploading them to networks gives anyone with a cell phone the chance in theory to appear instantly before an audience of billions on seven continents. In the absence of authority figures on the World Wide Web, exhibitionism is no longer judged by most as shameful. For those who measure success by counting hits on their websites, self-promotion is a necessary strategy in the competition for eyeballs in the digital marketplace.[4]

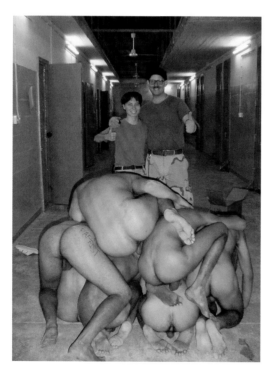

FIGURE 20. At Abu Ghraib prison in Iraq, two American soldiers pose behind a pyramid of naked Iraqi prisoners. Photograph originally appeared in *The New Yorker*, May 3, 2004

This generation—"Warhol's children," as they have been called—has grown up in a surveillance society and a wired world of voyeurs. Security cameras are now an accepted feature of daily life, installed by the millions in cities and suburbs to guard against the threat of crime and terrorism. Not only can these devices be found in almost any public space, from airports to department stores to hospital nurseries, their presence is often legally required to prevent lawsuits for negligence. We couldn't live without them now even if we wanted to.

Contemporary artists and critics have kept a watchful eye on these social mutations. The psychological effects of the camera in an array of spatial contexts have intrigued Bruce Nauman, Dan Graham, and other video artists since the 1960s. The self-portraits of Cindy Sherman are built from the images that shape a visual identity or character type in our media-saturated culture. Julia Scher, Emily Jacir, Merry Alpern, and Denis Beaubois are a few of those who have addressed surveillance in its many, sometimes insidious, forms.

But if the general public is heeding the message found in these works, a number of which regard with alarm the intrusion of cameras and pulsing electronic screens in our lives, the signs of protest are muted. In defiance of George Orwell's warnings, most people seem unconcerned by the erosion of the wall between a private and public self. Snapshots and home videos, once confined to a family scrapbook or attic trunk, are now indiscriminately shared. Sexual acts at home, formerly thought of as so personal that few dared to mention—much less photograph—them, are now routinely captured on cell phones by teenagers and sent to friends. Reality television has turned photographic surveillance into a lucrative entertainment genre with mass international appeal. More than a few criminals have lately captured their own violent deeds with camcorders. The torture documents from Abu Ghraib prove that the thrill of being photographed can trump mercy toward prisoners or the risk of picturing oneself breaking the Geneva conventions [fig. 20].

The digital revolution has altered many established patterns of thought, behavior, and commerce. But the need to be recorded or to record oneself with a camera has always been for many a temptation impossible to resist.

Warhol's children are also Bayard's. For those who "dare to be famous," in the words of the self-help exhortation, the camera has, since the first days of photography, been a labor-saving device that satisfies a primitive urge, one that our latest set of tools is feeding in ways we barely comprehend.

THE HISTORY OF PHOTOGRAPHY is in no small degree the history of its technology. John Szarkowski's catalogue essay for *Photography Until Now*, the 1990 exhibition at the Museum of Modern Art, New York, analyzed the medium's first 150 or so years in this light. What is photographed and how, he argued, has been largely determined by the equipment available to photographers at a given time.

In a chapter titled "Photographs in Ink," Szarkowski traces celebrity as it has fluctuated over the decades in tandem with advances in photographic reproduction. As an example of this relationship, he cites *Galerie Contemporaine*, a Parisian magazine that during the Second Empire featured photographs of French artists and intellectuals by Félix Nadar, Étienne Carjat, and others, printed as woodburytypes. "For technical and economic reasons, the woodburytype was not practical for very large editions," writes Szarkowski, "and the individual fascicles of the *Galerie Contemporaine* were probably produced in editions of not more than a few thousand."[5]

The cost of reproductions therefore shaped both the magazine's print run and the dimensions of increased recognition a person could expect by appearing in its pages. Furthermore, no incentive existed for the publisher to broaden the periodical's audience. "If the subjects of the publication's profiles were of interest to a larger number of potential readers," Szarkowski notes, "no economic advantage was served; the technological envelope had already been filled."[6]

Bayard was not a national figure in 1840, and even if *Galerie Contemporaine* had later run a portrait of him, a few thousand readers would hardly have increased his renown. His self-portrait as a drowned man requires a caption to inform us who he is and what he did. Indeed, to quote his melancholy text, such was his obscurity that "he has been at the morgue for several days, and no one has recognized or claimed him."

Bayard photographed himself many times. A self-portrait dated 1847, now in the collection of the J. Paul Getty Museum, shows him in his garden, a man rooted in *terroir*. In another, now in the Société française de photographie, he sits among his collection of plaster casts from antiquity. For an example from around 1850 he has donned a waistcoat, formal attire that lends an air of gravitas to the focus of the picture: a large brass camera.

These pictures only underline what an exceptional figure he was. Self-portraiture by photographers was not common even decades after his death, which itself was centuries after Albrecht Dürer and Rembrandt had established the genre as a virtuosic and psychological challenge for artists. Even when photographers took up the subject in earnest, self-portraits by painters remained more central to the art of their time. Examples by Vincent Van Gogh, Paul Gauguin, Pablo Picasso, Max Beckmann, Egon Schiele, and Frida Kahlo are still far better known than those by Julia Margaret Cameron, F. Holland Day, Alfred Stieglitz, or Claude Cahun.

Developments in photographic technology after Bayard's death in 1887 did not improve the climate for first-person images, and certain innovations may have decreased the ease of making them. The advent of handheld 35mm cameras in the 1920s and 1930s improved the speed and versatility of picture making but eliminated the need to carry a tripod and cable release, convenient tools for photographing oneself.

The picture magazines that sprang up after halftone reproduction and web presses slashed the cost of printing photographs did little to expand a network where confessional images could be seen. Publications with millions of readers, such as *Picture Post* in England or *Life* in the United States, were perhaps even less open to self-indulgent photography than *Galerie Contemporaine* might have been. The massive circulation numbers that fueled *Life* severely restricted the topics and personalities it dared to cover. As Szarkowski noted, "a person who was of interest to only a few thousand of his fellows could no longer be considered a celebrity."[7]

Photography and film, however, became more important than ever in the business of fame. Picture magazines and newspapers, in conjunction with the movie industry and advertisers, determined which faces would

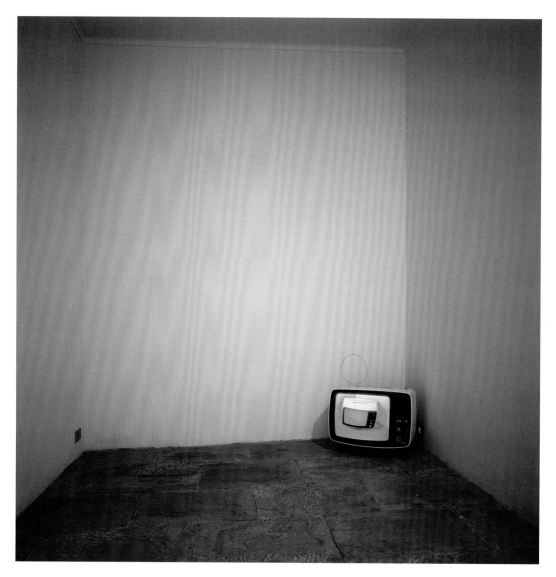

FIGURE 21. Bruce Nauman, *Video Surveillance Piece (Public Room, Private Room)*, 1969–70. Two video cameras, oscillating mounts, and two video monitors, dimensions variable. Solomon R. Guggenheim Museum, New York, Panza Collection, gift

be widely known. They were also essential in creating a new, fleeting variety of celebrity in which people gained fame by acting out dangerous or eccentric stunts for the camera. Anyone seeking notoriety in the 1920s and 1930s could, for instance, sit on a tower of chairs atop a skyscraper or dine on an airplane wing, knowing that a newsreel cameraman or tabloid photographer would record and sell the pictures as "human interest." The cast of the MTV series *Jackass* and thousands of aspirants on YouTube have merely tweaked this Depression-era formula.

Options for working in the first person increased radically in the late 1960s and early 1970s. The wave of autobiographical images and texts that has swept across the electronic frontier since the millennium has roots in video and performance art of those years. It was another time when novel and inexpensive technology led to self-scrutiny with cameras. The Sony Portapak video system, introduced in 1967, suited the atmosphere of social and artistic experimentation, while the "instant" gratification of the Polaroid process, which broadened its share of the photography market with many lower-priced and popular cameras during the decade, became a metaphor for the era.

Working on a much smaller scale but with some of the same tools as broadcast television, a business that was replacing picture

magazines as a news source and challenging the movies as a pathway to global fame, video artists could see themselves as populist (painting was "elitist") and as members of a guerilla movement, raising topics with a frankness that kept them off commercial networks. The attitude that drives so many of today's bloggers—fury or disgust with the mainstream media—can be found in the political and feminist videos of Ant Farm, Martha Rosler, Suzanne Lacy, and others. Susan Mogul's *Take Off* from 1974, a monologue about her new vibrator, is a parody of an enthusiastic testimonial for a new product, one far outside the bounds of television advertising in those days, and even now.[8]

The feedback qualities of video, in which you could record yourself and quickly (or simultaneously) watch the playback on a monitor, led younger artists throughout the United States, Europe, and Asia to perform for the camera. Materials were cheap—videotape, unlike photographic paper or film stock, could be erased and reused—and no crew was necessary. What's more, as in the early days of the internet, no one much cared what the participants were up to. There was no market for video, a condition that encouraged risk taking.

Bruce Nauman's *Video Surveillance Piece (Public Room, Private Room)* from 1969–70 [fig. 21] is a typical work of the period in that it explores formal dimensions of the medium with the simplest of means. A small room is empty except for a monitor in a corner of the floor and a camera fixed on the ceiling diagonally opposite. The monitor plays pictures from a camera panning the room. But as the visitor enters and sits down to watch, the images in the room show a monitor on which different pictures are playing. In fact, there are two cameras and two monitors in two rooms, a public one in which we view the piece and a private one to which we are denied access, each video system monitoring the other.

Qualities of the technology that promise childish wonder and narcissistic delight (the ability to look at yourself on a screen) become profoundly unsettling in this installation. One's frustrated expectations while in the room can verge on panic and paranoia. The philosophical questions Nauman plants here—about the ambiguity of perception, about hidden and revealed power—are issues that run through his body of work [see pl. 163] and that are raised by numerous other artists (including Graham, Gary Hill, Les Levine, and

Joan Jonas) who worked in film, video, dance, and performance during this fertile period.

Photographers responded to video by embarking on their own adventures in the first person. The self-portraits by Lee Friedlander in black-and-white 35mm were as deadpan as those by Lucas Samaras in SX-70 Polaroid color were madcap. For more than two decades Hannah Wilke photographed (often with help from a male camera operator) her own naked body in a manner both seductive and confrontational while, beginning in the 1980s, John Coplans revealed a charming frankness about his aging flesh. Chuck Close turned the camera on himself (and others) to make photographs that served as the basis for gridded paintings analyzing the synthetic nature of vision.

Cindy Sherman is the apotheosis of this movement in self-dramatization: she is the first artist in history to have achieved vast acclaim for an oeuvre consisting almost entirely of photographic self-portraits. They draw on her art school background in performance and video as well as the tradition of role-play found in the zany work of Cahun and Bayard.

Sherman's pictures ask us to construct the identity and read the emotional temper of her characters through the cues she provides, drawing on a shared visual literacy all of us have learned from books, magazines, advertising, TV, and films. Any exhibitionism is tempered by her careful choices of makeup, costumes, props, lighting, and camera angles. Voyeurs in search of painful confessions or erotic display are ultimately thwarted. Her self-portraits are only indirectly autobiographical.

In *Untitled Film Still #54* from 1979–80 [fig. 22], she explores the dynamics of fame and the various parties for whom it is a business. The picture is a dual portrait: of the mysterious woman in the frame, her collar upturned as she strides toward us at night on an urban sidewalk, and of the unseen photographer who has stood briefly in her path. Paparazzi make their living by stalking celebrities and by taking and selling "gotcha" snapshots similar to this. The young unaccompanied female seems not to mind the flash of the camera, however, and her expression suggests that her value in the eyes of others has to do with being a sought-after image: "I am photographed by strangers in public, therefore I am someone."

As the audience appreciating the artist's ingenuity, we are complicit in the transaction, an indispensable cog in the mechanism Sherman exposes. Were we not partners with the paparazzi in the age of mass media, and did we not perhaps share a fantasy about being celebrities ourselves, the photograph might be unintelligible; it certainly wouldn't be so appealing.

SHERMAN (BORN 1954) BELONGS to the first generation of Americans to have grown up with television and the security apparatus of the Cold War. Images made without a human hand pressing the shutter button were granted exceptional authority during this period. The United States and the Soviet Union almost unleashed their nuclear arsenals in 1962 after a U-2 spy plane photographed missiles in Cuba [pls. 110–11]. This crisis accelerated the Corona project (1959–72), a secret CIA reconnaissance program dependent on a fleet of satellites that filmed the earth from one hundred to three hundred miles overhead; reprogrammable from the ground, they could be aimed at any country deemed to threaten U.S. interests. And of course all of the photographs that mapped the moon before the Apollo 11 landing in 1969 were shot by cameras on unmanned vehicles.

Surveillance devices have since exploded across the landscape and the sky, as Trevor Paglen has documented in his photographs (themselves a form of countersurveillance) [pl. 115]. Fear and curiosity have driven a host of creative applications, from the nanny cam to Google Earth, and many of these fulfill wishful visions from the early days of photography that the technology could not yet bring about. The dream of mounting cameras on street corners and ridding cities of crime dates back at least to 1869.[9] But it wasn't until a century later that American banks installed them widely to prevent robberies. In 1974, when these machines (nicknamed one-eyed dicks) caught kidnapped heiress Patty Hearst—armed with an M1 carbine while holding up of a branch of the Hibernia Bank in San Francisco with her Symbionese Liberation Army captors—the grainy black-and-white video stills became icons of the seventies.

The recent public demand for (or acquiescence in) an unprecedented increase in security measures has been fueled in the U.S. by the Oklahoma City bombing of 1995[10] and the destruction of the World Trade Center towers in 2001, and in Great Britain by the Underground bombings in London in 2005. In each case, photographs taken by surveillance cameras helped to identify suspects and led to the prosecution of culprits.

But these sentinels are by no means foolproof when it comes to preventing or detecting a crime. The searching eyes of reconnaissance satellites conspicuously failed to reveal the truth about weapons of mass destruction in Iraq. And the potential for photographic exploitation is hardly restricted to only one side in this or any conflict. The so-called war on terror is on an important and disturbing level being fought with images, as I discuss below.

Issues of surveillance have in recent decades moved toward the center of the art world, as evidenced in prominent critical anthologies such as CTRL [SPACE][11] and the thriving international career of Sophie Calle. Boston-based Julia Scher has developed the theme through performance, audio and internet works, and since 1988 with a series of installations she calls Security By Julia. The 2002 version, Security By Julia XLV: Security Landscapes, exhibited at the Andrea Rosen Gallery in New York, had security guards dressed in pink as well as pink baby blankets strewn on the floor, soothing items contradicted by the cyclone fencing, roar of helicopters, and voices on loudspeakers. Governments and corporations that claim to protect us need to appear maternal, in her skeptical eyes, so they can better hide what is in reality a naked grab for power.

Emily Jacir has made numerous pieces that touch on her status as a Palestinian artist, including the 2002–3 autobiographical video Crossing Surda (a record of going to and from work), about her experiences trying to enter Israel through a checkpoint from Ramallah in Gaza. Soldiers confiscated her first tape, forcing her to conceal her camera in a bag as she recorded (from knee level) the clamor of the war zone, the despair of her fellow commuters, and her own harsh treatment at the border as a suspected terrorist.

The New York artist Merry Alpern began her work on surveillance and voyeurism by chance. In the winter of 1993–94 a friend told her about a Wall Street men's club operating in sight of his apartment. Crouched

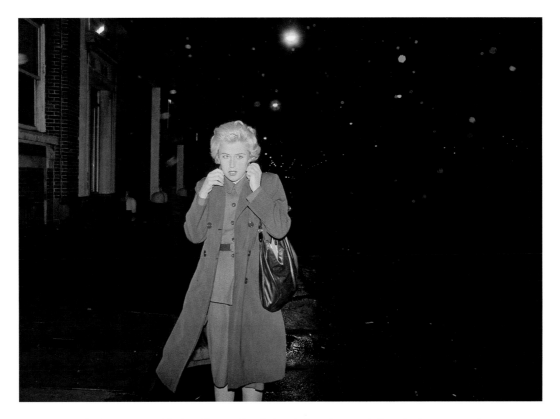

FIGURE 22. Cindy Sherman, *Untitled Film Still #54*, 1980. Black and white photograph, 8 x 10 in. (20.3 x 25.4 cm)

in his window and training her camera at the window opposite, she watched the nightly goings on. *Dirty Windows*, as she titled the series, offers glimpses of raunchy sex, drug taking, male and female nudity, and cash changing hands, all framed by black mullions and grime-covered glass [pls. 53–54]. As with Hitchcock's *Rear Window*, part of the thrill is sensing the danger to the photographer from viewing illicit acts, knowing that we're at a safe distance.

For her series *Shopping* from the late 1990s [pl. 153], Alpern decided to spy on those who secretly spy on us. Surveillance cameras in department stores are now used for everything from nabbing shoplifters to monitoring employees to tracking the eyes and movements of customers. Our responses to various displays and stimuli, captured on video, are useful to executives in order to help them help us become better consumers of their wares. Alpern slipped a miniature video camera into her purse and brought it to places she liked to shop. The result is both a self-portrait of her anxieties about her own body

and a sociological document of the rituals that accompany the trying on and buying of clothes by New York women (a lot of fabric touching and a lack of self-consciousness about stripping down in front of others). The series has the added voyeuristic kick of taking us inside dressing rooms, where the store's cameras are legally forbidden. The majority of Alpern's photographs here, if taken by a man, would have led to an arrest.

Most of us have internalized modes of surveillance so deeply by now they are a source of comfort or entertainment. Spying on others without their knowledge has been the basis for comedy on American television since the first version of *Candid Camera* in 1948. Hidden "lipstick" cameras located under the steering wheel capture the sordid secret-sharing on HBO's long-running *Taxicab Confessions*. On *Cops*, video cameras have gone with the police as they responded to calls since 1989, making it one of the most durable shows in American broadcast history. Surveillance images increasingly play a role in news events, whether it's Princess

Diana exiting through the revolving door at the Ritz in Paris minutes before her death in 1997 or the murder of security guard Stephen Tyrone Johns by white supremacist suspect James W. von Brunn in 2009 at the United States Holocaust Memorial Museum in Washington, D.C.

Even those members of society who formerly would evade or run from cameras seem now to welcome them. The MSNBC television network had an unexpected hit for several years (2004–7) with its regular specials, *To Catch a Predator*, in which men pursuing underage sex were lured from their online fantasy world into a house where a video crew waited to record their shock and disappointment at the reality—no children were in sight—and where the police were outside ready to lock them in handcuffs. Not only was the program a ratings winner with the public, it also became oddly popular with some accused pedophiles themselves. A number were seen confessing sleepily to the host about their uncontrollable desires instead of demanding to see a lawyer or bursting into tears. Some were even faithful viewers. As Alessandra Stanley noted in her review of the show for the *New York Times*, "many suspects are passive and astonishingly candid when confronted, a testimony, perhaps, to the hypnotic powers of a television camera."[12]

The show was canceled in 2008, a year after a Texas district attorney, accused of sexual misconduct by the show, committed suicide in front of a SWAT team that had broken down his door. But for others, fear of public exposure no longer seems to be a problem. Some lawbreakers are willing to indict themselves in order to have an archive of their deeds. In 2007 police were able to arrest a man in Nevada who allegedly raped a three-year-old girl. He was identified after they posted an image of his face on the web, taken from a video he had made of the act. This news item coincided with the arrest in Thailand of Christopher Paul Neil, a Canadian schoolteacher accused of having sex with a series of children. Neither would in all likelihood have been jailed so quickly had they not depicted themselves *in flagrante delicto*.

A partial list of others happy or compelled to document their own crimes in recent years would include the young arsonist in California who took pictures of himself against the background of the infernos he

had set. Or the Canadian joyriders who cruised around Vancouver at night, shooting terrified pedestrians with paintball guns while recording themselves whooping it up. Or Sean Gillespie, a neo-Nazi who videotaped himself in 2004 firebombing an Oklahoma City synagogue as part of a proudly racist agenda. Or the three Ft. Lauderdale, Florida, teenagers arrested in 2007 for clubbing with baseball bats three homeless men, one of them to death, assaults the boys commemorated on video.

Before heading off to the campus of Virginia Tech to gun down anyone unlucky enough to cross his path on April 16, 2007, the disturbed college student Seung-Hui Cho prepared a video and several photographic self-portraits in which he brandished his weapons. He sent this material, along with a letter, to NBC news. After he had killed thirty-two people, wounded dozens more, and committed suicide, these images were broadcast and printed in magazines and newspapers. They have outlived him as a kind of legacy and can be retrieved by anyone with a simple computer search, as this web-savvy killer must have known they would be.

Suicide bombers who step in front of the lens to say goodbye to their families and swear allegiance to their God before detonating themselves and others have participated in this trend. The members of Al Qaeda who beheaded journalists and aid workers are a subset as well. They posed as executioners for the cameras in hopes of promoting the group's ruthlessness.

Of course, the history of photography includes plenty of odious characters who, like the Abu Ghraib guards, documented their misdeeds, or those of others, because they didn't consider the evidence they were leaving behind to be especially barbaric or inhumane. Slave owners commissioned daguerreotypes of their human possessions. Postcards of lynchings were popular in several areas of the United States until after World War II. We know German soldiers committed atrocities on the Eastern front in that war from the snapshots they took of their comrades massacring Jews and Soviet POWs.

What is different now is the ease of image transmission and the uncontrolled increase in potential audience. Whether or not the internet abets lawless or transgressive behavior (at Abu Ghraib, the ease of

technology seemed to encourage a sense of childish play), it is indisputable that global networks allow more of these sorts of acts to be seen. In the age of paper, distribution was limited by print runs and further circumscribed by language barriers and censorship laws. Even cable television, which in the 1970s allowed violent and sexual content to enter American homes as never before, is still supervised by corporate executives and government agencies.

The internet has no such overseers. No scene is so horrific, no activity so intimate, no daily routine so mundane that we don't have means to see a photograph of it. Imagine a scene, however cruel or graphic, and chances are high a photograph of it now exists online. Scenes of violence against humans and animals are easily available. For anyone curious to see a man's face at the moment his throat is cut or his neck is snapped, there has been since 2001 a growing supply of "snuff films." These deaths were not faked like Bayard's.

Not enough is made of the fact that photographic technology, capable of rendering our lives in subatomic detail and discovering galaxies we never suspected were there, creates a hunger to gaze upon the previously unknown or the forbidden. If something can be photographed, chances are it will be.

In 2007 a one-minute Brazilian pornographic video, 2 *girls*, 1 *cup*, went viral. The staged scene featuring two women who engaged in coprophilia and then vomited into each other's mouths was clicked on by millions and became a test of what you were able to watch without turning away. Almost as disturbing—but perfectly in keeping with the self-reflexive voyeurism of the internet—YouTube soon had thousands of videos made by people as they or their friends or strangers watched the porn video and reacted with screams or laughter or both.

Such unpoliced freedom has left unforeseen traps for exhibitionists and voyeurs alike. Photographic images have unique legal status as evidence in that both the operator of a camera and the viewer of the picture can be guilty of a crime. Producers of child pornography (photographers and distributors) as well as consumers of the pictures are all culpable according to U.S. law. That some teenagers now routinely exchange sexually explicit photographs, a trend given the label "sexting" by the media, is entirely a creation of the digital age.[13] Taken in a spirit of fun or not, and even if by underage participants, these stills or clips may violate federal laws when sent over the internet. Mary Leary, assistant professor of law at Catholic University, told an audience in 2008 at the University of Virginia Law School: "The reality is that whenever a juvenile . . . creates the images of sexually explicit activities and then distributes them, they have now produced child pornography and they have now distributed it."[14]

What unites the sexter and the YouTube miscreants is a sense of adventure, of belonging to a huge, new, amorphous community, and of playing with tools that many of their parents never owned and don't really understand. Nor has it escaped the notice of the internet generation that fame, no matter what the source, is a desirable commodity.

The hotel heiress Paris Hilton owes her dubious, if richly rewarded, celebrity status to a 2001 bedroom tape shot by her boyfriend that circulated widely online. *Big Brother*, debuting in 1999 on Dutch television, exploited the covert nosiness of the webcam. Now an international franchise with versions in (at last count) seventy countries, the hit show turned Shilpa Shetty and Jade Goody into national celebrities in Great Britain. Television watchers in 2008 and 2009 could also observe in installments the slow, agonizing first-person testimony of two women—Goody in Great Britain and Farrah Fawcett in the U.S.—in the fatal throes of cancer. Death, like other sides of human life and behavior formerly hidden from public view, is now recorded for all to witness.[15]

But expecting that one's performance in front of a camera will find a sizeable audience may be no more realistic for unknowns today than in the time of Bayard or the heyday of *Life* and the Hollywood studio system. YouTube permits anyone to post videos and hope for viewers to look at them. Nothing in theory stands between the work and worldwide popularity. Alas, when Chris Wilson, an assistant editor at *Slate*, crunched the numbers, he found that "the odds of even 1,000 people viewing your video in a month's time are only 3 percent" and only a tiny fraction of the videos submitted ever reached "even 10,000 or 100,000 views." His conclusion: "You might have better odds playing the lottery than of becoming a viral video sensation."[16]

Emily Jacir's *linz diary* from 2003 [pl. 143, fig. 23] is a wistful meditation on the

LinzCam live

October 12, 2003 18:00 hours

me lying on the fountain, staring up at the patch of blue sky above linz, watching a small white airplane go by

FIGURE 23. Emily Jacir, *linz diary* (detail), 2003. See also plate 143

fragility of existence in the age of surveillance. Appearing every day at six p.m. somewhere in the main square of the Austrian city, she allowed herself to be recorded by one of the area's thirty-six webcams. A group of photographs is the residue of her ghostly presence at this time and place. Like her more overtly political works about the Middle East, *linz diary* is about statelessness, being nowhere. Such a condition is not altogether to be mourned, the piece suggests. Her estrangement and melancholy are bound up with the heady romance of freedom. Being photographed by machines with invisible operators, Jacir can let herself float in the global snow globe of images before the camera swings past and she disappears again into the milling strangers in the square, back into a cosmic state of anonymity.

We like to watch and, in turn, don't mind being watched. It's the pact we've made to satisfy our curiosity as well as our anxieties about terrorism and other unknown threats,

desires stronger at the moment than fears about loss of privacy. No wonder Orwell's vision of the future in *1984* has been popular with readers since the book was first published in 1948: the electronic screens buzzing with information that surround the citizens of Oceania turn out to be the way many of us want to live, or die. Worries about the invasion of surveillance devices in our midst seem naive when we can click on Google maps of our neighbor's house. Remaining off-camera this late in the day is probably hopeless.

Cameras memorialize whatever they're aimed at even as they purportedly guard civilization from harm. By embedding starlight into the fabric of their own creation, photographs hold out the promise of immortality, not just immediate fame. The suicidal murderer who makes a final video and the contestant on *American Idol* or *Britain's Got Talent* are both invested in this magical thinking. As they confront the lens, they have made the same gamble: any pain or disgrace

they face, or suffering they cause, matter little compared with the chance to craft an image that will launch them into the future as, if not a better person, then at least a more significant one. Pressing the button and taking a picture allows everyone to imagine there will always be an audience, even if it's an audience of one.

1 Author's translation from the French. "Le cadavre du Monsieur que vous voyez ci-derrière est celui de M. Bayard, inventeur du procédé dont vous venez de voir ou dont vous allez voir les merveilleux résultats. À ma connaissance, il y a à peu près trois ans que cet ingénieux et infatigable chercheur s'occupait de perfectionner son invention. . . . Le gouvernement qui avait beaucoup trop donné à M. Daguerre a dit ne rien pouvoir faire pour M. Bayard et le malheureux s'est noyé. . . . Messieurs et Dames, passons à d'autres, de crainte que votre odorat ne soit affecté, car la figure du Monsieur et ses mains commencent à pourrir comme vous pouvez le remarquer."

2 Bayard's *Still Life with Plaster Casts* was the first illustration in Louis-Désiré Blanquart-Évrard's pioneering history *La photographie, ses origins, ses progrès, ses transformations*, published in 1869. Furthermore, a tribute in the text calls Bayard "the most ingenious and skillful of our photographers" http://www.musee-orsay.fr/en/collections/works-in-focus/photography/commentaire_id/still-life-with-plaster-casts-11216.html?tx_commentaire_pi1%5BpidLi%5D=847&tx_commentaire_pi1%5Bfrom%5D=844&cHash=9125e9369c (accessed February 10, 2010).

3 Jean-Claude Gautrand and Michel Frizot, *Hippolyte Bayard: Naissance de l'image photographique* (Amiens, France: Trois Cailloux, 1986).

4 A friend who works as an economics editor for a prominent New York publisher reports that in 2008 he received at least one book proposal a week telling readers "How to Viralize Your Message in the Internet Age."

5 John Szarkowski, *Photography Until Now* (New York: Museum of Modern Art, 1990), 129.

6 Ibid.

7 Ibid., 190.

8 Glenn Phillips, ed., *California Video: Artists and Histories* (Los Angeles: Getty Research Institute, J. Paul Getty Museum, 2008), 178–81.

9 An 1869 article titled "The Legal Purposes of Photography" suggested that once the photography was "perfected" the "streets and alleys of our cities should be equipped with and surveyed by cameras so that anyone rioting or disturbing the peace would be caught on film." Quoted in Jennifer Mnookin, "The Image of Truth: Photographic Evidence and the Power of Analogy," *Yale Journal of Law & the Humanities* 10, no. 1 (Winter 1998): 19.

10 Charles Pierce, a security expert on the advisory board of the American Society for Industrial Security, traces the surge in camera surveillance to the 1995 bombing of the Alfred P. Murrah Federal Building. The worst domestic terrorist attack in United States history until 2001, it killed sixty-eight and wounded more than eight hundred. "Not many cities had cameras on the street at that time," according to Pierce. "That changed after they discovered [Timothy] McVeigh was recorded only by happenstance." Interview with the author, April 20, 2006.

11 Thomas Y. Levin, Ursula Frohne, and Peter Weibel, eds., CTRL [SPACE]: *Rhetorics of Surveillance from Bentham to Big Brother* (Cambridge, MA: MIT Press, 2002).

12 Alessandra Stanley, "Gotcha! 'Dateline' Paves a Walk of Shame for Online Predators," The TV Watch, *The New York Times*, May 17, 2006.

13 In January 2009 a Vermont television station found that "sexting" was common among students at South Burlington high school. The reporter also cited a report from a Chicago firm, Teenage Research Unlimited, that surveyed twelve hundred students. "One out of every five students told researchers they had used their cell phones to send sexy or nude photos of themselves." http://www.wcax.com/Global/story.asp?S=9612361&nav=menu183_2 (accessed January 3, 2009).

14 http://www.law.virginia.edu/html/news/2008_spr/online_exploit.htm (posted February 13, 2008).

15 This strain of televised revelation dates back in the U.S. to 1973 with the PBS broadcast of *An American Family*. The filmmakers Alan and Susan Raymond documented the lives of a middle-class family in Santa Barbara, California—Bill and Pat Loud and their five children—in twelve weekly installments. A cultural phenomenon worthy of a *Newsweek* cover, it attracted more than ten million viewers a week. *An American Family* depicted a real marriage in trouble; Bill and Pat Loud separated in episode ten. The couple's oldest son, Lance, the first gay character in American television history, was also perhaps the first reality television star, going so far as to ask the Raymonds to come back and film him when he was dying of AIDS, an episode broadcast on PBS in 2002. "He could have called for a priest or a minister," said Susan Raymond. "But instead he called for his filmmakers." See Richard B. Woodward, "Tied to Television to the Very Last," *The New York Times*, April 14, 2002.

16 Chris Wilson, "Will My Video Get 1 Million Views on YouTube?," *Slate*, July 2, 2009, http://www.slate.com/id/2221553/ (accessed February 10, 2010).

FROM OBSERVATION TO SURVEILLANCE

MARTA GILI

n 1969, Vito Acconci engaged in a seemingly simple ritual. He decided that, every day for a month, he would follow an anonymous pedestrian until he or she disappeared from public space. After each action Acconci typed a detailed account of the journey and sent it, together with some photographs, to a few members of the artistic community [fig. 24].

In 1981, Sophie Calle took a job as a hotel housekeeper. For three weeks, instead of cleaning the rooms, she photographed the guests' belongings and the traces of their stay. Twisted sheets, open books, jewelry, cosmetics, lingerie, luggage, letters . . . Calle lists dozens of personal objects in the notes she made after reviewing each room [pl. 154].

In 1991, only six months after the end of the first Gulf War, Sophie Ristelhueber traveled to Kuwait. Flying over the desert she realized that the network of interweaving trenches drew winding lines in the sand resembling sutured wounds on a body. From the air and ground, Ristelhueber captured seventy-two images of a land wounded in conflict [pl. 113].

From 2001 to 2003, Harun Farocki compiled images taken by cameras placed in the noses of missiles known as "smart bombs." In his office, using his editing table, Farocki took the raw footage created for military and propaganda purposes and analyzed, juxtaposed, and edited it to produce a new narrative [pl. 160].

Within the last decade four cities—Davos, Genoa, New York, and Evian, hosts to four world economic summits—were turned into unassailable fortresses. Jules Spinatsch turned his camera on the security systems and developed his own discourse of surveillance of "enemy lines" [pls. 138–40].

Of the many artists included in the "Surveillance" section of this exhibition, we mention these five for two fundamental, related reasons. On the one hand, their

timeliness: these projects were created during the last forty years, a period when art has asserted its social function, its liberation from the object, and its role as both document and archive. On the other hand, they share a plural nature, each encompassing several of the notions that define surveillance. They range from pure, detailed observation to exalted apprehension, and are concerned with both the observer and the observed.

Although the word *surveillance* has the same spelling in English and French, in each language its definitions vary significantly. *Larousse*, the French dictionary, describes surveillance as *"l'action de surveiller, de contrôler quelque chose, quelqu'un. Contrôle suivi auquel on est soumis; observation"* (The act of surveilling, of controlling something or someone. Subjecting someone to continuous supervision; observation). The *Collins English Dictionary* offers a different meaning—"Close observation of a person suspected of being a spy or a criminal"—whereas the online English thefreedictionary.com defines the word as: "Close observation of a person or group, especially one under suspicion. The act of observing or the condition of being observed." In Spanish, the word *surveillance* is translated as *"vigilancia,"* and the Royal Academy of the Spanish Language defines this as *"Cuidado y atención exactos en las cosas que están a cargo de cada uno"* (Meticulous attention and care paid to things that are in one's charge).

From these differences we can see that, while the French and Spanish definitions emphasize "control," "attention," and "care," the English ones underscore "suspicion." However, all three definitions point at observation as an integral element of surveillance.

Any act of observation implies a certain detached alertness, the act of carefully watching, listening, and registering events and their context without intervening in them. Although

OPPOSITE

FIGURE 24. Vito Acconci, *Following Piece* (detail), 1969. Gelatin silver print, 5 x 4 3/4 in. (12.7 x 12.1 cm). Collection of Robin Wright and Ian Reeves, San Francisco

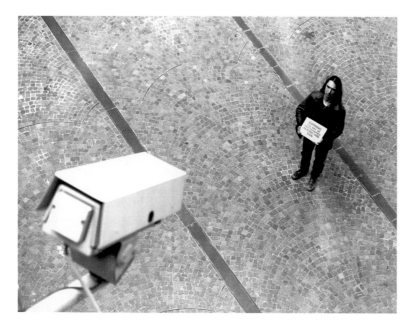

FIGURE 25. Denis Beaubois, *In the event of Amnesia the city will recall . . .*, 1996–97. Top: Performance, 1996, Sydney, Australia. Bottom: Still from 1997 video

it is not inherently innocent, observation in itself is not invasive; it is let loose upon that which is observed.

Control comes into play when the act of observing subverts the observable and interferes with its outcome. Control imposes the acceptance or rejection of what is observed by measuring it against a set of rules, a model. Sometimes, when control is ritualized, it becomes a profanation; it can be seen as contemptuous, and considered a misdemeanor or a crime.

Observation/care/attention and supervision/control/submission are lanes in a two-way highway that runs between two statements. At one end is "Everything is observable"; at the other, "Everything is suspect." When the works selected for the "Surveillance" section of this exhibition jump these lanes, they generate tension by questioning the boundaries between public and private, subject and object.

DOCUMENTATION

Every act of observation entails taking some sort of inventory, whether attentive and detailed or built on mistrust and suspicion. Although different in intensity and strategy, the aesthetic practices of Acconci, Calle, Ristelhueber, Farocki, and Spinatsch are all closely related to processes of gathering, handling, and creating documents. Their works' validity as contemporary art is to be found in the narrative that results from the artist's description of the situation and analysis of its context, which sometimes have the thoroughness of forensic rigor.

Following the ideas of German philosopher and essayist Boris Groys, we can identify two types of art documentation. One is the result of performances or ephemeral actions that can only be seen if documented at the time of their execution. Acconci's, Calle's, and Spinatsch's works in the exhibition exemplify this notion, as do Denis Beaubois's *In the event of Amnesia the city will recall . . .* (1996–97) [fig. 25], Emily Jacir's *linz diary* (2003) [pl. 143], Laurie Long's *The Dating Surveillance Project* (1998) [pl. 149], and Bruce Nauman's OFFICE EDIT I *(Fat Chance John Cage) Mapping the Studio* (2001) [pl. 163].

The second type consists of presentations or devices that themselves form a document, and are derived from artistic research into political and social themes. In addition to the works by Ristelhueber and Farocki, projects of this type in the exhibition include, among others, *Abscam (Framed)* (1981) by Chip Lord [fig. 26]; *Schlafende Häuser* (Sleeping Houses, 2002) by Peter Piller [pl. 133]; and *Crossing #14* (2005) by Mark Ruwedel [pl. 152].

In all of these examples, the documentation of real situations, whether natural or artificially generated, is part of the work itself. The result is a complex organism composed of a set of documents that articulate the work's

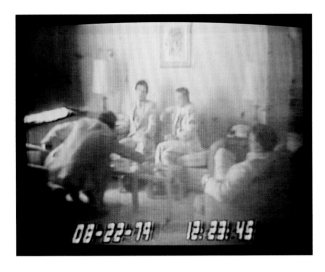

FIGURE 26. Chip Lord, *Abscam (Framed)*, 1981. Left: Still from FBI video of Congressman Michael Ozzie Meyers accepting $50,000 in cash at the Travel Lodge near JFK Airport. Right: Chip Lord (left) and Skip Blumberg reenact the scene at the same location

unique narrative structure. Because of the organic nature of some of these works created as and through documentation, Boris Groys considers them *bioart* (a concept with roots in biopolitics), since they develop "strategies of resisting and of inscription based on situation and context, which make it possible to transform the artificial into something living and the repetitive into something unique."[1]

Let us return to *Following Piece* (1969), one of Vito Acconci's first performances. As Acconci himself admits, in it he basically tried to explore the hazy line between the public and the private realms. Acconci used people who did not know they were being used, unaware someone was following them through the streets of New York. The documentation of the performance includes photographs taken by one of Acconci's colleagues; the images repeatedly show the subject and the artist, both from behind.

The simplicity of this action might seem a childish game; we are reminded of the mischief perpetrated by street urchins in some neorealist Spanish and Italian films of the 1950s, where gangs of kids ring every doorbell in an apartment building before running away. The objective of that game is to witness, from a safe hiding place, the confusion and outrage of the tenants.

According to Italian philosopher Giorgio Agamben, "to return play to its purely profane vocation is a political task."[2] In a way, Acconci's work returns play to the streets of New York, in order to explore ideas about public and private space and "to put them to a new use, to play

with them."[3] Acconci's political gesture is not limited to presenting the private as a realm where one can no longer remain anonymous. It unmasks the hidden framework of power structures and their misappropriations of space by pointing out the political implications of turning one's back (a biological reaction) to an invisible observer. Here, Johan Huizinga's *homo ludens* ("man the player") is also claimed as Aristotle's *zoon politikón* (the "political animal").

In *The Hotel* (1981–83) Sophie Calle creates twenty-one diptychs corresponding to as many rooms of a Venice hotel, "recorded" and "unveiled" through her renowned investigative rigor. As in most of Calle's works, the other is her object of study, and her own participation the variable. This piece could be considered a follow-up to *Venetian Suite* of 1980, in which Calle traveled to Venice in pursuit of a certain Henri B., whom she had met the previous night at a party in Paris. Disguised to avoid recognition, she recorded all the details of that stalking, with text and photographs, in a personal journal.

Like Acconci, Calle probes the physical and mental places where the boundary between the private and public spheres becomes muddled. Both artists use the shameless element of play, crossing the line of social convention, reviving certain rituals, and setting off some of the devices of fiction—in sum, managing desire.

However, when Calle exposes the limits of her own and others' intimacy, the result, paradoxically, is an exploration of the mechanisms of the intimate, of the secretive, and of

FIGURE 27. Bureau of Inverse Technology, *BIT Plane* (video still), 1999

subjectivity. For Calle, peeling away the crust of the private opens the door to the narrative strategies we use to construct our own personal stories in the public sphere. And, as Calle demonstrated in *The Shadow* (1981), when she asked her mother to hire a detective to follow her, the most meticulous recording of someone else's actions cannot reveal the personal narrative an individual constructs about herself.

Acconci and Calle's use of photography also challenges the modern dogma that grants the medium a unique aesthetic power based on the formal and technical balance of the image. Here their photographs purposefully take on a journalistic quality, the recording of evidence that proves an event. The artistic value of the works is in their ability to reveal situations and contexts.

If Acconci's *Following Piece* or Calle's *The Hotel* and *Venetian Suite* capitalize on a certain form of journalism, Sophie Ristelhueber's FAIT (Fact, 1992) does the same with documentary photography. Ristelhueber builds an allegory, a story with two sets of meanings. The seventy-two images that make up the work capture the topography of a desert landscape and the marks left on it after a battle as if they were scars on a mutilated body. FAIT presents a torn organism, forever scored by conflict, symbol of the pain and suffering that test the limits of the physical body and of the body politic.

After close and careful observation, Ristelhueber's work takes apart the notion of inventory in order to organize its parts as a subjective story. The artist builds an archive— a "territory of images," to quote Allan Sekula—relieving it of its testimonial charge in order to create her own set of meanings using her own narrative economy. Through fragmentation, perceptual displacement, and the sequencing and placement of objects in space, she addresses violence in places of conflict in a way that challenges oppressive models of exclusion and control of information. FAIT consists not of images presenting irrefutable facts but of provisory tales, open to the experience of the viewer.

Observation, attention, care, control, suspicion . . . but who is watching the watchmen? Who suspects whom? Who is the impostor? What is more important, the information or the secret?

As in many of his other works, in *Eye/Machine* (2001–3) Harun Farocki touches on the topic of surveillance using the point of view of intelligent weapons, and takes advantage of the opportunity to differentiate images recorded in real time from those created in simulated environments. Using well-known images from the Gulf War, his *Eye/Machine I* explores a new strategy of creating and managing images where "the loss of the 'genuine picture' means the eye no longer has a role as historical witness."[4] Here, the mastery of perception attributed to the human body is not only challenged but questioned suspiciously. Satellites, infrared vision systems, sophisticated listening equipment, remote-controlled devices, drones, radar, and video sensors replace human perception to create a battle-ready "technological army" capable of operating on several fronts under a single command. The absolute nature of *biopower*, that is, of the devices created by the mechanisms of power to control our senses, becomes more evident than ever.

In *Eye/Machine II*, Farocki expands on this concept by combining images taken by "intelligent cameras" in both the civilian and military spheres. *Eye/Machine III* closes the cycle; in this work, Farocki investigates the concept of operational images, those that "do not portray a process but are themselves part of a process."[5] It consists of images traced over previously recorded ones; for example, a landscape is superimposed over an earlier photograph of it, each challenging the other's

authenticity. Farocki explores differences and similarities, inclusions and omissions in comparing the sets, revealing the use of montage in their production.

In a way, *Eye/Machine* calls attention not only to the erasure of the binary differentiation between the human and the mechanical eye, but also to the dissolution of the subjective experience of reality itself. When virtual reality is experienced as if it were real, "we begin to experience 'reality reality' itself as a virtual entity."[6]

PROVOCATION

In *Temporary Discomfort* (2001–3), Jules Spinatsch documents the states of emergency declared in four cities that hosted world economic summits—cities that became giant laboratories for testing the latest equipment for surveillance, discrimination, control, and security. These technologies have a single objective: to identify in order to remove. Specifically, to identify subjects in order to associate them with a differentiated crowd—members of the anti-globalization movement—and remove them from political life. "The realm of bare life—which is originally situated at the margins of the political order—gradually begins to coincide with the political realm, and exclusion and inclusion, outside and inside, *bios* and *zoē*, right and fact, enter into a zone of irreducible indistinction."[7]

The deployment of police forces was broadly publicized, generating images that, in a way, put them on display. Spinatsch analyzes the complex power relationship established between photography, document, and information, as well as the expectations, real and suspected, of them today. Like the works by Ristelhueber and Farocki, *Temporary Discomfort* is halfway between speculation and observation, a playing field where the rules turn against the players. Spinatsch kidnaps the notion of suspicion and moves it into a different realm.

Along the same lines of displacement and provocation, the Bureau of Inverse Technology displays an array of devices and strategies aimed at analyzing the level at which control technologies are inserted in everyday life. In *BIT Plane* (1999) [fig. 27], BIT creates a miniature plane that flies over Silicon Valley in order to unveil the secrets of this financial fortress where capital and technological research share common goals.

A number of these contemporary artistic practices do not limit themselves to exploiting the devices and protocols of the most sophisticated surveillance and control systems in the world; they act as true counterespionage agents, exposing these devices for what they are. The goal is to generate tension between the notions of observation and surveillance, what can be said and what cannot, information and secrecy, the real and the virtual, the record and the document.

Translated from the Spanish by
Fernando Feliu-Moggi

1 Boris Groys, *Art Power* (Cambridge, MA: The MIT Press, 2008), 65.

2 Giorgio Agamben, *Profanations*, trans. Jeff Fort (New York: Zone Press, 2007), 77. Original quote in Spanish in *Profanaciones* (Barcelona: Anagrama, 2005), 100.

3 Ibid, 87 (*Profanaciones*, 114).

4 Harun Farocki, production statement: http://www.farocki-film.de/ (accessed February 10, 2010).

5 Ibid.

6 Slavoj Žižek, *Welcome to the Desert of the Real* (London, New York: Verso, 2002), 11.

7 Giorgio Agamben, *Homo Sacer: Sovereign Power and Bare Life*, trans. Daniel Heller-Roazen (Palo Alto, CA: Stanford University Press, 1998), 12. Original quote in Spanish in *Homo Sacer. El poder soberano y la nuda vida* (Valencia, Spain: Pre-Textos, 2003), 18–19.

CATALOGUE OF THE EXHIBITION

Vito Acconci
American, born 1940

Following Piece, 1969 fig. 24
Gelatin silver prints
Two prints, each: 5 x 4 3/4 in.
(12.7 x 12.1 cm)
Collection of Robin Wright and
Ian Reeves, San Francisco

s *Reception Room (Modern Art Agency, Naples, March 1973),* 1973
Gelatin silver and chromogenic prints,
acetate, and wax pencil on board
Four elements, each: 30 x 40 in.
(76.2 x 101.6 cm)
Collection of Chara Schreyer,
San Francisco

Acme Newspictures
Founded 1923, New York, New York

s *U.S. Bomber Goes Down in Action Over Germany,* 1944
Gelatin silver print
8 7/16 x 6 11/16 in. (21.4 x 17 cm)
San Francisco Museum of Modern Art,
Accessions Committee Fund purchase

Eddie Adams
American, 1933–2004

s *Viet Cong Officer Executed,* 1968 pl. 91
Gelatin silver print
6 1/2 x 9 1/4 in. (16.5 x 23.5 cm)
Collection of Alan Lloyd Paris

Merry Alpern
American, born 1955

T *Dirty Windows,* 1994
Gelatin silver prints
Twelve prints, each: 17 3/4 x 12 in.
(45.1 x 30.5 cm)
Wilson Centre for Photography,
London

s *Dirty Windows #6,* 1994
Gelatin silver print
17 3/4 x 12 in. (45.1 x 30.5 cm)
San Francisco Museum of Modern Art,
Foto Forum purchase

s *Dirty Windows #14,* 1994 pl. 53
Gelatin silver print
17 3/4 x 12 in. (45.1 x 30.5 cm)
San Francisco Museum of Modern Art,
Foto Forum purchase

s *Dirty Windows #16,* 1994 pl. 54
Gelatin silver print
17 3/4 x 12 in. (45.1 x 30.5 cm)
San Francisco Museum of Modern Art,
gift of the Bonni Benrubi Gallery

Shopping #16, 1999 pl. 153
Dye destruction print
16 1/2 x 23 in. (41.9 x 58.4 cm)
San Francisco Museum of Modern Art,
Accessions Committee Fund purchase

Shopping #35, 1999
Dye destruction print
16 3/4 x 23 in. (42.6 x 58.4 cm)
San Francisco Museum of Modern Art,
Accessions Committee Fund purchase

Nobuyoshi Araki
Japanese, born 1940

s *Kinbaku (Bondage),* from the series
Love in Winter, 1979, printed 2008 pl. 58
Gelatin silver print
8 7/8 x 11 1/4 in. (22.5 x 28.6 cm)
San Francisco Museum of Modern Art,
Accessions Committee Fund purchase

Untitled, from the series
Pseudo-Reportage, 1980
Gelatin silver print
11 3/4 x 16 in. (29.9 x 40.6 cm)
San Francisco Museum of Modern Art,
Accessions Committee Fund purchase

Associated Press
Founded 1848, United States

s *Italian Bomber Downed in Attack on British Convoy,* 1942
Gelatin silver print
11 3/8 x 16 in. (28.9 x 40.6 cm)
Collection of Alan Lloyd Paris

*Dallas, Texas, November 22, 1963,
Just Before Kennedy Shot,* 1963
Facsimile transmission print
6 x 9 in. (15.2 x 22.9 cm)
San Francisco Museum of Modern Art,
Foto Forum purchase

Johannesburg, South Africa—Jumps to Death, 1975
Gelatin silver print
8 11/16 x 5 7/8 in. (22 x 15 cm)
George Eastman House, Rochester,
New York

Johannesburg, South Africa—On the Edge, 1975 pl. 98
Gelatin silver print
5 13/16 x 9 in. (14.7 x 22.8 cm)
George Eastman House, Rochester,
New York

New York—Bank Bandit Exits After Haul, 1975 pl. 147
Gelatin silver print
8 7/8 x 5 1/2 in. (22.5 x 14 cm)
George Eastman House, Rochester,
New York

Richard Avedon
American, 1923–2004

s *Andy Warhol, artist, New York, August 20, 1969,* 1969 pl. 77
Gelatin silver print
60 3/4 x 48 3/4 in. (154.3 x 123.8 cm)
Pilara Family Foundation,
San Francisco

Doris Banbury
American, born 1930

Eddie Fisher, 1950s
Gelatin silver print
2 7/8 x 4 3/8 in. (7.3 x 11.1 cm)
San Francisco Museum of Modern Art,
Accessions Committee Fund purchase

Mamie Van Doren, 1950s pl. 67
Gelatin silver print
4 x 3 in. (10.2 x 7.6 cm)
San Francisco Museum of Modern Art,
Accessions Committee Fund purchase

Tallulah Bankhead, 1957
Gelatin silver print
4 x 3 in. (10.6 x 7.6 cm)
San Francisco Museum of Modern Art,
Accessions Committee Fund purchase

Stephen Barker
American, born 1956

Untitled, from the series
Nightswimming, N.Y.C., 1993–94 pl. 52
Gelatin silver print
20 x 24 in. (50.8 x 61 cm)
San Francisco Museum of Modern Art,
Accessions Committee Fund purchase

Letizia Battaglia
Italian, born 1935

*Dead man lying on a garage ramp,
Palermo, Italy,* 1977
Gelatin silver print
18 13/16 x 12 3/4 in. (47.8 x 49.7 cm)
International Center of Photography,
New York, gift of the photographer
to the W. Eugene Smith Legacy
Collection, 2007

Felice Beato
British, born Italy, 1832–1909

Interior of the Angle of North Fort on August 21, 1860, 1860
Albumen silver print
9 13/16 x 11 11/16 in. (24.9 x 30.2 cm)
Partial gift from the Wilson Centre
for Photography. The J. Paul Getty
Museum, Los Angeles

Denis Beaubois
Australian, born Republic of
Mauritius, 1970

In the event of Amnesia the city will recall . . .
Parts I & 2: Sydney & Cleveland
Performances, 1996–97 fig. 25
Single-channel black-and-white video
with sound, 7:41 min.
Courtesy the artist

Murray Becker
American, 1909–1986

s *Crash of the Hindenburg,* 1937
Gelatin silver print
10 1/2 x 13 1/2 in. (26.7 x 34.3 cm)
San Francisco Museum of Modern Art,
Accessions Committee Fund purchase

Auguste Belloc
French, ca. 1800–ca. 1868

Untitled, ca. 1860 pl. 39
Albumen stereograph
3 1/8 x 6 5/16 in. (8 x 16 cm)
La Bibliothèque nationale de France,
Paris, Département des Estampes et de
la photographie

Untitled, ca. 1860
Albumen stereograph
3 1/8 x 6 5/16 in. (8 x 16 cm)
La Bibliothèque nationale de France,
Paris, Département des Estampes et de
la photographie

E. J. Bellocq
American, 1873–1949

Storyville Portrait, ca. 1912,
printed later pl. 43
Gold-toned printing-out paper print
10 x 8 in. (25.4 x 20.3 cm)
San Francisco Museum of Modern Art,
gift of Lise Jeantet

Harry Benson
Scottish, born 1929

s *Los Angeles, Ethel Pleads on Kennedy's Behalf,* 1968 pl. 94
Gelatin silver print
6 7/8 x 9 3/4 in. (17.5 x 24.8 cm)
Collection of Alan Lloyd Paris

Attributed to Jacques-André Boiffard and Man Ray
French, 1902–1961; American,
1890–1976

Seabrook, Justine in Mask, 1930 pl. 42
Gelatin silver print
9 5/16 x 7 3/8 in. (23.7 x 18.7 cm)
The J. Paul Getty Museum, Los Angeles

Guy Bourdin
French, 1928–1991

Charles Jourdan Advertisement, Spring 1975, 1975 pl. 60
Chromogenic print
24 x 32 in. (60.9 x 81.2 cm)
San Francisco Museum of Modern Art, gift of the estate of Guy Bourdin

20 ans (20 years), ca. 1977
Chromogenic print
24 x 36 1/16 in. (61 x 91.6 cm)
San Francisco Museum of Modern Art, gift of the estate of Guy Bourdin

Brassaï (Gyula Halász)
French, born Hungary, 1899–1984

A Man Dies in the Street, 1932 pl. 20
Gelatin silver prints
Eight prints, overall: 14 1/2 x 92 in. (36.8 x 233.7 cm)
Private collection

Lovers in a Small Café, near the Place d'Italie, 1932, printed 1960
Gelatin silver print
11 1/8 x 8 7/8 in. (28.3 x 22.5 cm)
Private collection

At Suzy's, ca. 1932 pl. 47
Gelatin silver print
7 1/16 x 9 5/8 in. (17.9 x 24.5 cm)
Edwynn Houk Gallery, New York

Malcolm Browne
American, born 1931

s *Thich Quang Duc, Buddhist priest in Southern Vietnam, burns himself to death to protest the government's torture policy against priests, June 11, 1963*, 1963 pl. 90
Gelatin silver print
7 3/16 x 8 11/16 in. (18.3 x 22.1 cm)
Collection of Alan Lloyd Paris

Bureau of Inverse Technology
Established Melbourne, Australia, 1992

BIT Plane, 1999 fig. 27
Single-channel black-and-white video with sound, 13 min.
Courtesy the artists

Bill Burke
American, born 1943

s *Hôpital Calmette, Phnom Penh*, ca. 1990, printed 2008 pl. 104
Gelatin silver print
14 1/4 x 21 in. (36.2 x 53.3 cm)
San Francisco Museum of Modern Art, Accessions Committee Fund purchase

Harry Callahan
American, 1912–1999

Chicago, from the series *Women Lost in Thought*, 1950 pl. 28
Gelatin silver print
8 3/8 x 12 7/16 in. (21.3 x 31.6 cm)
Private collection

Chicago, from the series *Women Lost in Thought*, 1950 pl. 29
Gelatin silver print
8 3/8 x 12 7/16 in. (21.3 x 31.6 cm)
Private collection

T *Chicago*, from the series *Women Lost in Thought*, 1950
Gelatin silver print
8 3/8 x 12 7/16 in. (21.3 x 31.6 cm)
Private collection, San Francisco

Atlanta, 1984 pl. 33
Dye transfer print
9 1/2 x 14 7/16 in. (24.1 x 36.7 cm)
San Francisco Museum of Modern Art, Accessions Committee Fund purchase

Sophie Calle
French, born 1953

T *Room 28*, from the series *The Hotel*, 1981
Chromogenic prints with offset lithography and gelatin silver prints
Two prints, overall: 84 1/4 x 56 in. (214 x 142 cm)
Tate Gallery Foundation. Presented by the Patrons of New Art through the Tate Gallery Foundation, 1999

T *Room 29*, from the series *The Hotel*, 1981
Chromogenic prints with offset lithography and gelatin silver prints
Two prints, overall: 84 1/4 x 56 in. (214 x 142 cm)
Tate Gallery Foundation. Presented by the Patrons of New Art through the Tate Gallery Foundation, 1999

s *Room 25*, from the series *The Hotel*, 1981 pl. 154
Chromogenic prints with offset lithography and gelatin silver prints
Two prints, overall: 84 1/4 x 56 in. (214 x 142 cm)
The Doris and Donald Fisher Collection, San Francisco

T *Room 44*, from the series *The Hotel*, 1981
Chromogenic prints with offset lithography and gelatin silver prints
Two prints, overall: 84 1/4 x 56 in. (214 x 142 cm)
Tate Gallery Foundation. Presented by the Patrons of New Art through the Tate Gallery Foundation, 1999

T *Room 47*, from the series *The Hotel*, 1981
Chromogenic prints with offset lithography and gelatin silver prints
Two prints, overall: 84 1/4 x 56 in. (214 x 142 cm)
Tate Gallery Foundation. Presented by the patrons of New Art through the Tate Gallery Foundation, 1999

The Shadow, 1981
Gelatin silver prints, chromogenic print, offset lithography
22 parts, overall: 75 x 115 in. (190.5 x 292.1 cm)
The Museum of Contemporary Art, Los Angeles, gift of Judy and Stuart Spence

Henri Cartier-Bresson
French, 1908–2004

T *Hyères, France*, 1932
Gelatin silver print
11 x 13 13/16 in. (28 x 35 cm)
Tate Gallery Foundation, bequeathed by Barbara Lloyd 2008

s *Calle Cuauhtemoctzin, Mexico City*, 1934 pl. 21
Gelatin silver print
7 x 9 7/8 in. (17.8 x 25.1 cm)
San Francisco Museum of Modern Art, purchase through a gift of Randi and Bob Fisher, Lisa and John Pritzker, and the Accessions Committee Fund

T *Mexico City, 1934*, 1934
Gelatin silver print
6 x 8 15/16 in. (15.3 x 22.7 cm)
Fondation Henri Cartier-Bresson

Prostitutes, Calle Cuauhtemoctzin, Mexico City, 1934, printed 1946 pl. 46
Gelatin silver print
s 9 3/16 x 13 5/8 in. (23.3 x 34.6 cm)
Metropolitan Museum of Art, New York, Ford Motor Company Collection, gift of Ford Motor Company and John C. Waddell, 1987
T 6 x 8 15/16 in. (15.2 x 22.7 cm)
Fondation Henri Cartier-Bresson

Charles Henri Ford, Paris, 1935 pl. 23
Gelatin silver print
6 3/8 x 9 3/8 in. (16.2 x 23.8 cm)
San Francisco Museum of Modern Art, purchase through a gift of Byron R. Meyer

T *Interior with Marilyn Monroe*, ca. 1960, printed later
Gelatin silver print
9 1/4 x 14 in. (23.5 x 35.5 cm)
Tate Gallery Foundation, bequeathed by Barbara Lloyd 2008

Paul Emile Chappuis
English, born France, 1816–1887

A Peep Through the Key-Hole (Coup d'oeil indiscret), ca. 1875
Albumen stereograph
3 5/16 x 6 7/8 in. (8.4 x 17.4 cm)
George Eastman House, Rochester, New York

Rudolf Cisar
Czech, active 1940s

[Clandestine photograph taken at Dachau], 1943, printed 2010 pl. 121
Gelatin silver print
4 3/4 x 6 5/16 in. (12 x 16 cm)
KZ-Gedenkstätte Dachau (Dachau Concentration Camp Memorial Site)

Larry Clark
American, born 1943

Untitled, from the portfolio *Tulsa*, 1971, printed 1980 pl. 107
Gelatin silver print
8 x 12 in. (20.3 x 30.5 cm)
San Francisco Museum of Modern Art, gift of Gary Roubos

Untitled, from the portfolio *Tulsa*, 1971, printed 1980
Gelatin silver print
8 x 12 in. (20.3 x 30.5 cm)
San Francisco Museum of Modern Art, gift of Gary Roubos

s *Brother and Sister*, from the series *Teenage Lust*, 1972
Gelatin silver print
11 x 14 in. (27.9 x 35.6 cm)
Pilara Family Foundation, San Francisco

Jordan Crandall
American, born 1960

Drive, Track 3, 2000 pl. 162
Single-channel color video installation with sound, 22:30 min.
Dimensions variable
Courtesy the artist

Criminal Record Office
Great Britain

Surveillance Photograph of Militant Suffragettes, ca. 1913 pl. 120
Gelatin silver print and offset lithography
Overall: 5 1/2 x 8 1/2 in. (14 x 21.6 cm)
National Portrait Gallery, London

Bill Dane
American, born 1938

San Francisco, 1973 pl. 30
Gelatin silver print
6 3/4 x 4 1/2 in. (17.2 x 11.4 cm)
San Francisco Museum of Modern Art, gift of the artist

Untitled, ca. 1972–85
Gelatin silver print
10 1/4 x 15 1/2 in. (26 x 39.4 cm)
Collection of Joe and Pamela Bonino

Edgar Degas
French, 1834–1917

s *Nu féminin mettant ses bas*
(Seated Nude), 1895 pl. 37
Gelatin silver print
6 11/16 x 4 3/4 in. (17 x 12.1 cm)
The J. Paul Getty Museum, Los Angeles

Thomas Demand
German, born 1964

Camera, 2007 pl. 132
HD-video projection with stereo
sound, color, 1:40 min.
Dimensions variable
Sprüth Magers Berlin London and
Matthew Marks Gallery, New York

Lucinda Devlin
American, born 1947

*Lethal Injection Chamber from
Family Witness Room, Parchman State
Penitentiary, Parchman, Mississippi, 1998*,
1998 pl. 102
Chromogenic print
29 x 29 in. (73.7 x 73.7 cm)
San Francisco Museum of Modern Art,
Accessions Committee Fund purchase

Philip-Lorca diCorcia
American, born 1951

т *Head #4*, from the series *Heads*, 2001
Chromogenic print
48 x 60 in. (121.9 x 152.4 cm)
Sprüth Magers, London

Head #10, from the series *Heads*,
2001 pl. 32
Chromogenic print
48 x 60 in. (121.9 x 152.4 cm)
s Pilara Family Foundation,
San Francisco
т Courtesy the artist and David Zwirner,
New York

т *Head #23*, from the series *Heads*, 2001
Chromogenic print
48 x 60 in. (121.9 x 152.4 cm)
Courtesy the artist and David Zwirner,
New York

Louis-Camille d'Olivier
French, 1827–after 1870

Composition avec nu (Reclining Nude),
1853–56 pl. 36
Salt print
2 9/16 x 2 3/8 in. (6.5 x 6 cm)
George Eastman House, Rochester,
New York

Elena Dorfman
American, born 1965

s *Rebecca 2*, from the series *Still Lovers*,
2001 pl. 59
Chromogenic print
29 1/2 x 29 1/2 in. (74.9 x 74.9 cm)
San Francisco Museum of Modern Art,
purchase through a gift of Mary and
Thomas Field

Georges Dudognon
French, 1922–2001

Greta Garbo in the Club St. Germain,
1950s pl. 78
Gelatin silver print
7 1/16 x 7 1/8 in. (17.9 x 18.1 cm)
San Francisco Museum of Modern Art,
Foto Forum purchase

**Jimmie A. Duncan, U.S. Army
Photograph Agency**
American, active 1960s

Anti-Vietnam Demonstration
[Cameramen, still and motion
picture, document the anti-Vietnam
demonstration at the Pentagon],
1967, printed 2010 pl. 144
Chromogenic print
3 x 4 in. (7.6 x 10.2 cm)
National Archives, Washington, D.C.

Eastman Kodak Company
Established 1892, Rochester, New York

Kodak Ektra 90° finder, ca. 1950
Dimensions variable
George Eastman House, Rochester,
New York

Harold Eugene Edgerton
American, 1903–1990

Pentagon, 1940s pl. 141
Gelatin silver print
10 x 7 1/2 in. (25.4 x 19.1 cm)
San Francisco Museum of Modern Art,
gift of the Harold and Esther Edgerton
Family Foundation

Morris Engel
American, 1918–2005

Shoeshine Boy with Cop, 1947
Gelatin silver print
13 3/8 x 10 3/8 in. (34 x 26.4 cm)
Sack Photographic Trust of the
San Francisco Museum of Modern Art

Horace Engle
American, 1861–1949

Untitled (Interior of a Streetcar), 1888,
printed 1972 pl. 4
Gelatin silver print
8 9/16 in. (21.7 cm) diameter
The Museum of Modern Art, New York,
gift of Edward Leos

Untitled (People Watching a Fire), 1896,
printed 1972
Gelatin silver print
8 1/2 in. (21.7 cm) diameter
The Museum of Modern Art, New York,
gift of Edward Leos

Bill Eppridge
American, born Argentina, 1938

[*At lamppost on Broadway and West
71st Street, Karen, heroin addict and
prostitute, does some drug peddling,
New York*], 1965 pl. 128
Gelatin silver print
13 3/16 x 8 3/4 in. (33.5 x 22.2 cm)
International Center of Photography,
New York, The LIFE Magazine
Collection, 2005

[*Juan Romero, busboy at Ambassador
Hotel in Los Angeles, kneels to help
fallen Senator Robert F. Kennedy after
he was shot by Jordanian fanatic
Sirhan B. Sirhan*], 1968 pl. 95
Gelatin silver print
9 3/16 x 7 1/2 in. (23.3 x 19.1 cm)
International Center of Photography,
New York, The LIFE Magazine
Collection, 2005

Mitch Epstein
American, born 1952

Untitled, New York #22, 1997, from the
series *The City*, 1997 pl. 158
Chromogenic print
22 5/8 x 28 in. (57.5 x 71.1 cm)
San Francisco Museum of Modern Art,
gift of The Peter T. Joseph Foundation

Untitled, New York #1, 1998, from the
series *The City*, 1998 pl. 35
Chromogenic print
23 1/2 x 28 7/8 in. (59.7 x 73.3 cm)
San Francisco Museum of Modern Art,
gift of The Peter T. Joseph Foundation

Walker Evans
American, 1903–1975

[*Street Scene, New York*], 1928 pl. 19
Gelatin silver print
7 1/8 x 5 1/16 in. (18.1 x 12.9 cm)
San Francisco Museum of Modern Art,
purchase

[*Street Scene, Selma*], 1935
Gelatin silver print
5 3/4 x 6 3/8 in. (14.6 x 16.2 cm)
Promised gift of Paul Sack to the
Sack Photographic Trust of the
San Francisco Museum of Modern Art

[*Fireplace in Bedroom, Burroughs Family
Cabin, Hale County, Alabama*], 1936 pl. 11
Gelatin silver print
9 5/8 x 7 5/8 in. (24.5 x 19.4 cm)
Promised gift of Paul Sack to the
Sack Photographic Trust of the
San Francisco Museum of Modern Art

[*Sick Flood Refugee in the Red Cross
Temporary Infirmary, Forrest City,
Arkansas*], 1937 pl. 9
Gelatin silver print
7 x 9 in. (17.8 x 22.9 cm)
Promised gift of Paul Sack to the
Sack Photographic Trust of the
San Francisco Museum of Modern Art

[*Subway Passengers, New York*], 1938
Gelatin silver print
4 7/8 x 7 in. (12.4 x 17.8 cm)
San Francisco Museum of Modern Art,
Margery Mann Memorial Collection,
gift of Tom Vasey

[*Subway Passenger, New York*], 1938 pl. 17
Gelatin silver print
4 3/4 x 5 3/4 in. (12.1 x 14.6 cm)
Fractional and promised gift of
Carla Emil and Rich Silverstein to the
San Francisco Museum of Modern Art

[*Subway Passenger, New York*], 1941 pl. 18
Gelatin silver print
4 3/4 x 5 3/4 in. (12.1 x 14.6 cm)
Fractional and promised gift of
Carla Emil and Rich Silverstein to the
San Francisco Museum of Modern Art

Expo Camera Company
Established New York, 1900s

Expo Watch Camera, ca. 1905
1 x 2 5/16 x 3 5/16 in. (2.5 x 5.8 x 8.3 cm)
George Eastman House, Rochester,
New York

Harun Farocki
German, born Czechoslovakia, 1944

Eye/Machine II, 2002 pl. 160
Single-channel color/black-and-white
video with sound, 15 min.
Courtesy the artist

Gerard P. Fieret
Dutch, 1924–2009

s *Untitled*, 1967
Gelatin silver print
15 1/2 x 11 3/4 in. (39.4 x 29.9 cm)
Leiden University Library,
The Netherlands

Robert Frank
American, born Switzerland, 1924

т *On the road, Peru*, 1949
Gelatin silver print
13 x 6 7/8 in. (33 x 17.5 cm)
Tate Gallery Foundation, bequeathed
by Barbara Lloyd 2008

New York City, 1954 pl. 1
Gelatin silver print
9 3/4 x 13 1/2 in. (24.8 x 34.3 cm)
San Francisco Museum of Modern Art,
Foto Forum purchase

New York City, from *The Americans*, 1955, printed 1977 pl. 45
Gelatin silver print
13 1/8 x 8 3/4 in. (33.3 x 22.2 cm)
San Francisco Museum of Modern Art, gift of Dr. and Mrs. Barry S. Ramer

Hollywood—The Man with the Golden Arm, 1956, printed 1970s
Gelatin silver print
4 1/4 x 13 in. (10.8 x 33 cm)
San Francisco Museum of Modern Art, Accessions Committee Fund purchase

Lee Friedlander
American, born 1934

T *New York City, 1966*, 1966
Gelatin silver print
13 7/8 x 11 in. (35.3 x 28 cm)
Wilson Centre for Photography, London

T *Salinas, CA*, 1972
Gelatin silver print
11 x 13 15/16 in. (28 x 35.4 cm)
Wilson Centre for Photography, London

Ron Galella
American, born 1931

Summer in Skorpios, Jackie Taking a Swim, Skorpios, Greece, August 25, 1970, 1970
Gelatin silver print
7 3/4 x 10 in. (19.7 x 25.4 cm)
San Francisco Museum of Modern Art, Accessions Committee Fund purchase

What Makes Jackie Run? Central Park, New York City, October 4, 1971, 1971 pl. 76
Gelatin silver print
7 3/8 x 9 7/8 in. (18.7 x 25.1 cm)
San Francisco Museum of Modern Art, Accessions Committee Fund purchase

Marc Garanger
French, born 1935

s *Femme Algérienne*, 1960 pl. 130
Gelatin silver print
10 1/2 x 10 1/2 in. (26.7 x 26.7 cm)
San Francisco Museum of Modern Art, Accessions Committee Fund purchase

s *Femme Algérienne*, 1960
Gelatin silver print
10 1/2 x 10 1/2 in. (26.7 x 26.7 cm)
San Francisco Museum of Modern Art, Accessions Committee Fund purchase

s *Femme Algérienne*, 1960 pl. 131
Gelatin silver print
10 1/2 x 10 1/2 in. (26.7 x 26.7 cm)
San Francisco Museum of Modern Art, Accessions Committee Fund purchase

Alexander Gardner
American, born Scotland, 1821–1882

A Sharpshooter's Last Sleep, Gettysburg, Pennsylvania, 1863
Albumen print
7 x 9 in. (17.8 x 22.9 cm)
San Francisco Museum of Modern Art, Accessions Committee Fund purchase

Execution of the Presidential Conspirators, Lowering the Bodies, July 7, 1865, 1865 pl. 118
Albumen print
6 7/8 x 9 1/8 in. (17.5 x 23.2 cm)
San Francisco Museum of Modern Art, fractional gift of Paul Sack, and collection of the Sack Photographic Trust of the San Francisco Museum of Modern Art

Dave Gatley
American, born 1943

Ghostly view thru an older U.S. military version truck-mounted, cryogenic-cooled, thermal infrared imaging scope showing U.S. Border Patrol vehicles moving on a dirt road along the U.S./Mexico Border, ca. 1983 pl. 112
Gelatin silver print
10 1/2 x 13 1/2 in. (26.7 x 34.3 cm)
San Francisco Museum of Modern Art, Accessions Committee Fund purchase

Arnold Genthe
American, born Germany, 1869–1942

Merchant and Body Guard, Old Chinatown, San Francisco, ca. 1896–1906, printed ca. 1920 pl. 13
Gelatin silver print
8 7/8 x 12 5/8 in. (22.5 x 32.1 cm)
San Francisco Museum of Modern Art, Accessions Committee Fund purchase

Marcello Geppetti
Italian, 1933–1998

Albergo Ambasciatori (Incendio) (Fire at the Hotel Ambassador), 1959 pl. 100
Gelatin silver prints
Four prints, from a series of eight;
two: 8 x 10 in. (20.3 x 25.4 cm),
two: 10 x 8 in. (25.4 x 20.3 cm)
Collection of Bruce Moore, San Francisco

Elizabeth Taylor and Richard Burton, 1962 pl. 71, fig. 17
Gelatin silver prints
Four prints, each: 8 x 10 1/2 in. (20.3 x 26.7 cm)
Courtesy Stephen Wirtz Gallery, San Francisco

Nan Goldin
American, born 1953

s *The Ballad of Sexual Dependency*, 1979–96 pl. 64
Nine-carousel slide projection with soundtrack and titles
Dimensions variable
Whitney Museum of American Art, New York; purchase, with funds from The Charles Engelhard Foundation, the Mrs. Percy Uris Bequest, the Painting and Sculpture Committee, and the Photography Committee

T *The Ballad of Sexual Dependency*, 1979–2008
35mm slides transferred to video with soundtrack
Dimensions variable
Courtesy the artist and Matthew Marks Gallery, New York

Alair Gomes
Brazilian, 1921–1992

Beach Triptych no. 7, ca. 1980 pl. 157
Gelatin silver prints
Three prints, each: 14 x 10 13/16 in. (35.5 x 27.5 cm)
Fondation Cartier pour l'art contemporain, Paris

John Goodman
American, born 1947

Tremont Street #3, Boston, 1978
Gelatin silver print
12 x 18 in. (30.5 x 45.7 cm)
San Francisco Museum of Modern Art, purchase through a gift of Haluk and Elisa Soykan

Richard Gordon
American, born 1945

Chicago, Coffee Shop, 2003
Gelatin silver print
16 3/4 x 11 1/8 in. (42.6 x 28.3 cm)
San Francisco Museum of Modern Art, Accessions Committee Fund purchase

Emeryville, Post Office, 2003
Gelatin silver print
11 1/8 x 16 3/4 in. (28.3 x 42.6 cm)
San Francisco Museum of Modern Art, Accessions Committee Fund purchase

San Francisco, 2004 pl. 164
Gelatin silver print
16 3/4 x 11 1/8 in. (42.6 x 28.3 cm)
San Francisco Museum of Modern Art, Accessions Committee Fund purchase

San Francisco, Cal Train, 2005
Gelatin silver print
16 3/4 x 11 1/8 in. (42.6 x 28.3 cm)
San Francisco Museum of Modern Art, Accessions Committee Fund purchase

John Gossage
American, born 1946

Untitled, from *There and Gone* [Cover], 1996 pl. 151
Gelatin silver print and coffee on board
10 x 8 in. (25.4 x 20.3 cm)
San Francisco Museum of Modern Art, Accessions Committee Fund purchase

Untitled, from *There and Gone* [#011], 1996
Gelatin silver print and coffee on board
10 x 8 in. (25.4 x 20.3 cm)
San Francisco Museum of Modern Art, Accessions Committee Fund purchase

R. D. Gray
American, active 1880s

Concealed Vest Camera, ca. 1886
5 7/8 in. (14.9 cm) diameter,
2 3/8 in. (6 cm) depth
George Eastman House, Rochester, New York

Anthony Hernandez
American, born 1947

s *Landscapes for the Homeless #24*, 1989 pl. 34
Dye destruction print
50 x 73 1/2 in. (127 x 186.7 cm)
Hammer Museum, Los Angeles

**Rudolph Herrmann
(Dalibar Valouschek)**
Czech, active 1968–1977

[FBI surveillance photograph, Soviet KGB agent at dead drop (meeting place), Westchester, New York], ca. 1980, pl. 126
Gelatin silver print
8 x 10 in. (20.3 x 25.4 cm)
National Archives, Washington, D.C.

Lewis Wickes Hine
American, 1874–1940

Little spinner in Mollahan Cotton Mills, Newberry, South Carolina. Many others as small. Dec. 3/08 Witness Sara R. Hine. Location: Newberry, South Carolina, 1908
Gelatin silver print
4 7/8 x 6 5/8 in. (12.4 x 16.8 cm)
Promised gift of Paul Sack to the Sack Photographic Trust of the San Francisco Museum of Modern Art

T *One of the Smallest Spinners in a South Carolina Mill*, 1908
Gelatin silver print
4 3/4 x 6 5/16 in. (12 x 16 cm)
Wilson Centre for Photography, London

Sweepers and Mule-Room Boys, River Point, Rhode Island. Boy left hand end, Manuel Mites has been in mill 2 years. Clinton Silvey and Louis Perry (centre boys) have been in mill 1 year and said they are now 12 years old. Boy on right hand Manuel Silvey has been in mill 1 year. (They could not speak English.) Location: River Point, Rhode Island, 1909
Gelatin silver print
4 1/4 x 5 3/4 in. (10.8 x 14.6 cm)
San Francisco Museum of Modern Art,
Anonymous Fund purchase

Noon hour Knoxville Cotton Mill. Location: Knoxville, Tennessee, 1910
Gelatin silver print
4 5/8 x 6 5/8 in. (11.8 x 16.8 cm)
San Francisco Museum of Modern Art,
purchase

"Our Baby Doffer" they called him. This is one of the machines he has been working at for some months at the Avondale Mills. Said, after hesitation, "I'm 12," and another small boy added, "He can't work unless he's 12." Child labor regulations conspicuously posted in the mill. Location: Birmingham, Alabama, 1910 pl. 6
Gelatin silver print
4 5/8 x 6 5/8 in. (11.8 x 16.8 cm)
San Francisco Museum of Modern Art,
gift of Demetrios Scourtis

т *Child Workers in a Pennsylvania Coal Breaker*, 1911
Gelatin silver print
9 1/2 x 7 1/2 in. (24.1 x 19.1 cm)
Wilson Centre for Photography,
London

s *Noon hour in the Ewen Breaker, Pennsylvania Coal Co. Location: South Pittston, Pennsylvania*, 1911 pl. 8
Gelatin silver print
7 13/16 x 4 3/4 in. (19.8 x 12.1 cm)
Pilara Family Foundation,
San Francisco

Old Man Carrying Garments, Delaney Street, New York. Location: New York, New York, 1912
Gelatin silver print
4 1/2 x 6 1/16 in. (11.4 x 15.4 cm)
San Francisco Museum of Modern Art,
Accessions Committee Fund purchase

William Willoughby Hooper
British, 1837–1912

Child born of famine-stricken mother. Age 3 mos. Weight 3 lbs., ca. 1877 pl. 83
Albumen silver print bound in album
4 1/16 x 6 1/8 in. (10.3 x 15.6 cm)
The J. Paul Getty Museum, Los Angeles

Tom Howard
American, active 1920s

The Electrocution of Ruth Snyder, 1928 pl. 89
Gelatin silver print
4 x 4 in. (10.2 x 10.2 cm)
San Francisco Museum of Modern Art,
Accessions Committee Fund purchase

The Electrocution of Ruth Snyder, 1928
Gelatin silver print
1 1/4 x 2 1/4 in. (3.2 x 5.7 cm)
San Francisco Museum of Modern Art,
Accessions Committee Fund purchase

Sanja Iveković
Croatian, born 1949

s *Triangle 2000+*, 1979 pl. 134
Gelatin silver prints
Four prints, each: 11 13/16 x 15 3/4 in.
(30 x 40 cm)
Moderna galerija / Museum of
Modern Art, Ljubljana

Emily Jacir
Palestinian, born 1970

linz diary, 2003 pl. 143, fig. 23
Chromogenic prints
Twenty-six prints, each: 8 x 8 3/4 in.
(20.3 x 22.2 cm)
San Francisco Museum of Modern Art,
Accessions Committee Fund purchase

Alison Jackson
British, born 1960

Jack Road Rage, from the series
Confidential, 2007
Chromogenic print
16 x 12 in. (40.6 x 30.5 cm)
s Courtesy the artist and M+B Gallery,
Los Angeles
т Courtesy the artist and Hamiltons
Gallery, London

The Queen plays with her Corgies, from
the series *Confidential*, 2007 pl. 80
Chromogenic print
16 x 12 in. (40.6 x 30.5 cm)
s Courtesy the artist and M+B Gallery,
Los Angeles
т Courtesy the artist and Hamiltons
Gallery, London

Yale Joel
American, 1919–2006

[Man adjusting overcoat and grimacing while looking in trick one-way mirror, lobby of Broadway movie theater, Times Square, New York], 1946 pl. 148
Gelatin silver print
9 5/16 x 7 5/8 in. (23.7 x 19.4 cm)
International Center of Photography,
New York, The LIFE Magazine
Collection, 2005

[Woman moistening her lips, as others are checking out their own profiles, while looking in trick one-way mirror, in lobby of Broadway movie theatre, Times Square, New York], 1946 pl. 150
Gelatin silver print
9 3/8 x 7 5/8 in. (23.8 x 19.4 cm)
International Center of Photography,
New York, The LIFE Magazine
Collection, 2005

George E. Kelly
American, born England, 1881–1911

[View from a Wright Model B biplane over airfield near San Francisco, California, made with a folding camera], 1911 pl. 108
Gelatin silver print
9 5/8 x 7 13/16 in. (24.4 x 19.8 cm)
George Eastman House, Rochester,
New York

Keystone Pictures, Inc.
Active 1940s, New York

The Nazis Burn the Living [Gardelegen, Germany], 1945 pl. 87
Gelatin silver print
5 x 7 in. (12.7 x 17.8 cm)
National Archives, Washington, D.C.

Michael Klier
German, born Czechoslovakia, 1943

Der Riese (The Giant), 1982–83 pl. 161
Single-channel color/black-and-white
video with sound, 82 min.
Courtesy the artist

Shai Kremer
Israeli, born 1974

Urban Warfare Training Center, Panorama, Tze'elim, 2007 pl. 116
Chromogenic print
20 x 83 in. (50.8 x 210.8 cm)
San Francisco Museum of Modern Art,
Accessions Committee Fund purchase

Dorothea Lange
American, 1895–1965

White Angel Breadline, San Francisco, 1933 pl. 14
Gelatin silver print
10 x 8 in. (25.4 x 20.3 cm)
San Francisco Museum of Modern Art,
gift of Steven M. Raas and
Sandra S. Raas

Ernst Leitz GmbH
Established 1869, Germany

Leica IIIf, 1951
3 1/2 x 5 3/4 x 3 in. (8.9 x 14.6 x 7.6 cm)
George Eastman House, Rochester,
New York

Helen Levitt
American, 1913–2009

New York, 1939 pl. 26
Gelatin silver print
6 1/4 x 8 13/16 in. (15.9 x 22.4 cm)
San Francisco Museum of Modern Art,
Accessions Committee Fund purchase

New York, ca. 1940
Gelatin silver print
7 1/2 x 4 5/8 in. (19.1 x 11.8 cm)
San Francisco Museum of Modern Art,
purchase through a gift of Paul and
Prentice Sack

New York, 1942 pl. 27
Gelatin silver print
6 1/2 x 5 5/8 in. (16.5 x 14.3 cm)
San Francisco Museum of Modern Art,
Accessions Committee Fund purchase,
gift of the Modern Art Council

Laurie Long
American, born 1960

Compact, from *The Dating Surveillance Project*, 1998 pl. 149
Gelatin silver print
18 3/4 x 23 in. (47.6 x 58.4 cm)
San Francisco Museum of Modern Art,
Accessions Committee Fund purchase

Hairbrush, from *The Dating Surveillance Project*, 1998
Gelatin silver print
18 3/4 x 23 in. (47.6 x 58.4 cm)
San Francisco Museum of Modern Art,
Accessions Committee Fund purchase

Chip Lord
American, born 1944

Abscam (Framed), 1981 fig. 26
Single-channel color/black-and-white
video with sound, 10:17 min.
Courtesy the artist

Benjamin Lowy
American, born 1979

Iraq Perspectives II #8, 2003–7 pl. 129
Chromogenic print
26 x 40 in. (66 x 101.6 cm)
Courtesy the artist

Iraq Perspectives II #29, 2003–7
Chromogenic print
26 x 40 in. (66 x 101.6 cm)
Courtesy the artist

Oliver Lutz
American, born 1973

The Lynching of Leo Frank, 2009 pl. 96
Acrylic on canvas, CCTV System
Painting: 60 x 87 in. (152.4 x 221 cm),
overall dimensions variable
Courtesy the artist

Andreas Magdanz
German, born 1963

Linker Teil der Haupteinfahrt, im Hintergrund Parkplatz auf dem so genannten Bunker Hagen (Left side of the main entrance; in the background is the parking area of the so-called Hagen Bunker), 2005 pl. 137
Digital pigment print
18 1/8 x 23 1/2 in. (46 x 59.7 cm)
San Francisco Museum of Modern Art, Accessions Committee Fund purchase

Rechter Teil der Haupteinfahrt, im Hintergrund der ehemalige Busbahnhof (Right side of the main entrance; in the background is the former bus station), 2005 pl. 136
Digital pigment print
18 1/8 x 23 1/2 in. (46 x 59.7 cm)
San Francisco Museum of Modern Art, purchase through a gift of Jane and Larry Reed

Man Ray
American, 1890–1976

The Transvestite Barbette, Paris, 1926
Gelatin silver prints
Five prints; three: 3 3/8 x 4 3/4 in. (8.6 x 12 cm), two: 4 3/4 x 3 3/8 in. (12 x 8.6 cm)
Collection of Mme. Lucien Treillard

The Transvestite Barbette, Paris, 1926 pl. 44
Gelatin silver print
Dimensions unknown
Collection of Nan Goldin

Robert Mapplethorpe
American, 1946–1989

s *Man in Polyester Suit*, 1980 pl. 57
Gelatin silver print
16 x 20 in. (40.6 x 50.8 cm)
The Robert F. Mapplethorpe Foundation, Inc., New York

Robert Mapplethorpe and Patti Smith
American, 1946–1989; American, born 1946

Untitled I, 1978
Gelatin silver print and graphite
20 x 16 in. (50.8 x 40.6 cm)
Courtesy Paule Anglim, San Francisco

Paul Martin
British, born France, 1864–1942

Listening to the Concert Party in Yarmouth Sands, 1892 pl. 3
Platinum print
3 x 3 11/16 in. (7.6 x 9.4 cm)
Victoria and Albert Museum, London

On Yarmouth Sands, 1892
Platinum print
3 x 3 7/8 in. (7.6 x 9.8 cm)
Victoria and Albert Museum, London

Magazine Seller, Ludgate Circus, ca. 1892
Gelatin silver print
10 1/16 x 13 in. (25.6 x 33 cm)
Victoria and Albert Museum, London

Leonard McCombe
American, born Britain, 1923

[Eyes right is executed with almost military precision by dining car males aboard New York bound 20th Century Limited as Kim Novak eases into a seat], 1956 pl. 74
Gelatin silver print
9 1/4 x 13 1/2 in. (23.5 x 34.3 cm)
International Center of Photography, New York, The LIFE Magazine Collection, 2005

Susan Meiselas
American, born 1948

s *Lena on the Bally Box, Essex Junction, Vermont*, from the series *Carnival Strippers*, 1973
Gelatin silver print
8 x 11 7/8 in. (20.3 x 30.2 cm)
Promised gift of Paul Sack to the Sack Photographic Trust of the San Francisco Museum of Modern Art

t *Keeping the Crowd, Presque Isle, Maine*, from the series *Carnival Strippers*, 1974 pl. 63
Gelatin silver print
11 15/16 x 17 13/16 in. (30.3 x 45.2 cm)
Wilson Centre for Photography, London

t *The Spectator, Turnbridge, Vermont*, from the series *Carnival Strippers*, 1975
Gelatin silver print
11 15/16 x 17 13/16 in. (30.3 x 45.2 cm)
Wilson Centre for Photography, London

"Cuesta del Plomo," a well-known site of many assassinations carried out by the National Guard, where people searched daily for missing persons, Managua, Nicaragua, from the series *Nicaragua*, 1981 pl. 101
Chromogenic print
12 3/4 x 19 in. (32.4 x 48.3 cm)
San Francisco Museum of Modern Art, purchase through a gift of Photo Wings through Suzie Katz and the Anonymous Fund

Security TV IV, New York, from the series *Pandora's Box*, 1995 pl. 61
Chromogenic print
20 x 30 in. (50.8 x 76.2 cm)
Courtesy the artist and Amador Gallery, New York

Enrique Metinides
Mexican, born 1934

Rescate de un ahogado en Xochimilco con público reflejado en el aqua (Rescue of a drowning in Lake Xochimilco with the public reflected in the water), 1960
Gelatin silver print
13 3/4 x 20 3/4 in. (34.9 x 52.7 cm)
San Francisco Museum of Modern Art, Anonymous Fund purchase

Secuencia rescate de un suicide en la cúpula el toreo (Suicide rescue from the top of the Toreo Stadium), 1971 pl. 99
Gelatin silver prints
Six prints: dimensions variable
San Francisco Museum of Modern Art, Accessions Committee Fund purchase

Lee Miller
American, 1907–1977

Bürgermeister of Leipzig's Daughter, Suicided, 1945 pl. 88
Gelatin silver print
6 1/4 x 5 15/16 in. (15.9 x 15.1 cm)
Anthony Penrose Collection, London

Minox
Established ca. 1936, Germany

Minox Model B, ca. 1958
5/8 x 4 x 1 in. (1.6 x 10.2 x 2.5 cm)
Private collection

Pierre Molinier
French, 1900–1976

s *Self-Portrait*, ca. 1966 pl. 41
Gelatin silver print
6 1/4 x 5 15/16 in. (15.9 x 15.1 cm)
San Francisco Museum of Modern Art, Accessions Committee Fund purchase

Felix Jacques Moulin
French, 1800–1868

The Voyeur, ca. 1854 pl. 38
Stereo daguerreotype
2 5/8 x 4 7/8 in. (6.7 x 12.4 cm)
San Francisco Museum of Modern Art, Accessions Committee Fund purchase

Bruce Nauman
American, born 1941

OFFICE EDIT I *(Fat Chance John Cage) Mapping the Studio*, 2001 pl. 163
Single-channel color video projection with sound, 51:44 min.
Dimensions variable
Courtesy Sperone Westwater, New York

Helmut Newton
Australian, born Germany, 1920–2004

t *Untitled*, ca. 1970
Dye diffusion transfer print
2 3/4 x 3 5/8 in. (7 x 9.2 cm)
Courtesy Hamiltons Gallery, London

Woman Examining Man, Saint-Tropez, 1975 pl. 55
Gelatin silver print
70 7/8 X 47 1/4 in. (180 x 120 cm)
Courtesy The Helmut Newton Estate / Maconochie Photography

t *Untitled*, 1979
Dye diffusion transfer print
2 3/4 x 3 5/8 in. (7 x 9.2 cm)
Courtesy Hamiltons Gallery, London

t *Untitled*, ca. 1980
Dye diffusion transfer print
2 3/4 x 3 5/8 in. (7 x 9.2 cm)
Courtesy Hamiltons Gallery, London

t *Self-Portrait with June and Models*, 1981
Gelatin silver print
ca. 15 3/4 x 11 13/16 in. (40 x 30 cm)
Private collection, London

t *Untitled*, ca. 1990
Dye diffusion transfer print
2 3/4 x 3 5/8 in. (7 x 9.2 cm)
Courtesy Hamiltons Gallery, London

Simon Norfolk
British, born Nigeria, 1963

The BBC World Service Atlantic Relay Station at English Bay, from the series *Ascension Island: The Panopticon*, 2003 pl. 114
Chromogenic print
40 x 50 in. (101.6 x 127 cm)
San Francisco Museum of Modern Art, Accessions Committee Fund purchase

Jonathan Olley
British, born 1967

t *British Army firing range, Magilligan Point, Lough Foyle, Co. Londonderry*, 1998
Gelatin silver bromide print
16 x 20 in. (40.6 x 50.8 cm)
Collection of the artist, courtesy Diemar / Noble Photography, London

t *Grosvenor Road RUC Police Station, Grosvenor Road, Central Belfast*, 1998
Gelatin silver bromide print
16 x 20 in. (40.6 x 50.8 cm)
Collection of the artist, courtesy Diemar / Noble Photography, London

t *RUC Police Station and British Army Patrol Base, Strabane, Co. Tyrone*, 1998
Gelatin silver bromide print
16 x 20 in. (40.6 x 50.8 cm)
Collection of the artist, courtesy Diemar / Noble Photography, London

Golf Five Zero watchtower (known to the British army as 'Borucki Sanger'), Crossmaglen Security Force Base, South Armagh, from the series *Castles of Ulster*, 1999 pl. 135
Gelatin silver bromide print
30 x 40 in. (76.2 x 101.6 cm)
Collection of the artist, courtesy Diemar / Noble Gallery, London

Yoko Ono
Japanese, born 1933

s *Rape*, 1968–69 pl. 65
16mm film, color, sound, transferred
to video, 77 min.
Directed by Yoko Ono;
produced by John Lennon
Commissioned for Austrian
Television ORF
Courtesy the artist

Trevor Paglen
American, born 1974

*Chemical and Biological Weapons
Proving Ground / Dugway, UT / Distance
~42 miles / 10:51 a.m., 2006*, 2006 pl. 115
Chromogenic print
50 x 50 in. (127 x 127 cm)
San Francisco Museum of Modern Art,
Anonymous Fund purchase

Gilles Peress
French, born 1946

Nyarubuye, from the series *The Silence*,
1994, printed 2008 pl. 103
Digital pigment prints
Three prints, each: 30 x 44 1/2 in.
(76.2 x 113 cm)
San Francisco Museum of Modern Art,
Accessions Committee Fund purchase
and gift of the artist

**Pierre-Louis Pierson and
Christian Bérard**
French, 1822–1913; French, 1902–1949

т *La comtesse en buste dans un cadre
pleurant dans son mouchoir*
(The Countess of Castiglione weeping
into her handkerchief) From an album
composed in 1930 of eighteen photo-
graphs of the Countess of Castiglione
and three gouaches inspired by her in
1863 and 1866, plate 3, 1863–66 pl. 70
Albumen print
4 3/4 x 5 1/2 in. (12 x 14 cm)
Musée d'Orsay, Paris. Acquired in
the name of the State with help from
HSBC France, 2007

т *Scherzo di Follia* (Game of Madness)
From an album composed in 1930 of
eighteen photographs of the Countess
of Castiglione and three gouaches
inspired by her in 1863 and 1866,
plate 2, 1863–66 fig. 1, pl. 69
Albumen print
5 7/8 x 4 5/16 in. (15 x 11 cm)
Musée d'Orsay, Paris. Acquired in
the name of the State with help from
HSBC France, 2007

т *Les yeux* (The Eyes) From an album
composed in 1930 of eighteen
photographs of the Countess
of Castiglione and three gouaches
inspired by her in 1863 and 1866,
plate 1, 1863–66 pl. 68
Albumen print
7 7/8 x 7 1/2 in. (20 x 19.1 cm)
Musée d'Orsay, Paris. Acquired in
the name of the State with help from
HSBC France, 2007

Peter Piller
German, born 1968

Schlafende Häuser (Sleeping Houses),
from the series *Von Erde schöner*
(More Beautiful from the Ground),
2000–2004 pl. 133
Chromogenic prints
Nine prints, each: 9 13/16 x 9 13/16 in.
(25 x 25 cm)
San Francisco Museum of Modern Art,
Accessions Committee Fund purchase

Giuseppe Primoli
Italian, 1851–1927

*Parigi: Degas esce in strada nei pressi
del Boulevard du Conservatoire* (Paris:
Degas coming out of a pissoir near the
Boulevard du Conservatoire), ca. 1889,
printed 2010
Printing-out paper print
3 9/16 x 3 1/8 in. (9 x 8 cm)
Courtesy Fondazione Primoli, Rome

*Parigi: Gabrielle Réju detta Réjane in rue
de Rougemont, nei pressi del Boulevard
du Conservatoire. Nel vano della porta,
sulla destra, Edgar Degas* (Paris: Actress
Rejane on the rue de Rougemont, near
the Boulevard du Conservatoire. In the
doorway on the right, Edgar Degas),
ca. 1889, printed 2010
Printing-out paper print
3 9/16 x 3 1/8 in. (9 x 8 cm)
Courtesy Fondazione Primoli, Rome

[Swiss Guards at the Vatican Palace],
ca. 1889, printed 2010 pl. 5
Printing-out paper prints; two prints,
one: 3 9/16 x 3 1/8 in. (9 x 8 cm),
one: 2 3/4 x 2 3/8 in. (7 x 6 cm)
Courtesy Fondazione Primoli, Rome

Barbara Probst
German, born 1964

*Exposure #11A: N.Y.C., Duane & Church
Streets, 06.10.02, 3:07 p.m.*, 2002 pl. 159
Digital pigment prints
Two prints, each: 24 1/16 x 16 1/16 in.
(61.1 x 40.8 cm)
San Francisco Museum of Modern Art,
purchase through a gift of Mark
McCain in honor of Frish Brandt

John Reekie
American, active 1860–1869

*Incidents of the War: A Burial Party, Cold
Harbor, Virginia, April, 1865*, 1865 pl. 81
Albumen print
7 x 9 in. (17.8 x 22.9 cm)
Black Dog Collection

Jacob August Riis
American, born Denmark, 1849–1914

*Lodgers in a Crowded Bayard Street
Tenement—"Five Cents a Spot,"* 1889,
printed 1946 pl. 10
Gelatin silver print
8 1/8 x 9 3/4 in. (20.6 x 24.8 cm)
San Francisco Museum of Modern Art,
gift of Howard Greenberg

A "Scrub" and Her Bed—The Plank, 1892,
printed later pl. 7
Gold-toned printing-out paper print
4 x 5 in. (10.2 x 12.7 cm)
The Museum of the City of New York

**Jacob August Riis with Richard Hoe
Lawrence and Henry G. Piffard**

A Downtown Morgue, 1887, printed later
Gold-toned printing-out paper print
4 x 5 in. (10.2 x 12.7 cm)
The Museum of the City of New York

Sophie Ristelhueber
French, born 1949

т *FAIT*, 1992
Chromogenic prints
Six prints, each: 39 3/4 x 49 1/2 in.
(101 x 130.2 cm)
Albright-Knox Art Gallery, Buffalo,
New York, George B. and Jenny R.
Matthews Fund, 1997

s *FAIT*, 1992 pl. 113
Chromogenic print
39 3/4 x 49 1/2 in. (101 x 130.2 cm)
Albright-Knox Art Gallery, Buffalo,
New York, George B. and Jenny R.
Matthews Fund, 1997

Richard Ross
American, born 1947

Isolation Room CBP, San Ysidro, CA, 2004
Chromogenic print
20 x 20 in. (50.8 x 50.8 cm)
San Francisco Museum of Modern Art,
Anonymous Fund purchase

Thomas Ruff
German, born 1958

Nacht 3 I, 1992
Chromogenic print
19 x 18 1/2 in. (48.3 x 47 cm)
Collection of Jane and Larry Reed,
San Francisco

Nacht 12 III, 1992
Chromogenic print
19 x 18 1/2 in. (48.3 x 47 cm)
Collection of Jane and Larry Reed,
San Francisco

т *Nacht 15 II (Stellwerk Basel)*, 1994 pl. 142
Chromogenic print
74 13/16 x 74 13/16 in. (190 x 190 cm)
The Art Collections of Ruhr University,
Bochum, Germany

Mark Ruwedel
American, born 1954

т *Crossing #2*, 2005
Digital pigment print
15 3/4 x 20 in. (40 x 50.8 cm)
Collection David Knaus, courtesy
Gallery Luisetti

т *Crossing #6*, 2005
Digital pigment print
15 3/4 x 20 in. (40 x 50.8 cm)
Collection David Knaus, courtesy
Gallery Luisetti

т *Crossing #7*, 2005
Digital pigment print
15 3/4 x 20 in. (40 x 50.8 cm)
Collection David Knaus, courtesy
Gallery Luisetti

Crossing #14, 2005 pl. 152
Digital pigment print
15 3/4 x 20 in. (40 x 50.8 cm)
Promised gift of David Knaus to the
San Francisco Museum of Modern Art

т *Crossing #18*, 2005
Digital pigment print
15 3/4 x 20 in. (40 x 50.8 cm)
Collection David Knaus, courtesy
Gallery Luisetti

т *Crossing [bottle]*, 2005
Digital pigment print
15 3/4 x 20 in. (40 x 50.8 cm)
Collection David Knaus, courtesy
Gallery Luisetti

Erich Salomon
German, 1886–1944

*Genf, Völkerbund. Zwei Zuschauerinnen
auf der Publikumstribüne, die an Daumier
erinnern. Aufnahme mit Telekamera aus
22 m Entfernung.* (Geneva, League of
Nations. Two spectators in the public
gallery who reminded me of Daumier.
Taken with a telecamera at a distance
of 22 meters.), 1928 pl. 124
Gelatin silver print
7 3/16 x 9 7/16 in. (18.3 x 24 cm)
San Francisco Museum of Modern Art,
purchase through a gift of Christine
Murray, Sale of Photographs Fund, and
Accessions Committee Fund

Hague Conference, 1930 pl. 123
Gelatin silver print
4 1/4 x 6 in. (10.8 x 15.2 cm)
Promised gift of Paul Sack to the
Sack Photographic Trust of the
San Francisco Museum of Modern Art

William Saunders
British, 1832–1892

Chinese Execution, 1860s pl. 82
Albumen print
6 1/8 x 8 1/8 in. (15.6 x 20.6 cm)
San Francisco Museum of Modern Art,
Accessions Committee Fund purchase

Julia Scher
American, born 1954

s *Predictive Engineering 2,* 1998
Web project
http://www.sfmoma.org/media/exhibi-
tions/espace/scher/jsindex.html
San Francisco Museum of Modern Art,
gift of the artist

Tazio Secchiaroli
Italian, 1925–1998

*Anita Ekberg and Husband Anthony Steel,
Vecchia Roma,* 1958 pl. 72, fig. 16
Gelatin silver prints
Seven prints: dimensions variable
San Francisco Museum of Modern Art,
Accessions Committee Fund purchase

Marie Sester
French, born 1955

s *ACCESS,* 2003 pl. 165
Computers, cameras, robotic spotlight,
robotic acoustic beam, internet,
custom software
Dimensions variable
Project supported by Eyebeam,
New York, and by the Creative Capital
Foundation, New York
Courtesy the artist

Ben Shahn
American, born Lithuania, 1898–1969

*Asleep on Sidewalk, Bowery, New York
City,* 1933 pl. 22
Gelatin silver print
6 x 9 1/2 in. (15.2 x 24.1 cm)
San Francisco Museum of Modern Art,
Accessions Committee Fund purchase

Three Men With Iron Pilaster, New York,
1934 pl. 25
Sepia-toned gelatin silver print
6 x 9 1/4 in. (15.2 x 23.5 cm)
San Francisco Museum of Modern Art,
purchase

Post Office, Crossville, Tennessee,
1937 pl. 15
Gelatin silver print
6 1/2 x 9 11/16 in. (16.5 x 24.6 cm)
International Center of Photography,
New York, gift of Mildred Baker, 1975

*Main and Court Streets, Circleville,
Ohio,* 1938
Gelatin silver print
6 3/8 x 9 3/8 in. (16.2 x 23.8 cm)
San Francisco Museum of Modern Art,
purchase through a gift of Jane and
Larry Reed and the Accessions
Committee Fund

Stephen Shames
American, born 1947

IRA Gunman, Ireland, 1971, 1971, printed
2009 pl. 105
Chromogenic print
18 x 12 1/4 in. (45.7 x 31.1 cm)
San Francisco Museum of Modern Art,
Accessions Committee Fund purchase

SOVFOTO
Established 1932, Russia

Lublin Murder Camp, Poland, ca. 1944
Gelatin silver print
6 1/2 x 8 1/2 in. (16.5 x 21.6 cm)
National Archives, Washington, D.C.

Ted Spagna
American, 1943–1989

Untitled, from the series *Sleep/People,*
ca. 1980 pl. 146
Chromogenic prints
Overall: 19 9/16 x 30 15/16 in.
(49.7 x 78.6 cm)
George Eastman House, Rochester,
New York

Jules Spinatsch
Swiss, born 1964

*Bodyguard/Driver No. 2, at Hotel Pöstli
(waiting for Yassar Arafat),* from the
series *Temporary Discomfort, Chapter I,
The Valley. World Economic Forum WEF,
Davos-CH, January 2001,* 2001
Chromogenic print
32 1/4 x 40 in. (81.9 x 101.6 cm)
San Francisco Museum of Modern Art,
Accessions Committee Fund purchase

*Hotspot_A1_North_Entry_270103_
19h20,* from the series *Temporary
Discomfort, Chapter IV, World Economic
Forum WEF, Davos-CH,* 2003 pl. 140
Chromogenic print
16 15/16 x 22 1/16 in. (43 x 56 cm)
Courtesy the artist and Galerie Luciano
Fasciati, Chur, and Blancpain art
contemporain, Geneva

Hotspot_A1_North_Entry_280103_14h10,
from the series *Temporary Discomfort,
Chapter IV, World Economic Forum WEF,
Davos-CH,* 2003 pl. 138
Chromogenic print
16 15/16 x 22 1/16 in. (43 x 56 cm)
Courtesy the artist and Galerie Luciano
Fasciati, Chur, and Blancpain art
contemporain, Geneva

Hotspot_A4_Promenade_230103_19h35,
from the series *Temporary Discomfort,
Chapter IV, World Economic Forum WEF,
Davos-CH,* 2003 pl. 139
Chromogenic print
16 15/16 x 22 1/16 in. (43 x 56 cm)
Courtesy the artist and Galerie Luciano
Fasciati, Chur, and Blancpain art
contemporain, Geneva

Wolfgang Stoerchle
German, 1944–1976

Untitled Video Works, 1970–72 pl. 62
Single-channel black-and-white video
with sound, 4:36 min. excerpt
[flash piece]
Wolfgang Stoerchle Papers, Research
Library, The Getty Research Institute,
Los Angeles

Cecil Stoughton
American, 1920–2008

*Lyndon Johnson, flanked by Lady Bird
Johnson and Jacqueline Kennedy, aboard
Air Force One,* 1963 pl. 75
Gelatin silver print
10 x 13 1/2 in. (25.4 x 34.3 cm)
Accessions Committee Fund purchase

Paul Strand
American, 1890–1976

s *Blind Woman, New York, 1916,* 1916 pl. 16
Gelatin silver print
12 7/8 x 9 7/8 in. (32.7 x 25.1 cm)
Pilara Family Foundation,
San Francisco

Man, Five Points Square, New York, 1916,
1916 pl. 2
Silver and platinum print
9 3/4 x 10 3/8 in. (24.8 x 26.4 cm)
Private collection

t *Untitled,* 1916
Platinum print
12 5/8 x 9 3/8 in. (32 x 23.7 cm)
The J. Paul Getty Museum, Los Angeles

Miroslav Tichý
Czech, born 1926

Untitled, 1950s–80s
Gelatin silver print and ink
7 x 4 5/8 in. (17.8 x 11.8 cm)
San Francisco Museum of Modern Art,
Accessions Committee Fund purchase

Untitled, 1950s–80s pl. 48
Gelatin silver print
7 x 4 3/4 in. (17.8 x 12.1 cm)
San Francisco Museum of Modern Art,
Accessions Committee Fund purchase

Cammie Toloui
American, born 1968

The Couple, from the series *Lusty Lady,*
1992, printed 2010
Digital pigment print
9 1/2 x 6 1/2 in. (24.1 x 16.5 cm)
Collection of the artist

Milk Squirt, from the series *Lusty Lady,*
1992, printed 2010 pl. 51
Digital pigment print
9 1/2 x 6 1/2 in. (24.1 x 16.5 cm)
Collection of the artist

Underwood and Underwood
Active 1880s–1940s, United States

Oh! You Naughty Man!, from the series
The French Cook, ca. 1900
Gelatin silver print stereograph
3 3/8 x 6 7/8 in. (8.5 x 17.5 cm)
George Eastman House, Rochester,
New York

United Press International
Founded 1907, United States

*Suffolk, Virginia, Race Confrontation,
May 6, 1964,* 1964 pl. 93
Gelatin silver print
6 1/4 x 8 3/4 in. (15.9 x 22.2 cm)
San Francisco Museum of Modern Art,
Accessions Committee Fund purchase

United States Air Force

*SA-2 antiaircraft site, Havana, Cuba,
August 29, 1962,* 1962 pl. 111
Gelatin silver print
7 1/2 x 9 1/2 in. (19 x 24.1 cm)
National Archives, Washington, D.C.

United States Army

s *Rennes, France, Death of a Traitor,*
1944 pl. 86
Gelatin silver print
6 7/8 x 9 1/4 in. (17.5 x 23.5 cm)
San Francisco Museum of Modern Art,
purchase through a gift of
PhotoWings and the PhotoWings
Outreach Program

United States Army Air Forces
Active 1941–1947

s *Over Wiener Neustadt, Austria,* 1944
Gelatin silver print
9 7/16 x 7 5/16 in. (24 x 18.6 cm)
Collection of Alan Lloyd Paris

United States Army Air Service, 1st Aero Squadron
Active 1913–1921

First Mosaic Photograph Taken in United States with Original Brock Aerial Automatic Camera, Fort Sill, Oklahoma, 1915, printed 2010 pl. 109
Gelatin silver prints
Dimensions variable
National Air and Space Museum, Washington, D.C.

United States Atomic Energy Commission
Established 1946, dissolved 1974

s *Diablo Shot, fireball, July 15, 1957,* from *Atomic Tests in Nevada,* 1957 pl. 106
Gelatin silver print
7 5/8 x 9 1/2 in. (19.4 x 24.1 cm)
San Francisco Museum of Modern Art, Accessions Committee Fund purchase

s *Shasta Shot, cloud, August 15, 1957,* from *Atomic Tests in Nevada,* 1957
Gelatin silver print
7 5/8 x 9 1/2 in. (19.4 x 24.1 cm)
San Francisco Museum of Modern Art, Accessions Committee Fund purchase

Unknown (American)

View on Top of Lookout Mountain, Chattanooga, ca. 1864 pl. 117
Albumen print
5 1/2 x 7 1/2 in. (14 x 19 cm)
San Francisco Museum of Modern Art, Accessions Committee Fund purchase

s *[Dead man, killed by bomb at Anarchist riot, Union Square, New York City, March 28, 1908],* 1908, printed 1950s pl. 85
Gelatin silver print
4 3/4 x 6 1/2 in. (12.1 x 16.5 cm)
George Grantham Bain Collection, Library of Congress

Mrs. William Thaw, veiled, on street, White Plains, New York, 1909, printed 2010
Gelatin silver print
5 x 7 in. (12.7 x 17.78 cm)
George Grantham Bain Collection, Library of Congress

s *[Dead bodies, Monroe Street fire, New York City],* 1913, printed 1950s
Gelatin silver print
4 3/4 x 6 5/8 in. (12.1 x 16.8 cm)
George Grantham Bain Collection, Library of Congress

t *Anarchists, Union Square, July 11, 1914,* 1914, printed 2010
Gelatin silver print
5 x 7 in. (12.7 x 17.8 cm)
George Grantham Bain Collection, Library of Congress

s *Berkman Addressing Anarchists, Union Square, July 11, 1914,* 1914, printed 1950s pl. 119
Gelatin silver print
5 x 7 in. (12.7 x 17.8 cm)
George Grantham Bain Collection, Library of Congress

[Aerial View of Battlefield with Soldiers and Trenches], ca. 1918
Gelatin silver print
13 3/8 x 19 in. (34 x 48.3 cm)
San Francisco Museum of Modern Art, Arthur W. Barney Bequest Fund purchase

[Body of George Hughes hanging from a tree, Sherman, Texas], 1930 pl. 84
Gelatin silver print
6 5/16 x 4 7/16 in. (16 x 11.3 cm)
International Center of Photography, New York, gift of Daniel Cowin, 1990

[Unidentified Lynched Man], ca. 1930
Gelatin silver print
6 x 8 1/16 in. (15.2 x 20.5 cm)
International Center of Photography, New York, gift of Daniel Cowin, 1990

[Couple engaged in sexual activity in the back of a car], ca. 1945
Sepia-toned gelatin silver print
4 3/16 x 6 3/16 in. (10.7 x 15.8 cm)
The Kinsey Institute for Research in Sex, Gender, and Reproduction

[Maksim Grigorlevich Martynov case, Agent arrives by taxi, FBI files, Russian Spy], ca. 1954
Gelatin silver print
5 x 8 in. (12.7 x 20.3 cm)
National Archives, Washington, D.C.

[Maksim Grigorlevich Martynov case, Martynov speaks in code, FBI files, Russian Spy], ca. 1954 pl. 127
Gelatin silver print
5 x 8 in. (12.7 x 20.3 cm)
National Archives, Washington, D.C.

[Photograph taken from television monitor on September 28, 1962, showing Nelson Cornelius Drummond opening a locked file cabinet containing classified documents], 1962 pl. 125
Gelatin silver print
8 x 10 in. (20.3 x 25.4 cm)
National Archives, Washington, D.C.

Unknown (French)

s *Nude study of a black female,* ca. 1855 pl. 40
Daguerreotype
5 1/2 x 4 1/8 in. (14 x 10.5 cm)
The J. Paul Getty Museum, Los Angeles

Unknown (Unknown)

Camera concealed in walking cane, n.d.
Wood, metal, and glass
35 3/4 x 4 3/4 x 1 1/2 in. (90.8 x 12.1 x 3.8 cm)
National Museum of American History Photographic History Collection, gift of The New York News

Men's shoes with camera hidden in heel, n.d. fig. 2
Leather, cloth, rubber, metal, glass
4 1/8 x 3 x 11 1/2 in. (10.5 x 7.6 x 29.2 cm)
National Museum of American History Photographic History, gift of The New York News

Aerial reconnaissance photograph, May 6, 1944, Normandy cliffs, 1944
Gelatin silver print
10 x 10 in. (25.4 x 25.4 cm)
Private collection

Aerial reconnaissance photograph, May 20, 1944, Normandy cliffs, 1944
Gelatin silver print
10 x 10 in. (25.4 x 25.4 cm)
Private collection

[Gas chamber of crematorium V of Auschwitz], 1944, printed 2010
Gelatin silver print
11 13/16 x 9 7/16 in. (30 x 24 cm)
Courtesy the Auschwitz-Birkenau State Museum

U.S. Government, U-2 Reconnaissance Aircraft

Completed SA-2 missile site showing characteristic Star of David pattern, 1962, printed later pl. 110
Gelatin silver print
10 x 8 in. (25.4 x 20.3 cm)
Dino A. Brugioni Collection, The National Security Archive, Washington, D.C.

Nick Ut
American, born Vietnam, 1951

Terror of War: South Vietnamese forces follow terrified children running down Route 1, near Trang Bang, South Vietnam, June 8, after a misplaced napalm strike. Girl at center had ripped off her burning clothes. She suffered back burns. The firebomb was dropped by a Skyraider plane, June 8, 1972, 1972
Gelatin silver print
7 15/16 x 9 9/16 in. (20.2 x 24.3 cm)
International Center of Photography, New York, The LIFE Magazine Collection, 2005

Paris Hilton is seen through the window of a police car as she is transported from her home to court by the Los Angeles County Sheriff's Department in Los Angeles on Friday, June 8, 2007, 2007 pl. 79
Chromogenic print
11 x 14 in. (28 x 35.6 cm)
Press Association, United Kingdom

Chris Verene
American, born 1969

Untitled, from the series *Camera Club,* ca. 1996 pl. 66
Chromogenic print
18 7/16 x 14 1/2 in. (46.8 x 36.8 cm)
San Francisco Museum of Modern Art, gift of Robert Harshorn Shimshak and Marion Brenner

H. R. Voth
American, 1855–1931

Siviletstiwa, Flute Priest Getting Water for Ceremony in the Kiva, 1897
Printing-out paper print
3 1/2 in. (8.9 cm) diameter
San Francisco Museum of Modern Art, Foto Forum purchase

Smoke Ceremony in Kiva, 1897 pl. 12
Printing-out paper print
3 1/4 in. (8.26 cm) diameter
San Francisco Museum of Modern Art, Foto Forum purchase

Andy Warhol
American, 1928–1987

s *Blow Job,* 1964 pl. 56
16mm film, black-and-white, silent, 16 frames per second, transferred to video, 41 min.
Dimensions variable
The Andy Warhol Museum, Pittsburgh Contribution The Andy Warhol Foundation for the Visual Arts, Inc.

Weegee (Arthur H. Fellig)
American, born Poland, 1899–1968

Murder in Hell's Kitchen, 1935–45 pl. 97
Gelatin silver print
10 1/2 x 13 5/8 in. (26.7 x 34.6 cm)
San Francisco Museum of Modern Art, gift of Jan Kesner and Accessions Committee Fund purchase

Lovers on the Beach, Coney Island, 1940 pl. 49
Gelatin silver print
7 1/2 x 9 1/2 in. (19.1 x 24.1 cm)
International Center of Photography, New York, gift of Wilma Wilcox, 1993

Lovers at the Movies, ca. 1940 pl. 145
Gelatin silver print
10 5/8 x 13 3/8 in. (27 x 34 cm)
San Francisco Museum of Modern Art, purchase through a gift of Lynn Frances Kirshbaum

τ *Palace Theatre*, ca. 1940
Gelatin silver print
12 13/16 x 10 3/16 in. (32.5 x 26 cm)
Wilson Centre for Photography,
London

"Their First Murder," 1941
Gelatin silver print
10 1/2 x 13 5/8 in. (26.7 x 34.6 cm)
International Center of Photography,
New York, purchase, with funds
provided by the bequest of Wilma
Wilcox, 1997

[Marilyn Monroe], 1950s pl. 73
Gelatin silver print
11 3/4 x 10 1/4 in. (29.9 x 26 cm)
International Center of Photography,
New York, gift of Wilma Wilcox, 1993

τ *[Marilyn Monroe Arriving at a Film
Premiere]*, 1953
Gelatin silver print
13 3/8 x 10 3/16 in. (34 x 25.8 cm)
Wilson Centre for Photography,
London

Ad Windig
Dutch, 1912–1996

*Laatste groep Duitse soldaten marcheert
over de Dam, kort voor de intocht van
de Canadezen* (The last German troops
march across Dam Square shortly
before the arrival of the Canadians),
ca. 1945 pl. 122
Gelatin silver print
8 x 10 in. (20.3 x 25.4 cm)
San Francisco Museum of Modern Art,
Accessions Committee Fund purchase

Garry Winogrand
American, 1928–1984

New York, ca. 1968
Gelatin silver print
9 x 13 3/8 in. (22.9 x 34 cm)
San Francisco Museum of Modern Art,
gift of Carla Emil and Rich Silverstein,
courtesy Fraenkel Gallery

New York, 1969 pl. 24
Gelatin silver print
11 x 14 in. (28 x 35.6 cm)
Fractional and promised gift of
Carla Emil and Rich Silverstein to the
San Francisco Museum of Modern Art

*Reopening, Waldorf-Astoria Peacock Alley,
New York*, ca. 1971
Gelatin silver print
8 5/8 x 13 in. (21.9 x 33 cm)
San Francisco Museum of Modern Art,
purchase through a gift of the Judy Kay
Memorial Fund

Santa Monica, 1982–83 pl. 31
Gelatin silver print
15 x 22 in. (38.1 x 55.9 cm)
San Francisco Museum of Modern Art,
gift of the estate of Garry Winogrand
and Fraenkel Gallery

Shizuka Yokomizo
Japanese, born 1966

Stranger No. 1, 1998 pl. 155
Chromogenic print
31 1/4 x 31 1/4 in. (79.4 x 79.4 cm)
San Francisco Museum of Modern Art,
purchase through a gift of Mary and
Thomas C. Field

Stranger No. 2, 1999 pl. 156
Chromogenic print
31 1/4 x 31 1/4 in. (79.4 x 79.4 cm)
San Francisco Museum of Modern Art,
Accessions Committee Fund purchase

Kohei Yoshiyuki
Japanese, born 1946

τ *The Park*, 1971
Gelatin silver prints
Nine prints, each: 12 1/4 x 18 5/16 in.
(31.1 x 46.5 cm)
Wilson Centre for Photography,
London

s *Untitled*, from the series *The Park*, 1971
Gelatin silver print
12 1/4 x 18 5/16 in. (31.1 x 46.5 cm)
San Francisco Museum of Modern Art,
Anonymous Fund purchase

s *Untitled*, from the series *The Park*,
1971 pl. 50
Gelatin silver print
12 1/4 x 18 5/16 in. (31.1 x 46.5 cm)
Private collection

s *Untitled*, from the series
Love Hotel, 1978
Gelatin silver print
12 1/4 x 18 5/16 in. (31.1 x 46.5 cm)
Private collection

Abraham Zapruder
American, born Russia, 1905–1970

*Assassination of John F. Kennedy,
November 22, 1963*, 1963 pl. 92
Gelatin silver print
4 3/8 x 5 5/8 in. (11.1 x 14.3 cm)
San Francisco Museum of Modern Art,
Accessions Committee Fund purchase

Zeiss
Established 1846, Germany

Contax II [Camera Walker Evans used
to photograph his subway pictures],
ca. 1936
Dimensions variable
Collection of Jerry L. Thompson and
Marcia L. Due

PHOTOGRAPHY CREDITS

All artworks are reproduced by permission of the artist and the owners of the works named in the checklist. Additional photography credits appear below.

PLATES

1 © Robert Frank

2 © Aperture Foundation, Inc., Paul Strand Archive

3 © V&A Images/Victoria and Albert Museum, London

4 © The Museum of Modern Art/Licensed by SCALA/Art Resource, NY

5 Courtesy Fondazione Primoli, Roma

7 Courtesy Museum of the City of New York

8 Ben Blackwell for the San Francisco Museum of Modern Art, courtesy the Pilara Family Foundation, San Francisco

9 © Walker Evans Archive, The Metropolitan Museum of Art

11 © Walker Evans Archive, The Metropolitan Museum of Art

14 © The Dorothea Lange Collection, Oakland Museum of California, City of Oakland. Gift of Paul S. Taylor

15 International Center of Photography, Gift of Mildred Baker, 1975

16 Ben Blackwell for the San Francisco Museum of Modern Art, courtesy the Pilara Family Foundation, San Francisco; © Aperture Foundation, Inc., Paul Strand Archive

17–19 © Walker Evans Archive, The Metropolitan Museum of Art

20 Ben Blackwell for the San Francisco Museum of Modern Art, courtesy a private collection; © The Brassaï Estate—RMN

21 © Henri Cartier-Bresson/Magnum Photos

22 © Estate of Ben Shahn/Licensed by VAGA, New York, NY

23 © Henri Cartier-Bresson/Magnum Photos

24 © 1984 The Estate of Garry Winogrand, courtesy Fraenkel Gallery, San Francisco

25 © Estate of Ben Shahn/Licensed by VAGA, New York, NY

26–27 © Estate of Helen Levitt, courtesy Laurence Miller Gallery, New York

28–29 Ben Blackwell for the San Francisco Museum of Modern Art, courtesy a private collection; © The Estate of Harry Callahan, courtesy Pace/MacGill Gallery, New York

30 © Bill Dane

31 © 1984 The Estate of Garry Winogrand, courtesy Fraenkel Gallery, San Francisco

32 Ben Blackwell for the San Francisco Museum of Modern Art, courtesy the Pilara Family Foundation, San Francisco; © Philip-Lorca diCorcia, courtesy David Zwirner, New York

33 © The Estate of Harry Callahan, courtesy Pace/MacGill Gallery, New York

34 © Anthony Hernandez, courtesy the artist and Christopher Grimes Gallery

35 © Mitch Epstein/Black River Productions, Ltd., courtesy the artist

36 Courtesy George Eastman House, International Museum of Photography and Film

37 Courtesy the J. Paul Getty Museum, Los Angeles

39 Bibliothèque nationale de France

40 Courtesy the J. Paul Getty Museum, Los Angeles

41 © 2010 Artist Rights Society (ARS), New York/ADAGP, Paris

42 Courtesy the J. Paul Getty Museum, Los Angeles; © 2010 Man Ray Trust/Artist Rights Society (ARS), New York/ADAGP, Paris

44 Courtesy the Museum of Modern Art/Licensed by SCALA/Art Resource, NY; © 2010 Man Ray Trust/Artist Rights Society (ARS), New York/ADAGP, Paris

45 © Robert Frank, from *The Americans*

46 © Henri Cartier-Bresson/Magnum Photos

47 © The Brassaï Estate—RMN, CNAC/MNAM/Dist. Réunion des Musées Nationaux/Art Resource, New York

48 © Miroslav Tichý, courtesy Foundation Tichy Ocean, Zurich, Switzerland

49 © Weegee/International Center of Photography/Getty Images

50 © Kohei Yoshiyuki, courtesy Yossi Milo Gallery, New York

51 © Cammie Toloui, courtesy the artist

52 © Stephen Barker

53–54 © Merry Alpern, courtesy Bonni Benrubi Gallery, New York

55 © The Helmut Newton Estate/Maconochie Photography

56 © 2010 The Andy Warhol Museum, Pittsburgh, PA, a museum of Carnegie Institute. All rights reserved

57 © Robert Mapplethorpe Foundation. Used by permission

58 © Nobuyoshi Araki

59 © Elena Dorfman

60 © Estate of Guy Bourdin/Art + Commerce

61 Courtesy Amador Gallery; © Susan Meiselas/Magnum Photos

62 Research Library, The Getty Research Institute, Los Angeles (2009.M.16)

63 © Susan Meiselas/Magnum Photos, courtesy the artist

64 Courtesy Whitney Museum of American Art, New York; © Nan Goldin, courtesy Matthew Marks Gallery

65 © Yoko Ono, courtesy the artist

66 © Chris Verene

67 © Doris Banbury

68–70 Alexis Brandt, Réunion des Musées Nationaux/Art Resource, New York; Christian Bérard © 2010 Artist Rights Society (ARS), New York/ADAGP, Paris

71 Ben Blackwell for the San Francisco Museum of Modern Art, courtesy Stephen Wirtz Gallery, San Francisco; © Eredi Geppetti

72 © Tazio Secchiaroli/David Secchiaroli

73 © Weegee/International Center of Photography/Getty Images

74 International Center of Photography, The LIFE Magazine Collection, 2005/Getty Images

76 © Ron Galella, Ltd., courtesy the artist

77 © 2010 The Richard Avedon Foundation

78 © Georges Dudognon

79 Associated Press/Nick Ut

80 © Alison Jackson, courtesy M+B Gallery

81 Ben Blackwell for the San Francisco Museum of Modern Art, courtesy Black Dog Collection

83 Courtesy the J. Paul Getty Museum, Los Angeles

84 International Center of Photography, Gift of Daniel Cowin, 1990

85 Courtesy the Library of Congress

87 Courtesy National Archives, photo no. 111_SC-203771

88 © Lee Miller Archives, England 2010. All rights reserved

90 Associated Press/Malcolm Browne

91 Associated Press/Eddie Adams

92 © 1967 (Renewed 1995) The Sixth Floor Museum at Dealey Plaza. All rights reserved

93 © United Press International, Inc. All rights reserved

94 © Harry Benson, courtesy the artist

95 International Center of Photography, The LIFE Magazine Collection, 2005/Getty Images

96 © Oliver Lutz, courtesy the artist

97 © Weegee/International Center of Photography/Getty Images

98 Courtesy George Eastman House, International Museum of Photography and Film

99 © Enrique Metinides, courtesy Anton Kern Gallery, New York

100 Ben Blackwell for the San Francisco Museum of Modern Art, courtesy Bruce Moore, San Francisco; © Eredi Geppetti

101 © Susan Meiselas/Magnum Photos

102 © Lucinda Devlin, courtesy Paul Rodgers/9W Gallery, New York

103 © Gilles Peress/Magnum Photos

104 © Bill Burke

105 © Stephen Shames

107 Courtesy the artist and Luhring Augustine, New York

108 Courtesy George Eastman House, International Museum of Photography and Film

109 National Air and Space Museum (NASM 9A08001–4), Smithsonian Institution

110 Dino A. Brugioni Collection, The National Security Archive, Washington, D.C.

111 Courtesy National Archives, photo no. 342_B-167783AC

112 © Dave Gatley

113 Courtesy Albright-Knox Art Gallery; © 2010 Artist Rights Society (ARS), New York/ADAGP, Paris

114 © Simon Norfolk

115 © Trevor Paglen

116 © Shai Kremer

119 Courtesy the Library of Congress

120 © National Portrait Gallery, London

121 Courtesy KZ-Gedenkstätte Dachau

122 © Estate of Ad Windig

125 Courtesy National Archives, photo no. 065_CC-50-1

126 Courtesy National Archives, photo no. 065_CC-48-3

127 Courtesy National Archives, photo no. 065_CC-49-2

128 International Center of Photography, The LIFE Magazine Collection, 2005, reproduced by permission of the artist

129 © Ben Lowy, courtesy the artist

130–31 © Marc Garanger

132 Courtesy Sprüth Magers Berlin London and Matthew Marks Gallery, New York; © 2010 Artist Rights Society (ARS), New York/VG Bild-Kunst, Bonn

133 © 2010 Artist Rights Society (ARS), New York/VG Bild-Kunst, Bonn

134 Courtesy Museum of Modern Art, Ljubljana; © Sanja Ivekovic

135 © Jonathan Olley

136–37 © Andreas Magdanz

138–40 © Jules Spinatsch, courtesy the artist

141 © Massachusetts Institute of Technology

142 Courtesy David Zwirner, New York; © 2010 Artist Rights Society (ARS), New York/VG Bild-Kunst, Bonn

143 Courtesy the artist and Alexander and Bonin, New York

144 Courtesy National Archives, photo no. 111_CC-46427

145 © Weegee/International Center of Photography/Getty Images

146 Courtesy George Eastman House, International Museum of Photography and Film; © The Estate of Ted Spagna

147 Courtesy George Eastman House, International Museum of Photography and Film

148 International Center of Photography, The LIFE Magazine Collection, 2005/Getty Images

149 © Laurie Long

150 International Center of Photography, The LIFE Magazine Collection, 2005/Getty Images

151 Courtesy Amador Gallery; © John Gossage

152 © Mark Ruwedel, courtesy Gallery Luisotti

153 © Merry Alpern, courtesy Bonni Benrubi Gallery, New York

154 Ian Reeves, courtesy the Doris and Donald Fisher Collection, San Francisco; © Artist Rights Society (ARS), New York/ADAGP, Paris

155–56 © Shizuka Yokomizo

157 Courtesy Fondation Cartier pour l'art contemporain, Paris; © Alair Gomes. All rights reserved

158 © Mitch Epstein/Black River Productions, Ltd., courtesy the artist

159 © 2010 Artist Rights Society (ARS)/VG Bild-Kunst, Bonn

160 © Harun Farocki, courtesy the artist

161 © Michael Klier

162 © Jordan Crandall, courtesy the artist

163 Courtesy Sperone Westwater; © Bruce Nauman/Artist Rights Society (ARS), New York

164 © Richard Gordon

165 © Marie Sester

FIGURE ILLUSTRATIONS

1 Alexis Brandt, courtesy Réunion des Musées Nationaux/Art Resource, New York; Christian Bérard © 2010 Artist Rights Society (ARS), New York/ADAGP, Paris

3 Courtesy Bayerisches Nationalmuseum, Munich

4 Courtesy George Eastman House, International Museum of Photography and Film; © Georgia O'Keeffe Museum/Artist Rights Society (ARS), New York

8–10 © Bill Brandt/Bill Brandt Archive Ltd.

11 Universal Studios Licensing LLLP

12 Courtesy Pacific Film Archive; Universal Studios Licensing LLLP

13–14 © Robert Frank

15 © David Secchiaroli

16 © Tazio Secchiaroli/David Secchiaroli

17 Ben Blackwell for the San Francisco Museum of Modern Art, courtesy Stephen Wirtz Gallery, San Francisco; © Eredi Geppetti

18 Courtesy Staley-Wise Gallery, New York; © Bert Stern

19 © coll. Société française de photographie, Paris. TOUS DROITS RESÉRVÉS

21 Courtesy and © Giorgio Colombo, Milano; © Bruce Nauman/Artist Rights Society (ARS), New York

22 Courtesy the artist and Metro Pictures

23 Courtesy the artist and Alexander and Bonin, New York

24 Betsy Jackson, courtesy Acconci Studio

25 Courtesy the artist

26 Courtesy the artist

27 Courtesy the artist